WHAT IS A PICTURE?

George Boas
and
Harold Holmes Wrenn

WHAT IS A PICTURE?

SCHOCKEN BOOKS · NEW YORK

First published by the University of Pittsburgh Press

To our wives

First SCHOCKEN PAPERBACK edition 1966

© 1964 University of Pittsburgh Press

Library of Congress Catalog Card No. 66-14867

Manufactured in the United States of America

Preface

This short book is the result of a collaboration between a teacher of philosophy who has indulged in aesthetics and a practicing artist who is an architect and painter. The former is largely responsible for the words, the latter for the illustrations. Nevertheless everything between its covers has been discussed by both and nothing has been included that was not acceptable to both. It is hoped that one of the fruits of this wedding of theory and practice will not be sterile and will be greater enjoyment of an art which has proved to be a source of intense pleasure to both authors throughout their lives.

Neither pretends to be more than he is. They are both fully aware of the dangers of pontificating and of the probability that their opinions will be superseded by the work of their juniors. It is the general fate of books to grow old as their authors do, and the only immortality which can be hoped for lies in reincarnation. A book may be reborn in the minds of its readers and appear in new form. Many a book has turned out to be wrong in detail and right as a whole and some have been wrong as a whole and right in detail. Since it would be impossible to be entirely right in every respect, we hope that our errors lie in details.

It should be explained that what we have to say about pictures is supposed to apply only to pictures and not to constitute a general theory of art and artistry. Some of what we say will of course be true of architecture, sculpture, and possibly music. But that will be so only accidentally. We are not attempting to erect a grandiose theory of art which will be true of all arts, nor are we so arrogant as to believe that even the art of painting will not in the future develop in directions which we have not foreseen.

It is customary for authors to express their thanks to those who have helped them in the writing of their books, a custom which we gladly follow. First, we must thank our wives for so many reasons that it would be endless to list them. Second, our students who, though captives, listened and made our talks worth giving. Third, the artists whose works have been a stimulus to passionate enjoyment. Fourth, the innumerable historians of art who have brought to our attention analyses and comments which have so often been illuminating. We both feel that there is no substitute for the direct acquaintance with pictures. But we know from our own experience as students and teachers that such acquaintance can be enriched by comment. We owe special thanks to the National Gallery in Washington and to Mrs. John Shapley, Curator of Painting; to the Walters Art Gallery in Baltimore and Miss Dorothy Miner; and to the staff of the Baltimore Museum of Art.

Finally, we should like to say that our aim is not to create new historians nor aestheticians. It is, if possible, to make looking at pictures more interesting and thus more enjoyable. We make no apology for believing that pleasure is worth while.

<div align="right">G.B.—H.H.W.</div>

Contents

List of Illustrations

Chapter I The Problem

The purpose of this book is very simple. It is to point out with copious illustrations how complicated a thing a picture is. It is not a discussion of the technique of drawing and painting. Aestheticians for years have been trying to elaborate theories of art which will conclude with a definition of a work of art applicable to all pictures, sculptures, musical compositions, buildings, poems, and in short to everything which may be called beautiful or ugly. We prefer to let theories wait a while, to wait at least until an adequate survey of the field has been made. By "adequate" we mean a survey covering all aspects of pictures from the onlooker's point of view and, though it may turn out that our conclusions are true of the other arts, we shall be satisfied if what we find throws some light on painting alone.

In man's long history pictures have served a great variety of purposes and, though some writers would insist that several of these purposes are illegitimate, we are insisting that whatever has made a painting something to be valued, something worth looking at carefully, something to study and appreciate, to hang on a wall of a room because someone likes it, is a legitimate aspect of the picture.

There have been times when men made pictures and others looked at them because they expressed a moral lesson or illustrated a religious parable. Thus Duccio's *Agony in the Garden* (Fig. 1) vivifies for those who look at it one of the most moving scenes in the life of Christ, and Rembrandt's *Prodigal Son* (Fig. 2) illustrates a parable. The almost countless paintings of this type were obviously made because of the lesson which the story has to tell; so Pisanello's *Vision of St. Eustace* (Fig. 3) would be meaningless unless one had some idea of the story which lies behind it. There have been other times when men made pictures with no moral in mind, no lesson to teach, but on the contrary turned their attention to scenes of natural beauty, as Claude Lorrain did in his *Landscape with Merchants* (Fig. 4), to pictures of animals, for which Cuyp is famous (Fig. 5), to arrangements of flowers, as in the Huysum (Fig. 6), none of which could be called moral or religious except in some derivative sense. There have been still other times when the subject matter of paintings was of no special importance, as in Monet's *Etretat* (Fig. 7),

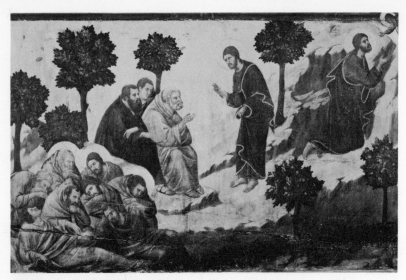

Fig. 1. Duccio di Buoninsegna: *Agony in the Garden*. Museo del Duomo, Siena.

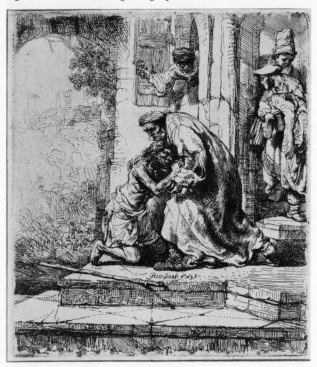

Fig. 2. Rembrandt van Ryn: *The Prodigal Son*. Baltimore Museum of Art.

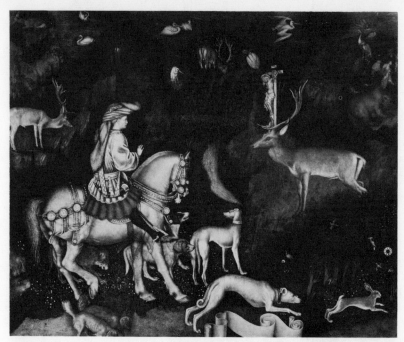

Fig. 3. Pisanello: *Vision of St. Eustace*. National Gallery, London.

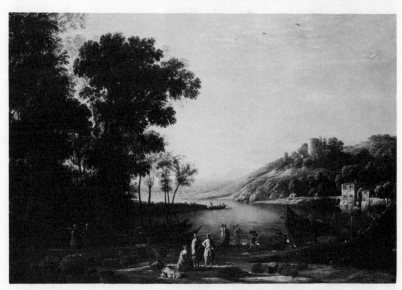

Fig. 4. Claude Lorrain: *Landscape with Merchants*. National Gallery of Art, Washington.

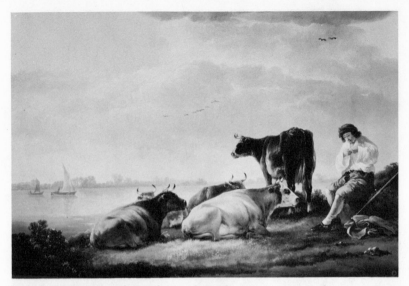

Fig. 5. A. Cuyp: *Cows and a Herdsman*. The Frick Collection, New York.

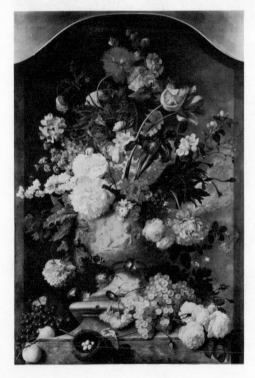

Fig. 6. Jan Huysum: *Flowers*.
National Gallery, London.

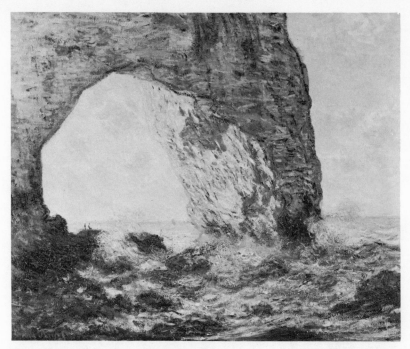

Fig. 7. Claude Monet: *Etretat*. Metropolitan Museum of Art, New York.

where the focus of our attention is the artist's style of painting rather than the cliff eaten away by the waves. There have also been times when no subject matter whatsoever was demanded and when in fact, if some were found, it was considered to be a blemish. There is no subject matter in the Mondrian *Opposition of Lines* (Fig. 8) except the lines themselves, nor in the Kandinsky *Penetrating Green* (Fig. 9). These are clearly pure design.

When one thinks of the history of this one art, painting, one is forced to the conclusion that almost every aspect of a painting has been the center of some observer's attention and the source of whatever pleasure he could get from looking at it. It seems absurd to maintain that in a situation of this sort only one observer is right and everyone else wrong. We cannot reasonably argue that everyone is stupid who does not agree with us and it makes more sense to state flatly that pictures are very complex, that sometimes they are one thing, at others another, and that, hard as this may seem, they are several things at once.

Let us take an analogous situation. Works of art like human beings are individuals. Individuals are never entirely unlike other individuals, but nevertheless they are not entirely like them either. Even the children of the same parents have each their own character, though Mary may resemble her father and John his mother. In spite of family resemblances, they still can be

5

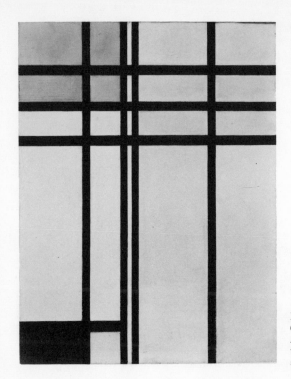

Fig. 8. Piet Mondrian: *Opposition of Lines*. A. E. Gallatin Collection, Philadelphia Museum of Art.

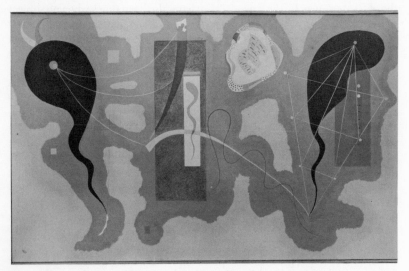

Fig. 9. Wassily Kandinsky: *Penetrating Green*. Philadelphia Museum of Art.

told apart and usually have enough character to want to be told apart. When they go to school, some turn out to be typical specimens of the school's ideal, others are non-conformists and would prefer death to being like their schoolmates. Probably the largest group wavers in between, conforming in some things and refusing to conform in others. So with pictures. One can often look at a painting and immediately see that it is, for instance, a Florentine painting of the fifteenth century or an imitation of one. Or one may see that it is by a follower of Caravaggio or David or Picasso. But nevertheless not all paintings produced in fifteenth-century Florence or eighteenth-century France or twentieth-century Paris are alike. We know that Raphael was a pupil of Perugino, but even a cursory glance at his *Galatea* (Fig. 10) and at his master's *Bestowal of the Keys on Peter* (Fig. 11) will convince one that he was no slavish copyist of his teacher. At the same time no one could fail to see the likeness between this Perugino and Raphael's *Marriage of the Virgin* (Fig. 12). It must not be forgotten that Matisse worked for some weeks in the studio of none other than Bouguereau, but who would ever think that Matisse's *Blue Nude* (Fig. 13) had been painted by a pupil of the man who painted Bouguereau's *Bacchante* (Fig. 14)?

But what else should we expect? Every painter—except perhaps Saint Luke[1]—is a human being and if no two human beings have even the same handwriting or the same accent and pronunciation and intonation in speaking, not to mention fingerprints and faces, why should the things which they make with so much passion and which are supposed to be expressive of their deepest feelings be expected to be more alike than they are? There is an old saying among physicians that everyone gets a disease in his own way. One could also say that everyone paints a picture in his own way, which is obvious, and that everyone looks at a picture in his own way, which is not obvious at all.

Since we have mentioned human beings as specimens of innate diversity, let us also point out that just as critics have never agreed on what makes a work of art a work of art, so philosophers have never agreed on what makes a human being human. Man has been defined as a rational animal, a featherless biped, a social animal, an animal which laughs, a religious animal, a special form of primate, an alimentary tract, a tool-making animal, the one animal with foresight, the one being between the angels and the beasts, the one creature with a sense of sin and of estrangement from God, the one self-conscious animal, and doubtless a score of other things. Without denying the uniqueness of man, it is not illogical to argue that he could be all of these things together without any internal contradictions being involved. It would be foolish to write a treatise on human nature which treated men only as rational animals and omitted any mention of their sense of humor, their technical skill, their

[1] It may be worth recording that the earliest surviving record of the legend that Saint Luke was a painter is to be found in a fragment of Theodorus Lector, a Byzantine chronicler of the sixth century, which runs, "It is said that Eudocia sent to Pulcheria from the city of Jerusalem a portrait of the Lord's Mother, which the Apostle Luke had painted." See Migne's *Patrologia Graeca*, vol. 86, col. 165.

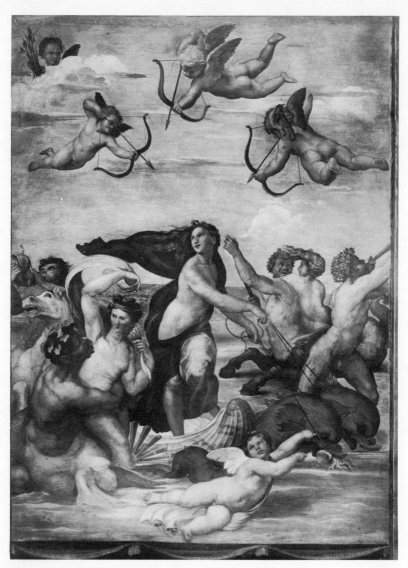

Fig. 10. Raphael: *Galatea*. Farnesina Palace, Rome.

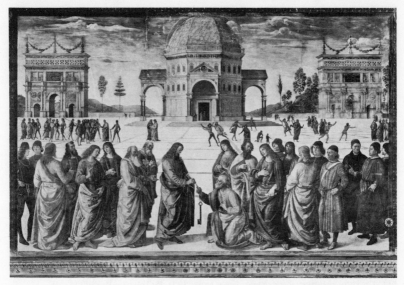

Fig. 11. Perugino: *Bestowal of the Keys on Saint Peter*. Sistine Chapel, Rome.

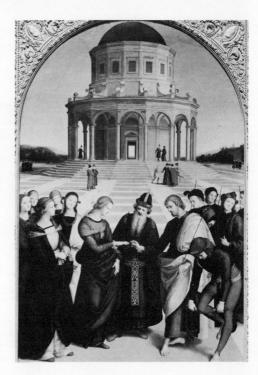

Fig. 12. Raphael: *Marriage of the Virgin*. Brera Gallery, Milan.

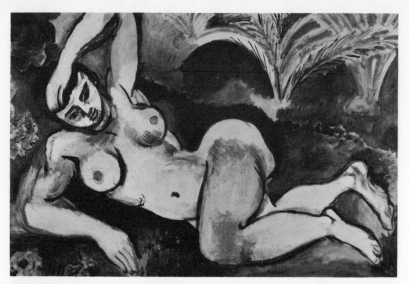

Fig. 13. Henri Matisse: *Blue Nude*. Cone Collection, Baltimore Museum of Art.

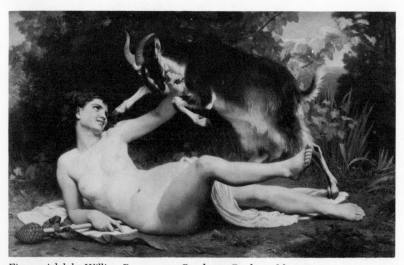

Fig. 14. Adolphe William Bouguereau: *Bacchante*. Bordeaux Museum.

habit of planning for the future, their relation to the great apes and indeed to the other beasts. Nor could these true characteristics be deduced logically from their rationality. No one author would know enough to write a treatise which did include all these matters, but if one wished to be exhaustive, one probably ought to know even more.

It is precisely because we are so many things that we find ourselves frequently in a state of conflict. We may be rational animals, but we also have a sense of humor and we are tempted at times to be unreasonably humorous and at others to be humorlessly rational. Between the buffoon and the long-faced prig, as Aristotle said, there is a happy medium. Again, we know that we should plan for the future and lay up stores for the lean years which are bound to come, but we are also anxious to enjoy the passing moment. There is no need to extend our examples, for they are known to all. Such conflicts have always been the special target of moralists and, as we have said, everyone has felt them in his own life. But it should not be forgotten that our characters are formed not simply by applying one of these definitions of humanity to the solution of life's problems, but by the strains which the feeling of conflict produces.

We have brought this upon the stage to throw some light on the problem of pictures. We hope to show that while most of the definitions of painting are true, they are true collectively and not in isolation from one another. Man is a rational animal, but he is also an emotional animal. He is a member of society, but he is also an individual. He has a sense of sin, but he has also a sense of self-esteem. Furthermore, each individual man has a peculiar proportion of each ingredient in him and it is likely that no two men, except identical twins, are mixed up according to the same recipe. So pictures, we hope to show, are a complex of many traits. They may resemble other pictures in some of their predominant features, but, as with human beings, the mixtures vary. Flowers, for instance, have been painted by thousands of artists and we reproduce here a group of eight paintings of flowers by eight different painters: Caravaggio (Fig. 15), Odilon Redon (Fig. 16), Cézanne (Fig. 17), Henri Rousseau (Fig. 18), Degas (Fig. 19), Matisse (Fig. 20), Monet (Fig. 21), and Georgia O'Keeffe (Fig. 22). These pictures may all be lumped together as "flower paintings," but one look is enough to show how superficial such a lumping together would be. No one would think that what is of interest in the O'Keeffe is its resemblance to the Redon, nor that the importance of the Rousseau is its resemblance to the Monet. Each has its own special individuality. Nor would a man who wanted an O'Keeffe and couldn't find one, console himself with the thought that he could always look at a Cézanne, beautiful as the latter might be. Works of art are no more interchangeable than people are, regardless of their common characteristics.

One of the most peculiar things about human life is that it has a history. One might imagine that if certain deeds were right and others wrong, regardless of circumstances, people would have discovered which was which thousands of years ago. Then we should never have had to change our stand-

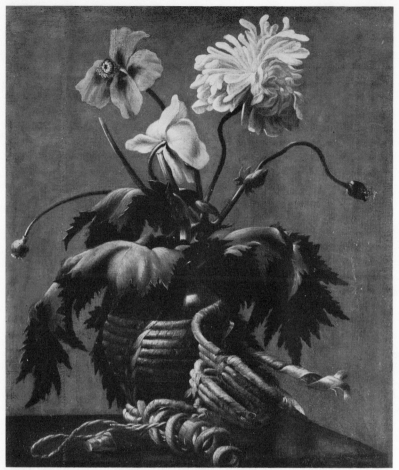

Fig. 15. Michelangelo Caravaggio: *Flowers*. Boston Museum of Fine Arts.

ards of behavior. Similarly, why did not people discover how to strike a fire and let it go at that? To float on a log and not bother to make boats? To pick up their food from the ground and not spend their time growing it and cooking it? But we know that our fellowmen have never been completely satisfied with any institution, standard, or instrumentality. Government, moral codes, tools, have all changed as time has passed, some slowly, some quickly. This is a commonplace but one whose significance seems to have escaped most people. Even religion, according to historians of the subject, which might have been expected to remain immutable, has changed. Professor W. F. Albright in his book, *From Stone Age to Christianity,* has shown how the Old Testament Hebrews modified their ideas of God as generations of priests,

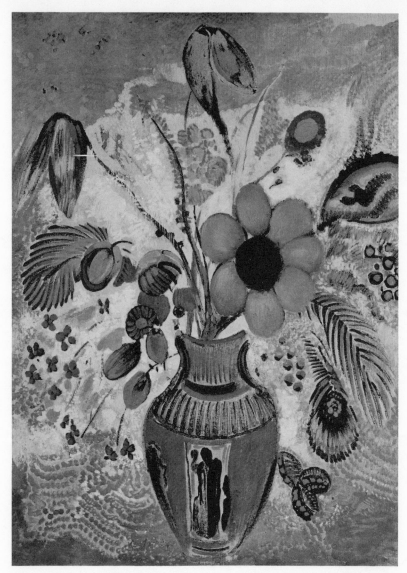

Fig. 16. Odilon Redon: *The Etruscan Vase*. Metropolitan Museum of Art, New York.

judges, prophets, and kings arose and fell, and yet each generation believed its conception of God to be everlasting. It is apparently next to impossible for a man to believe in the death of his own ideas. We need no great knowledge of the history of morals to learn how what once was considered reasonable conduct now seems barbarous to us. The Romans, for instance, for some

Fig. 17. Paul Cézanne: *Vase of Flowers*. Chester Dale Collection, National Gallery of Art, Washington.

time gave fathers of families the power of life and death over their children; the early Greeks exposed their unwanted babies to die; only a few decades ago women were second-class citizens having no right to vote; and Americans held slaves as late as 1865. As for our tools, who could deny the fantastic development of technology, with the motive power passing from muscles to wind and water, to steam, to electricity, and now to atomic energy?

If religion, morality, and technology, to say nothing of other matters, have all been modified during the course of years, why should it be astonishing

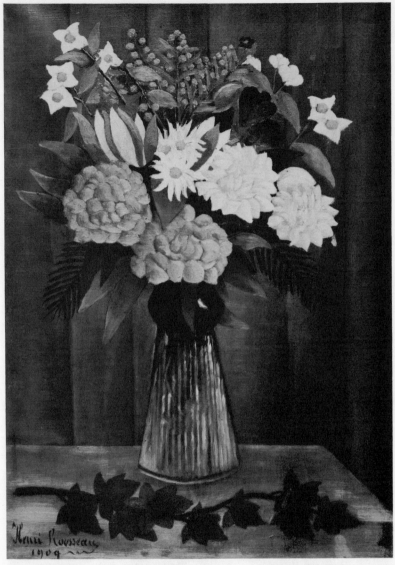

Fig. 18. Henri Rousseau: *Flowers in a Vase*. Albright Art Gallery, Buffalo, N.Y.

that works of art and artistry should also have changed? It would be absurd to say that modern painting is the same as primitive painting, even though some modern painters have found their inspiration in the works of primitives. More than anything else, it is our appreciation of the arts of our ancestors which has changed. We have learned to understand, through the studies of

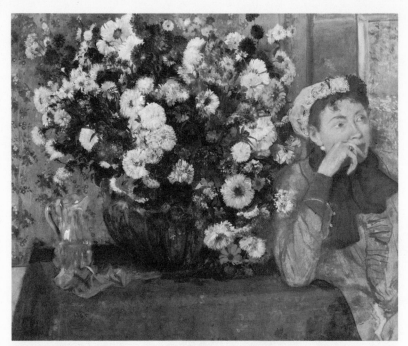

Fig. 19. Edgar Degas: *Woman with Chrysanthemums*. Havemeyer Collection, Metropolitan Museum of Art, New York.

Fig. 20. Henri Matisse: *Anemones and the Chinese Vase*. Cone Collection, Baltimore Museum of Art.

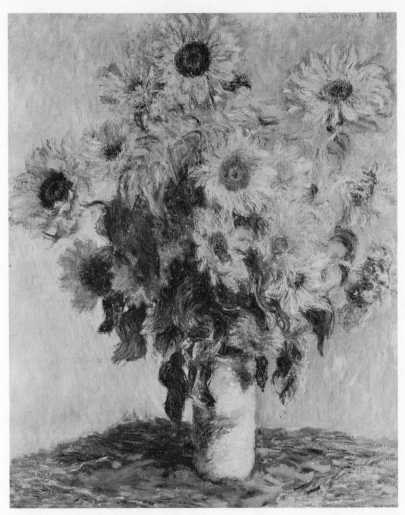

Fig. 21. Claude Monet: *Sunflowers*. Metropolitan Museum of Art, New York.

historians of art, what directed the artistry of our forebears and we are more willing than men used to be to accept the savage, the exotic, the childlike, the fantastic, as worth our while. It seems folly to insist that only those forms of painting of which we approve and which we like are right and proper. At any rate it is the point of view of this book that critics should admit the mutations of art as real. And they should try to find out why they have occurred.

We shall never know the entire answer to this question, for those interests which cause people to ask certain questions are also subject to change. There are some people whose main purpose in life is to uncover the permanent

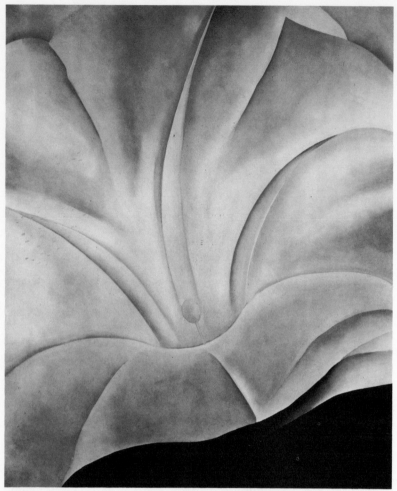

Fig. 22. Georgia O'Keeffe: *Morning Glory*. Cleveland Museum of Art.

aspects of things, whereas others are more interested in the impermanent. Furthermore, because of the very complexity of works of art—the complexity which forms the subject matter of this book—one man will be interested in studying one phase of painting, another in another. Nevertheless we can suggest certain causes of change, even if our account is incomplete.

The most important cause is the interaction of all human interests. There is nothing which a man does which does not influence all his other occupations. A man's religious beliefs will affect his business, his social relations, the books he reads, and the pictures he likes to look at. If a man is sincerely religious and accepts the moral code of the Bible, he will try not to seek

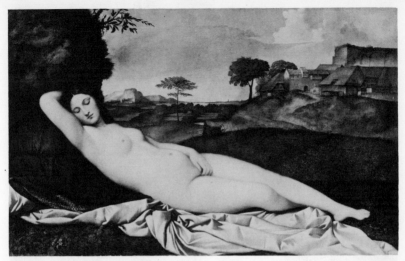

Fig. 23. Giorgione: *Venus.* Pinakothek, Dresden.

revenge on his enemies nor cheat nor commit any of the other acts which are condemned in Scripture. But if this is so, then his economic life is bound to be affected and his attitude towards other people as well. There are bound to be certain works of art which he will find repellant, whatever others may say. The most obvious case is that of the pictures which used to be called immoral. He will probably condemn the nude and any other pictures which stimulate those feelings which he finds evil. We do not pretend to say that the nude body is or is not immoral; that is not our problem. But if a man thinks that Giorgione's *Venus* (Fig. 23), or Boucher's *Toilet of Venus* (Fig. 24), or Franciabigio's *Venus* (Fig. 25), or Cranach's *Judgment of Paris* (Fig. 26) will incite men to commit adultery or fornication, and if he believes such acts are forbidden by God, it is not unreasonable that he should also believe such paintings to be evil. There are many "if's" in this sentence and all of them may be unjustified in the minds of some readers, but that is not our point. There have been people to whom the "if's" were flat statements of fact. Would any of us want to see a picture of Hitler in which he was represented as a hero? Would any Christian approve of a book in which Judas was portrayed as an admirable character? And yet, just as Saint Ambrose was willing to call the sin of Adam and Eve a *felix culpa* because it permitted the Incarnation and subsequent Redemption, so one might easily think of the betrayal of Judas as a necessary crime if there was to be the Atonement on the Cross. We are often told that we ought to keep religious or moral and aesthetic judgments separate. It cannot be denied that many a moral sinner has been socially charming; if he had not been, he could not have sinned so easily. Similarly we have been told by Tolstoy that a work of art which was immoral was by that very fact alone ugly. He has been harshly criticized for saying so.

19

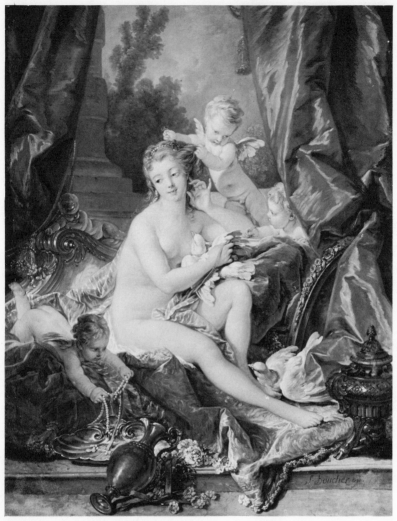

Fig. 24. François Boucher: *Toilet of Venus*. Metropolitan Museum of Art, New York.

But if one were Tolstoy, one might really find immorality ugly. One might not merely disapprove of liars, cheats, adulterers, murderers, and their tribe, but also loathe them.

When we write books, we can divide ourselves up into heart and mind, emotion and reason, sense and sensibility, theory and practice, even life and art, but actually these contrasting acts and attitudes are all intertwined. One can talk of many things which have different names as if they were separate things, but that does not separate them in reality. A bowl is both concave and

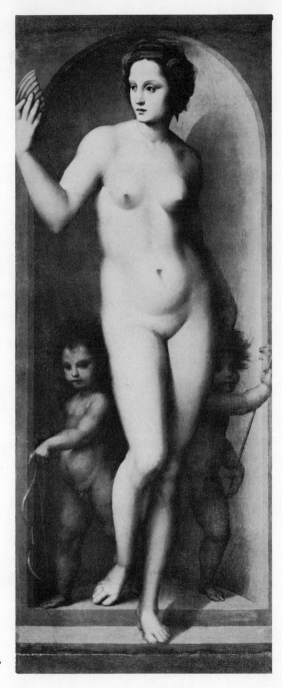

Fig. 25. Franciabigio:
Venus. Borghese Palace,
Rome.

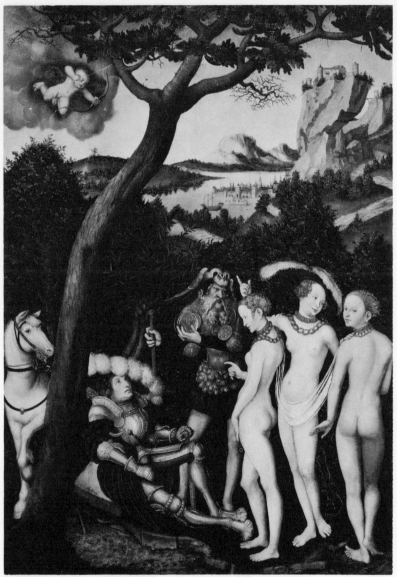

Fig. 26. Lucas Cranach: *The Judgment of Paris*. Metropolitan Museum of Art, New York.

convex and it cannot be one without being the other. One can reasonably talk about the concave inside without talking about the convex outside, but each is dependent on the other if the bowl has been hammered out of a single piece of metal or coiled out of a rope of clay.

Again, it might be said that purely rational man is to be found in the mathematician. But we often forget that what seems like a satisfactory proof to a mathematician is determined by the feeling that he has reached the answer. There have been plenty of mathematicians who were satisfied with proofs which seemed too weak to be acceptable to their successors. The contemporary mathematician believes Euclid's *Elements of Geometry* to be all right for schoolboys but totally inadequate for professionals. There exists, as William James pointed out long ago, a "sentiment of rationality." And the satisfaction of that sentiment may be as important as logic when people begin to argue. Furthermore, the premises that an individual chooses may be determined by what he wants to prove. And finally, does reason alone choose our problems for us? Or do we see them for ourselves? Aristotle was as good a reasoner as anyone alive today, but his problems were not ours and he did not —could not—see ours.

If, as Pascal said, the heart has its reasons which the reason does not know, only the reason can tell the heart what they are—assuming that it wants to find out. A man who followed his heart, regardless of what his reason might have to say, might turn out to be a great saint, but he would be more like a noble animal than a man, a single-minded fellow trusting in what he would call, if he ever talked at all, his instincts. Of course the moment he tried to communicate the promptings of his heart to others, he would lapse into rational discourse and, though the reason which elaborated and controlled his discourse would not be his but that of his society and tradition, it would still be reason.

In short, one must be wary of attributing existential difference to qualitative difference, that is, one must avoid thinking that every noun and adjective names a separate thing connected loosely with other things. One can talk about colors, shapes, tastes, textures, and so on, as if each were existentially cut off from the others. But every single object will have some color—including black, grey, and white among the colors—some shape, some taste, some texture, some grand combination of all sorts of sensory qualities which do not and cannot exist in separation from the others.

The moral of this for our purposes is that it gives us some clue to changes in taste and changes in painting. Taste is determined both by what we ourselves find pleasing and displeasing before we begin to read books and take courses in school, and what we discover to be pleasing to other people whom we respect or admire or are supposed to respect or admire under penalty of being thought Philistines. Now babies seem to be fairly undisciplined in their tastes, handling almost everything, tasting almost everything, and, if one may judge from their parents' outcries when their youngsters put a worm or a handful of loam in their mouths, they are expected to accept the tastes of others rather than their own. If a child is punished for eating unclean objects, it will no doubt sooner or later stop eating them, unless it is more of a glutton for punishment than for unclean objects. Masochists, unlike poets, are probably made and not born. But we could be wrong. In any event we are no

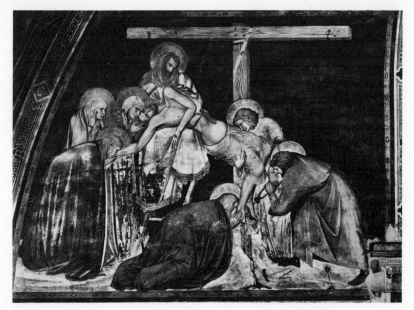

Fig. 27. Pietro Lorenzetti: *The Descent from the Cross*. Lower Church, Assisi.

sooner out of our mothers' wombs than education sets in. We are taught to control all our bodily functions in accordance with our parents' standards of decency, to take over their manner of speaking, to eat what they give us or can be induced to give us, to satisfy our emotional life as they approve. And if we have brothers and sisters, their standards must also be taken into account. At an early age we are sent to school whether we like it or not. Thereupon we have to adjust to still other standards, those not only of our teachers but also of our schoolmates. These standards are sometimes harmonious with those of our families and sometimes not. Every parent has had the humiliating experience of hearing his child, just home from school, interrupt a conversation with the horrid words, "But *The Teacher* says. . . ." The great clash in taste has begun.

This, however, is only the beginning. From then on the child, unless protected from all contacts with society, discovers that opinion on all sorts of subjects varies and that he no sooner accepts one idea than he finds another in conflict with it. Years ago children grew up on books illustrated by Walter Crane, then Maxfield Parrish, Howard Pyle, Elizabeth Shippen Green, and Jessie Wilcox Smith. But their children grew up to see Wanda Gag and then Walt Disney take over. The grand-parents of the present generation of children saw Alma-Tadema and Landseer on the walls of their schoolrooms. The present generation is more likely to see reproductions of Miró and Braque. We do not automatically accept what we are accustomed to, but the chances are that what we are not accustomed to will be displeasing. One does not

accept everything The Teacher says as true, but if The Teacher is admired, the chances are that one will admire what The Teacher admires. It is very easy to transfer one's affection for a person to that which the person is fond of.

Then in the background hover The Great Authorities, the Ruskins, the Berensons, the Roger Frys, the Clive Bells, the Otto Ranks, the Herbert Reads. One makes the awful discovery that Holman Hunt's *The Light of the World*, Watts's *Hope*, and John Alexander's *Pot of Basil* are not considered to be the greatest masterpieces of the Occident in spite of their having been hung in the front hall of one's own house or even in the Principal's office. This is about as upsetting as the realization that comes to all of us that our parents are not infallible. The pillars of the temple begin to totter and the earth quivers under our feet. One begins to find that behind liking and disliking there are certain principles or rules which determine whether a work of art is to be given one's approval or disapproval. Significant form, tactile values, high seriousness, membership in the Great Tradition, fidelity to Nature, unity in variety, organic unity, vitality, dynamism, social consciousness hit one like so many hard pellets shot through a blowgun and a man no sooner capitulates to one Great Authority than another arises to pepper him.

Let us insist once more that many of these traits (assuming that the terms mean something recognizable) may exist together in the same picture. *The Descent from the Cross* (Fig. 27) in Assisi, attributed to Pietro Lorenzetti, and Rubens' double portrait of himself and his first wife (Fig. 28), certainly have vitality, organic unity, unity in variety, high seriousness, and the former illustrates a great moment in the history of Christianity. We have yet to find anyone who would disapprove of either of these paintings. Why then should one principle be selected as the ground for approval rather than another? Each critic, as a matter of fact, is influenced by certain dominant themes of philosophy and science, and an historian of ideas could take each of the principles just mentioned and show its roots in the non-aesthetic interests of the times in which it was developed.

To take but one example, in times like the middle of the nineteenth century, when natural science had acquired great prestige and had not yet taken on the sinister aspect which middle twentieth-century science seems to have assumed, it was likely that people would enjoy learning all sorts of facts about nature and that there would be dozens of books written for amateurs to spread scientific data abroad. Observed facts became very popular, facts about flowers, birds, insects, marine life. Never before did the layman learn so much of the structure of plants and animals, just as today his interest has swung to physics and chemistry, mechanics, atomic explorations, and outer space. Nature became visible nature and, though shells, leaves, flowers, and various beasts had always been part and parcel of decoration, never before had such a variety of plants and animals been painted for their own sakes. It was the great age of landscape and there was scarcely a bird, beast, or fish which was not painted as men and women had been painted earlier. The love of botanizing and making herbaria, of collecting butterflies, birds' eggs,

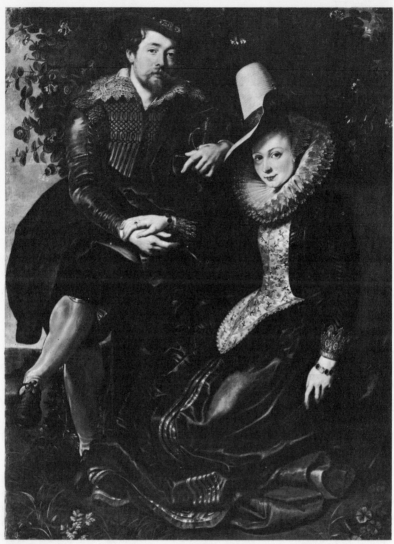

Fig. 28. Peter Paul Rubens: *Portrait of the Artist and His Wife*. Pinakothek, Munich.

seashells, became the passion of almost every boy or girl to whom such things were accessible. Where the child of the mid-twentieth century dreams of flying to the moon or one of the nearer planets, his grandfather and great-grandfather dreamed of finding a lunar moth, a clump of garnets, or a rare fern. Ruskin's enthusiasm for depicting each botanical detail, cloud or mineral formation, was typical and his grand oratorical style made his enthusiasm seem not only reasonable but the mark of a cultivated person. He laid it down

as a guiding principle that one should examine and illustrate the manner in which beauty appears "in every division of creation, in stones, mountains, waves, clouds, and all organic bodies, beginning with vegetables, and then taking instances in the range of animals, from the mollusc to the man."[2]

In America such writers as Emerson and Thoreau, followed by John Burroughs and Dallas Lore Sharp, performed the same task. The non-human part of nature began to take on a supernatural cast and poems were written to and about birds and flowers as if they were somehow or other imbued with a life which was nobler than human life. Meanwhile in France the painter Gustave Courbet was announcing that everything natural was beautiful for the very reason that it was natural and he prided himself on painting things just as they were, without embellishments. The admiration for the natural became a kind of religion and the study of nature a substitute for the study of Scripture. Nature was a revelation of the Creator's power and skill and it was a revelation which was open to the most untutored mind. This had been said as early as Seneca, but little had been done about it in the field of the visual arts. But now representations of the details of the natural order were as highly admired as that order itself, for they brought to attention exquisite designs in both form and color whose existence, though perhaps known, had not been stressed. But when Courbet presented the public with his *Bather* (Fig. 29), most critics were quick to proclaim the superiority of "ideal" beauty to natural beauty. This was perhaps because the eye always first sees nature through art and for these critics the tradition had been established that one form of the human body, that derived from Greek sculpture, had become the standard of human beauty. Ironically enough, when the camera began to give us the most accurate accounts of natural objects, naturalism lost its pre-eminence as an aesthetic doctrine.

This is an oversimplified statement of the case, to be sure, for naturalism was always opposed by those who feared lest science take over entirely the work of religion. Moreover, there were always people who were disgusted by some of the things which turned out to be every bit as natural as the more pleasing items. Furthermore, no aesthetic doctrine has ever lasted as a dominant force for more than three generations in the Occident, though several have been revived from time to time with slightly new overtones. A Surrealist today may paint with all the accuracy and detail of a Naturalist of the mid-nineteenth century. But no one would group Courbet and Salvator Dali together as members of the same "school."

The history of painting then is in part the story of how diverse human interests are expressed in art. One cannot give a single formula which will explain why one interest rather than another seems to predominate at a given time. One can only point to cases. Thus the growth of popular interest in

2 *Modern Painters,* II, Pt.iii, section 1, ch. 11, par. 1. But for a full, if not sympathetic, account of Ruskin's theory of the artist and critic in relation to nature, one might read R. H. Wilenski, *John Ruskin: An Introduction to Further Study of His Life and Work* (London, 1933), especially Part III.

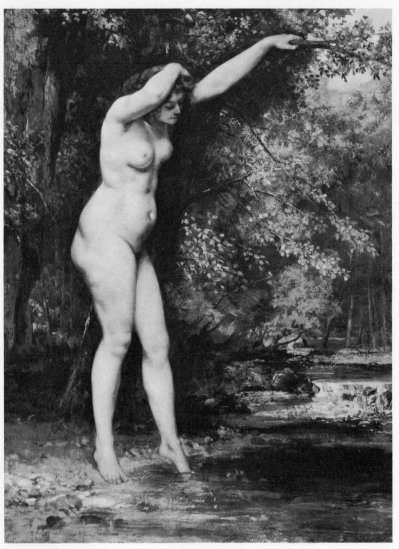

Fig. 29. Gustave Courbet: *The Young Bather*. Metropolitan Museum of Art, New York.

science in the nineteenth century may be attributable to the rapidity with which scientific novelties appeared at that time, novelties like the theory of organic evolution, to take but one. In the late fifteenth and sixteenth centuries a similar thing occurred, but the science which made the most rapid strides at that time was mathematical physics. And we can see how the passion for perspective and architectural paintings went along with the growth

of that science (Fig. 30. Laurana, *Renaissance City*). Similarly when psychologists of the Freudian school made new discoveries in the field of psychical behavior and showed the influence of repressed desires in dreams and other forms of fantasy, the painters and writers were not slow to profit by what they had learned. But we do not know precisely why this type of psychology should have developed to such an extent in our own time any more than we know why mathematical physics took such a spurt in the sixteenth century.

Moreover, sometimes the same interest will express itself aesthetically in one way here and in another there. Thus Picasso is a Communist painter in France, but Communist painting in Russia resembles the magazine covers of Norman Rockwell in America, minus Rockwell's sense of humor. And to complicate things more, no aesthetic doctrine ever pervades the whole of any society. For instance, while the Pre-Raphaelites were hailed by Ruskin as perfect exemplars of his teachings, the standard painters of the Royal Academy were still producing the standard works of art of their narrative tradition. And while Courbet was strenuously fighting the battle of naturalism in France, the painters of the Beaux-Arts were carrying on as if he had never existed. At the present moment there must be almost as many aesthetic doctrines being preached as there are preachers, each artist having his own. And if this is contradicted by the seeming homogeneity of some exhibitions of contemporary work, it should not be forgotten that such exhibitions are chosen by juries who have their own bases of discrimination and reject everything which is not built upon them.

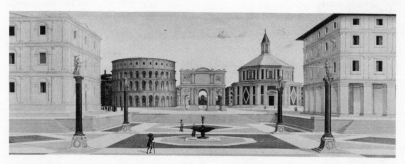

Fig. 30. Francesco da Laurana: *Renaissance City*. Walters Art Gallery, Baltimore.

A further complication lies in the fact that the names of aesthetic doctrines such as realism, idealism, naturalism, romanticism, classicism, expressionism, impressionism, abstractionism, non-objectivism, are all ambiguous. They are labels which seem to be more useful than they really are. Someone undoubtedly begins with what he thinks is a clear and simple theory of what artists ought to do. But from there on individual painters apply the principles in their own particular way. The naturalism of Caravaggio is far from being that of Courbet and the idealism of Poussin is certainly not that of Ingres. For each individual artist has his own notion of what the key words in his doctrine

mean. To take but one instance, who is to say what nature looks like? Why is one human body more natural than another? There is such a tremendous variety of all natural classes, stones, trees, flowers, birds, and beasts, that the artist has to select that specimen which seems to him for some reason or other significant. But the significance can never be anything other than his own fascination with that particular thing. Moreover, the whole natural scene on a grand scale is so full of different kinds of things that they cannot all be put down on a canvas. Some painters seem to think that wild nature is more natural than domesticated. Some go in heavily for landscapes, animals, the sea, the mountains, rather than for human beings. Others maintain that peasants or children or savages are more natural than urban dwellers, adults, or civilized people. Some think that only "typical" things are natural and that strange or monstrous or peculiar things are unnatural. But similarly the ideal can be defined in at least twenty ways, according to last count, and the variety of romanticisms is at least as great. All doctrines diversify as time goes on.

Thus when all is said and done, it is the individual artist who determines what his pictures will look like, even if he is trying his utmost to imitate some great master. The eye of a connoisseur like Berenson or Venturi or Focillon can usually spot the differences between a painting by a well-known master and a fake, and this can be done without the aid of X-rays or infra-red photographs or the various chemical tests now in use. Although the eye is far from infallible and the experts have admittedly made mistakes, the fact that they have frequently been right is enough to show that it is next to impossible to conceal one's own particular style or what the Germans call one's hand-writing.[3]

Even doodles have style and we all know that we can recognize a person by his speech as well as by his looks. Yet he may be talking the same language as everyone else. The contribution of the individual to his art is much greater than academicians seem willing to admit. If one takes three or four paintings of an identical theme, anyone can see that though the subject matter is the same, the style is vastly different. This is clearly illustrated by religious paintings which of all others might be expected to adhere closely to tradition. Thus the Crucifixions of Barna da Siena (Fig. 31), of Grünewald (Fig. 32), and of Rouault (Fig. 33) were all done by deeply religious painters, but the interpretation of the subject as well as the manner in which they were painted are different.

Consequently it would be absurd to maintain that the art of the future will not be vastly different from that of either the past or the present. One can

3 One of us during the Second World War interviewed a man who had been put by Hitler to forging the banknotes of the various allies. He insisted that any engraver would be able to spot his own forgeries in spite of their being so similar to genuine notes that they could pass as such. In other words, two five dollar bills engraved by two different engravers would be distinguishable to the eyes of their engravers, though not to other people.

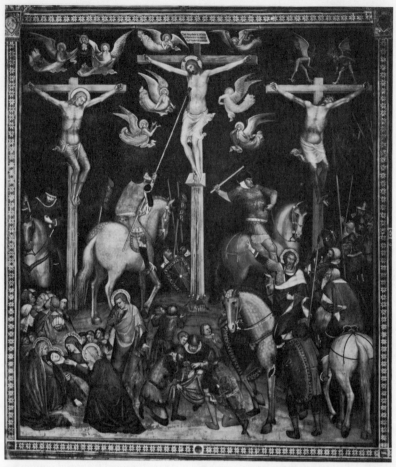

Fig. 31. Barna da Siena: *Crucifixion*. Chiesa della Collegiata, San Gimignano.

no more prevent change than one can stop the flow of time. We are not argu-
ing that there are not civilizations which approach stability. It is possible
that the Egyptian and Chinese cultures were more static than Occidental
culture. But no scholar who is versed in the history of either Egypt or China
would be willing to say that there were not great differences in all features
of both through the centuries. Han bronzes do not resemble Ming bronzes
and Egyptian art of the Fourth Dynasty can be easily distinguished from
that of the Eighteenth. It is true that to the untrained eye all Egyptian
sculpture looks alike, but we have heard people say that all Chinese and all
Negroes look alike. One might test one's powers of discrimination by observ-
ing the four Egyptian heads in the accompanying illustration (Fig. 34).

Now we make no claim to having discovered some law in accordance with

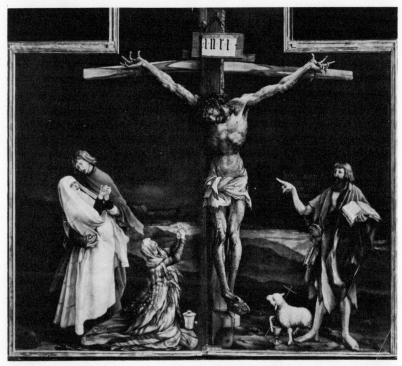

Fig. 32. Matthias Grünewald: *Crucifixion*. Esenheim Altarpiece, Colmar.

which art changes. But we do assert that along with other human interests, art too will change. Pictures, like houses, vehicles, airplanes, clothing, even language, develop to fill definite needs. And human needs change. We have but to take one example as a specimen of what we are driving at. As the territory of the United States expanded across the Mississippi to the shores of the Pacific Ocean, there arose a greater and greater need for rapid communications. The telegraph, the telephone, the airplane have all evolved in the direction of increasing speed. Moreover, we know why we demand great speed of communication. It is because of the continental size of our country and the increased centralization of power in Washington, which is remote from much of the population. There are no longer regional capitals of any importance. This interest in speed has been reflected in all the arts and not merely in America. The dynamic has been given a value which would have been undreamt of 150 years ago. Indeed one aesthetic movement, Futurism, had the dynamic as its cardinal principle. The suppression of transitions in literary style, of modulations from one key to another in music, the introduction of brusque passages from one color to another in painting are only a few examples of this influence. Is it not likely that such a development is due to the growing prestige of that which is supposed to be typically Ameri-

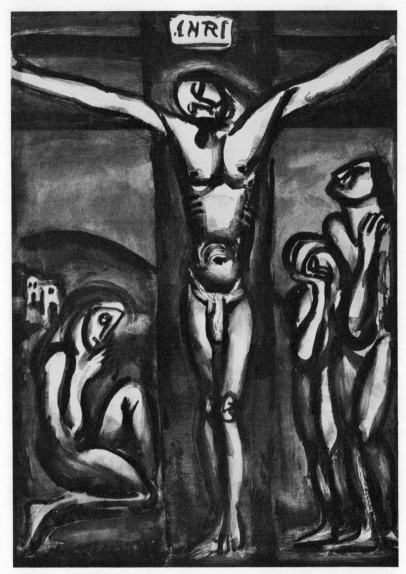

Fig. 33. Georges Rouault: *Crucifixion*. From the *Miserere*. Baltimore Museum of Art.

can? For instance, what is known as "The American Novel" in France is the novel in which action takes the place of thoughtful meditation. One has, as far as painting is concerned, only to glance at the Marin *Sun, Isles, and Sea* (Fig. 35) to see how movement has taken the place of quiescence. We have for that matter so idealized motion that we now have streamlined flatirons,

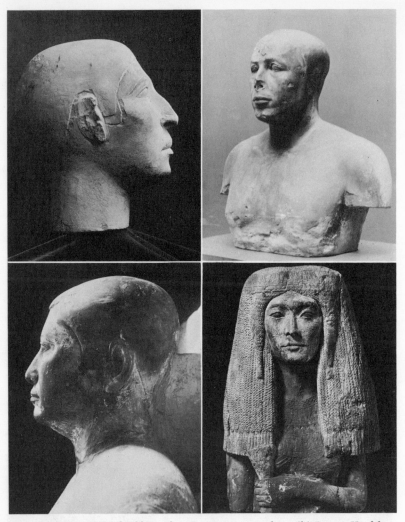

Fig. 34. (a) Portrait Head, Old Kingdom, Boston Museum of Art. (b) Portrait Head from Giza, IVth Dynasty, Boston Museum of Art. (c) Ranofer, Vth Dynasty, Cairo Museum (d) Woman's Head, New Kingdom. Florence, Museo Archeologico.

baby carriages, and coffee pots. Streamlining was invented for extremely high-speed vehicles. But the line itself became in and for itself an object of admiration, whether it was found in a high-speed article or in some thing which did not move at all, like a chair, a paperweight, or a lamp.

We shall now turn to some of the aspects of pictures to illustrate in detail how the various human interests emerge in visual form. We begin with something found in all pictures, whatever else may be in them, design.

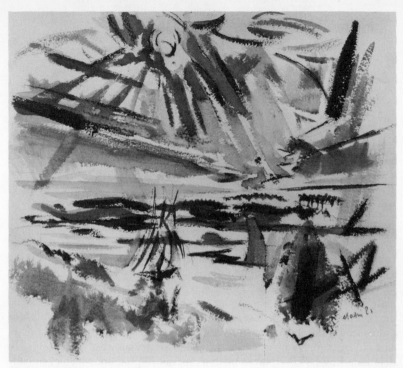

Fig. 35. John Marin: *Sun, Isles, and Sea.* E. J. Gallagher Memorial Collection, Baltimore Museum of Art.

Chapter II A Picture as a Design
upon a Flat Surface

Back in 1890 the French painter Maurice Denis produced a definition of a painting which seems about as incontrovertible as any such statement could well be. He said, "It must be remembered that a picture—before it is a picture of a battle-horse, a nude woman, or some anecdote—is essentially a flat surface covered with colors arranged in a certain order."[1] It requires no close scrutiny of this sentence to see that Denis did not say a painting should never be anything other than a flat surface covered by colored areas. Quite the contrary, he said very clearly that it might also be a representation of something. And his own paintings, as far as we know, always were. His definition was, however, taken up as a program, a program which eventually was to deny the prevalent notion that a picture must be a picture *of* something and the subsequent notion that one could judge the merits of the picture by the merits of that which it represented. In fact, the protest against representation grew so strong that some critics seemed to argue that if a painting really was representational, it was to that extent a poor painting. Matisse might be considered to be a painter who stood between both extremes. Such a canvas as his *Purple Robe* (Fig. 36) is both representational and an ordered design in which the colors are flattened out and the forms distorted to organize the pattern of color and movement which its painter wanted. If there is no body under the robe, it is because Matisse was presumably more interested in the movement of the robe than in intimations of a female body concealed within it. The surface is, moreover, kept flat by avoiding the indication of any shadows. The whole interest of the canvas lies in the interplay of color and form. There is very little on this canvas of an anecdotal nature; no attempt has been made to interest the eye in the identity of the woman or the character of the room in which she is seated. There is scarcely any indication of three dimensions. And a hostile critic might maintain that Matisse had deliberately dehumanized the whole scene and reduced a human being to a puppet, a head attached to an empty robe.

1 For an excellent discussion of Denis' theory of painting, see C. E. Gauss, *Aesthetic Theories of French Artists* (Baltimore, 1949).

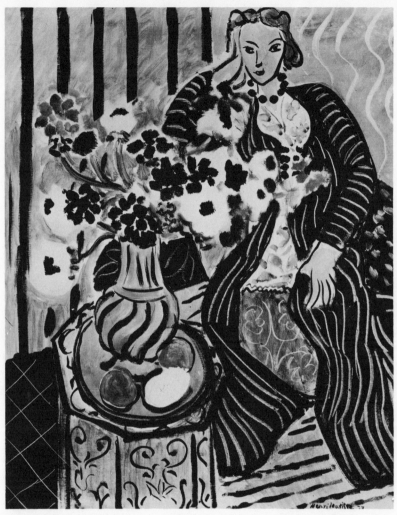

Fig. 36. Henri Matisse: *Purple Robe*. Cone Collection, Baltimore Museum of Art.

The question immediately arises of why artists drew back from representation. No one could maintain that the subject matter of works of art was what alone made them important. It had been understood for centuries that many of the subjects explored by writers and painters were far from being edifying and sometimes were revolting. Tragedies were usually based on crimes and sometimes, as in the *Hippolytus* of Euripides and the *Macbeth* of Shakespeare, on crimes which were pretty horrible. Yet tragedy has always held a place of high esteem in the works of critics. Paintings of martyrdom were outspoken in their presentation of blood and torture, heads that had

been chopped off and which lay spurting blood beside their bodies, Saint Lawrence on his gridiron, Saint Lucy with her eyes held in her hand, John the Baptist with blood streaming from his severed neck. Dante did not hesitate to describe the punishment of all sorts of sinners and their sins ran the gamut of crime; this was inevitable if he was to write of Hell. Shakespeare covered the stage with gore: Macbeth slew his guests; Othello strangled his wife; before *Hamlet* is finished dead bodies litter the boards; the eyes of Gloucester are put out. Madness, incest, deceit, adultery have always attracted some poets and novelists, witness the novels of Caldwell and Faulkner. New and more hideous sins were dwelt upon for the fascination of thousands of readers and it is questionable whether even the Gothic novel served up as many corpses as the modern detective story. Similarly painting has not been far behind drama in its depiction of ugliness both physical and moral. As far as subject matter is concerned, crucifixions and martyrdoms are not alone in representing horror. The theme of the temptation of Saint Anthony produced a crop of nightmares unparalleled by anything dreamt by Edgar Allan Poe. Bosch and his disciples, Callot, Goya, and in our own times Dali, have all put down on canvas what some would call the dredgings of the unconscious. But everyone knows that such things take on a new tone when incorporated in works of art. We do not go to *Macbeth* just to see murders committed nor do we look at a crucifixion for the sake of seeing torture. If we like to read about horror, we have only to read the yellow press. Yet horror in all such cases is an integral part of the effect which the artist is trying to produce.

The trouble with the nineteenth century academician was that he was trying to coat the pill with sugar. Just as poverty was often presented as an occasion for charity, so labor was presented as an occasion for endurance. It was men like Daumier, Courbet, and to some extent Millet, who began to change men's minds about such things. To take a different kind of example, the story of Roger and Angelica is really heroic, the story of the liberation of a girl from a monster. But when Ingres painted it, it became sickening in its sweetness. It was, on the whole, against this sort of thing that Maurice Denis was protesting.

The contribution of the painter, he was saying, lay in design, that is, in the order which he introduces into the material presented. Pictorial design must first of all be visual, and to make it clear to the spectator, everything on the canvas must be simplified so that the design elements predominate as soon as one looks at the picture. Therefore colors, shapes, and the movement of lines and masses demand the artist's primary attention and, though Denis himself, like Matisse, never did away with subject matter, he always subordinated it to the visual structure of the whole. He taught that the artist had to choose a color scheme in which one set of hues would be dominant, with harmonious or contrasting hues playing along with it or against it. The artist then selected a main pattern into which the shapes would fit so as to emphasize it. And finally the artist chose a general dynamic swing which would

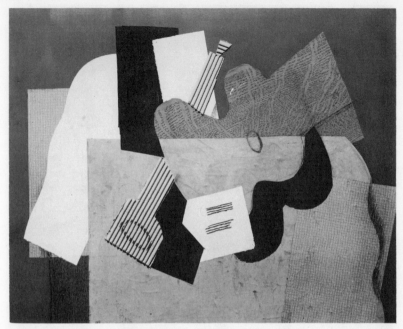

Fig. 37. Georges Braque: *Musical Forms*. Philadelphia Museum of Art.

induce the eye to move in a deliberately chosen direction, with contrasting subordinate motions to keep it within the frame. In this way the artist would be able to emphasize certain details which seemed to him to be important, to utilize the emotional effect of color and movement, and thus to interpret in his own way whatever he was trying to communicate to others.

But if the art of painting was the art of making designs, what was the use of introducing any subject matter at all? On the analogy of music, which need not—though it sometimes does—imitate natural sounds, it was believed that one could have a kind of visual music and, as we all know, twentieth-century painting began to eliminate subject matter in the traditional sense and to put on canvas only lines, shapes, and colors. This type of painting has been called abstract when the forms were taken from or, if one will, abstracted from those of physical objects, such as living beings or artifacts. It has been called non-objective when they arose out of the artist's imagination unhindered by any contact with the external world. Thus the painting by Braque which we reproduce (Fig. 37) would be abstract in this sense, while that of Kandinsky (Fig. 38) would be non-objective.[2]

2 The way was paved for the elimination of subject matter by those artists who ceased to illustrate historical or religious incidents and began to paint still life and landscape not as accessory to anecdote but for their own sake. A still life by Chardin, for instance, has only the most remote connection with human life. Its aesthetic quality lies in its design more than in our associations with the objects represented in it.

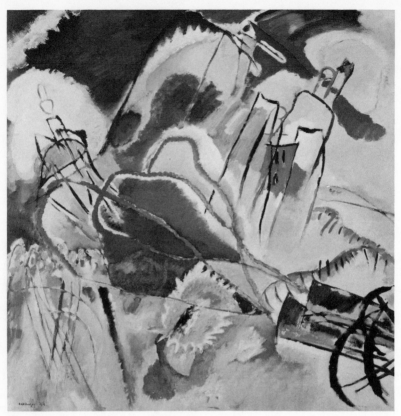

Fig. 38. Wassily Kandinsky: *Improvisation No. 30, Warlike Theme*. Arthur Jerome Eddy Memorial Collection, Art Institute of Chicago.

In the main stream of Occidental painting many different examples of composition, some simple, some intricate, can be found. Masaccio's *Trinity* (Fig. 39) is clearly built on a pyramid, one of the favorite forms of the painters of his time, a favorite since men have always associated ascending lines with their feelings for the supernatural. Raphael on the other hand was more given to symmetrically balanced forms, though the two structures are not incompatible. In Rubens (Fig. 40) we come upon arabesques of S-shaped curves which in El Greco (Fig. 41) mount like twisted flames. There seems to be no limit to the inventiveness of painters and there is undoubtedly an emotional effect associated with each pattern, much as there is in the dance or in music or in poetic meters. No one any longer knows why the adjective "high" has always been used to name those values which we specially cherish: the higher senses, the gods on high, the high style, the heights of glory, and in French *les hautes études*. Height is in origin a purely spatial term and one might think that high things would be no better than low. But though in some

40

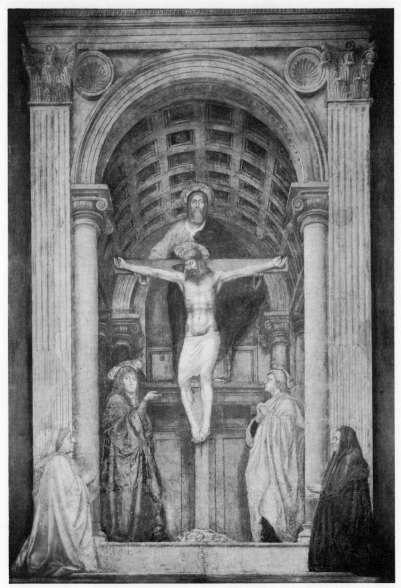

Fig. 39. Masaccio: *Trinity*. Santa Maria Novella, Florence.

religions there have been gods of the earth as well as of the sky, there is no need perhaps to point out that in our own tradition the supernatural beings below the earth are the personification of evil, while those in the heavens are their polar antitheses. This would seem to be some justification for the belief

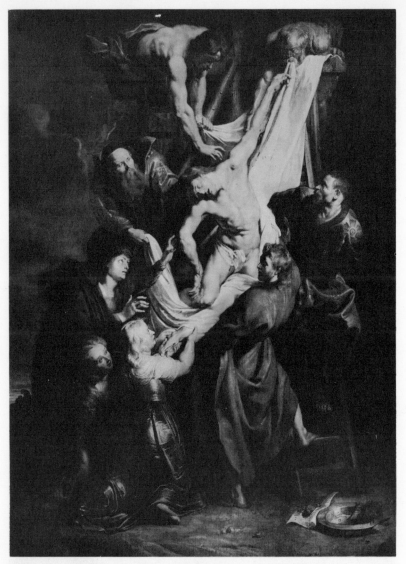

Fig. 40. Peter Paul Rubens: *Descent from the Cross*. Antwerp Cathedral.

that visual compositions which seem to mount upwards do produce an emotional effect of elation or something close to it.

This case is not, however, unique. We also think more highly of balance than of disequilibrium and probably most of us are moved by something sharp more strongly than by something flat. Only an experimental psychologist could lay down the general principles by which our emotions are gov-

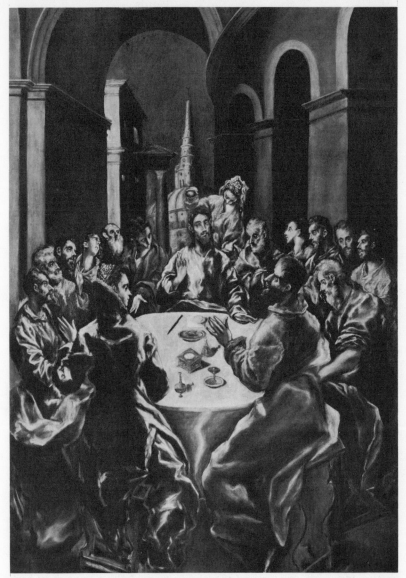

Fig. 41. El Greco: *Feast in the House of Simon*. John Winterbotham Collection, Art Institute of Chicago.

erned and we make no claims to that sort of specialized knowledge. But one thing is certain: the painters themselves have a firm conviction that their designs in themselves, regardless of whether they are incorporated in recognizable forms or not, can stir the spectator to feelings of sublimity, depression,

conflict, tension, and so on. Gauguin, for instance, testifies that in his opinion, "There is an impression resulting from any certain arrangement of colors, lights, and shadows. It is what is called the music of the picture. Even before knowing what the picture represents—[as when] you enter a cathedral and find yourself at too great a distance to make out the picture—frequently you are seized by this magic accord. Here is the true superiority of painting over other forms of art, for this emotion addresses itself to the most intimate part of the soul." In a more famous declaration of principles, Matisse comments: "When I see the frescoes of Giotto at Padua I am not concerned to know what scene from the life of Christ I have before me, but immediately I understand the feeling which it conveys for it is in the lines, the composition, the color, and the title only confirms my impression."[3]

When Braque, Picasso, and Juan Gris began making their abstractions, they took their forms from the everyday objects found in their studios: jugs, tables, bits of newspaper, bottles, violins, and guitars. Sometimes they broke them up into fragments and distributed the fragments about their canvases to form more complex patterns; sometimes they distorted the shapes to conform to the general pattern or design of their pictures as wholes. In our own time painters have been known to turn to the microscopic world and find their inspiration in the unicellular organisms which inhabit it. There was no limit to the adventures of the painter's eye. If a painting was above all a flat surface covered by colored shapes, there was no more reason to find the shapes in one world rather than in another.

The question of the nature of design now arises. We shall state dogmatically that all design is a form of order. Order may be of several sorts which, it goes without saying, can be combined. There are the various serial orders with which we are familiar in arithmetic, such as 2, 4, 6, 8 . . .; 1, 3, 2, 4, 3, 5, 4, 6 . . .; 1, 4, 9, 16, 25 . . .—a simple algebraic formula may be given for any of these. Temporal orders pervade our daily lives in the natural cycles which arise because of the orbits of the planets, the path of the earth round the sun and of the moon round the earth. The progression of the seasons, the ebb and flow of the tides, the life cycle from birth to death, are all examples of temporal orders which have been used by artists. But since painting is not a temporal art—unless one considers Chinese scrolls, which have to be unrolled bit by bit, to be temporally ordered—spatial order is that which has occupied the painter's attention more than any other.

Spatial order may be found in nature in shells, leaves, animal skeletal forms, the typical shapes of trees such as pines, maples, elms, and oaks, or of flowers such as lilies, roses, irises, or of the various fruits. Indeed, most of us have come to recognize a great variety of flora by their shapes. Sometimes they form patterns symmetrically disposed about a vertical axis, as in lilac leaves, but sometimes they radiate from a center, as in the flowers of the daisy family. Sometimes, as in snail shells, they are spiral. And sometimes, as in the ginko leaf or the scallop shell, they are fan-shaped. There seems to be no

3 See Gauss, *Aesthetic Theories of French Artists,* pp. 56, 63.

end to the inventiveness of nature and one would be foolhardy to attempt to find one single design which would be primordial. There is, to be sure, a good bit of symmetry in nature, but nevertheless we know from our own anatomy that not all of our organs are duplicated and that they are not all balanced about the spine as a vertical axis. But if we are to *see* order, then there must be duplication, repetition, even when one shape is the mirror-image of another. Sometimes, as in *The Circus* of Seurat, there are echoes or ripples which extend from a central shape to the borders of the pictures. Sometimes, as in the *Odalisque* of Matisse (Fig. 42), certain shapes appear in the seated figure which are repeated in various ways all over the canvas. The updrawn knee of the odalisque becomes a sort of dominant theme which is repeated even in the background. Such manipulations of the human figure are bound to lead to distortions and the distortions have sometimes evoked the harshest criticism. But such criticism is valid only if the purpose of the painter is to reproduce as accurately as possible the objects which are before him. And that was not the purpose of Matisse.

It must also be said that since we are accustomed to the simpler geometrical forms, the triangle, the circle, the parallelogram, we often fail to see the design in certain abstractions. Yet any shape is a geometrical figure whether we have a name for it or not. The artist's problem, if he is interested in design above all else, is to make his basic forms clear to the observer's eye. But observers need visual training and just as the literary critic can detect literary forms which the casual reader has not grasped, so the art critic could help the observer in detecting the underlying structure of paintings.

In many cases the shapes which the painter has used are his own invention. His use of them does not come from copying natural formations or from abstracting patterns from such formations. The very instruments which he uses may determine in part the resulting forms, for a pencil or brush may limit what can be put on paper as well as suggest forms which it seems to produce by free play. All of us in moments of distraction have let pencils wander over a piece of paper without being aware of what we are drawing. At times we turn out the simpler patterns of geometry, at times things that look like the forms of various microscopic organisms and crystals. The so-called zoomorphs or living patterns of Arp (Fig. 43) illustrate this. And as one flies over the country in an airplane and sees the patterns made by contour plowing, the erosion of gullies, the spreading of estuaries, in fact the interplay of hills and valleys and meandering rivers, one realizes that the artist whose imagination has been captivated by freely flowing patterns is perhaps closer to nature, in the sense of the forces which mold the landscape, than the painter who clings to the elementary shapes of Euclid. He may think that he is basing his designs on pure fantasy, but nevertheless he is also reproducing an order determined by physical law. When one looks at the extraordinary skeletons of radiolaria (Fig. 44) or the sand dollars which children pick up on the New England beaches, one is hard put to it to decide whether one is dealing with geometry or life. Fortunately, as the classic work

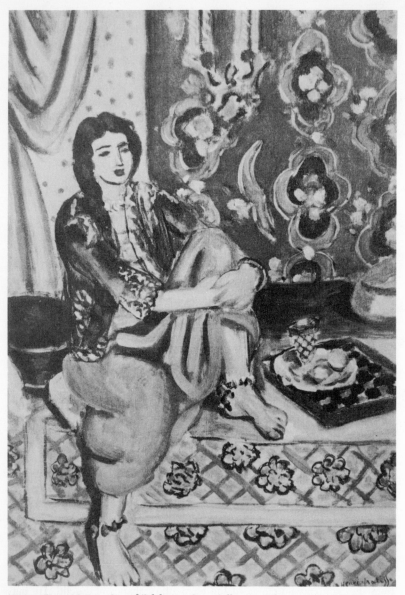

Fig. 42. Henri Matisse: *Seated Odalisque*. Cone Collection, Baltimore Museum of Art.

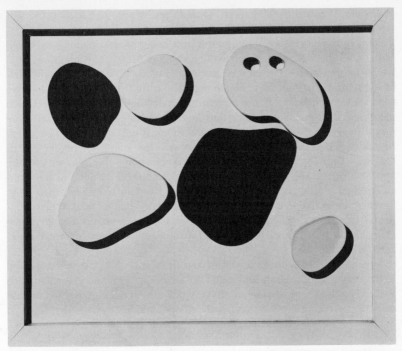

Fig. 43. Arp: *Configuration*. A. E. Gallatin Collection, Philadelphia Museum of Art.

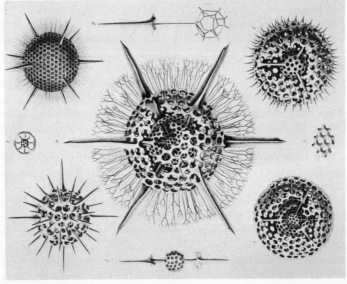

Fig. 44. Radiolaria.

of D'Arcy Wentworth Thompson, *Growth and Form,* has shown, the distinction is more superficial than profound.

Some of the most interesting designs now being produced are those which arise out of the artist's unconscious. The books of Margaret Naumburg, from which we reproduce *Patterns of Anxiety* (Fig. 45a-b) have demonstrated how a neurotic patient may release repressions by freely painting whatever comes into his head. Only the patient or his doctor is able to interpret such paintings; they may seem monstrous and unintelligible to others. But they may also give the spectator an emotional shock, if only of horror, which may be evidence that they have touched a very sensitive spot in his psyche too. In that way they resemble the drawings of very young children, which may appear insignificant scrawls and blobs to the adult, but which to the child are packed with significance (Fig. 46). No one can tell in advance what anything looks like to anyone else except in a very general way. When Japanese artists drew the members of Perry's expedition to Japan (Fig. 48), they made them look like caricatures of Japanese by emphasizing their noses and outlandish costumes.

As one studies children's drawings and the drawings of neurotics, as well as the drawings of exotic peoples and savages (Fig. 47), one realizes at once that our traditions of representation may be nothing more than standardized ways of presenting experience visually. All communication, whether through pictures or speech or gestures, demands standardization. If everyone spoke a language which he invented for himself, no one would understand anyone else. Our languages are standardized ways of presenting experience verbally, some of which seem nonsensical when analysed. For instance, our habit of greeting people with the question, "How do you do?" does not mean that we think they have been doing something in some peculiar manner about which we want information. Standardized methods of communication are so impressed upon children when young, as their speech is corrected by adults, that they soon put the inevitable question, "How do you draw a man?" as if there were some ritualized manner of representation according to which the drawing or painting becomes a sort of hieroglyph. In this the child is not too far off the track, for all arts become ritualized as time goes on and the rituals are broken only by certain outstanding rebels who feel no compulsion to obey them.

We now know enough of the history of Occidental art to understand how far ritualization has gone. We know, for instance, that the mediaeval artist did not use linear perspective as the Renaissance Italians did and that perspective itself soon became a new ritual. To our eyes things look more real if the perspective is correct. But that does not mean that all human eyes must see things according to Renaissance perspective in order to see them as real. For one thing, we move our eyes about as we look at things and do not fix them at some one point on the horizon. Any traditional manner of representation will do, for the compulsion of tradition operates in vision as in everything else. The main difference between the "modern" painter and the aca-

THE EMPTY BOX, THE EMPTY COCOON, AND THE BUTTERFLY

Painting by a psychoneurotic patient. The artist interprets this painting in the following words, "Here I've climbed out of the box in which I used to hide and cower in terror; I'm trying instead now to live as a human being. The box formerly contained the stagnated part of me, filled with hates and fears; but now the box is empty; I'm outside my frame, like a snake shedding its skin. The empty cocoon-shaped form contained another embryo part of me. Now that embryo has emerged like a butterfly being born, soon it will flit away to seek the light." From Margaret Naumburg, *Psychoneurotic Art: Its Function in Psychotherapy*. By permission of the author.

MYSELF AS AN IDIOT CHILD OVERWHELMED BY MY PARENTS, CHANGING INTO A NEW ME.

Painting by a psychoneurotic patient. From Margaret Naumburg, *Psychoneurotic Art: Its Function in Psychotherapy*. New York, 1953. By permission of the author. After studying this picture, the reader would do well to read the painter's own interpretation of it on page 37 of Miss Naumburg's book.

Fig. 45a-b. *Patterns of Anxiety*.

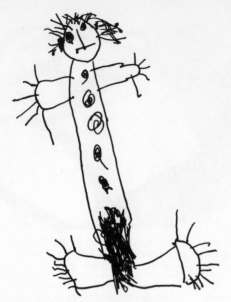

Fig. 46. Child's drawing.

Fig. 47. Australian "X-ray" drawing.

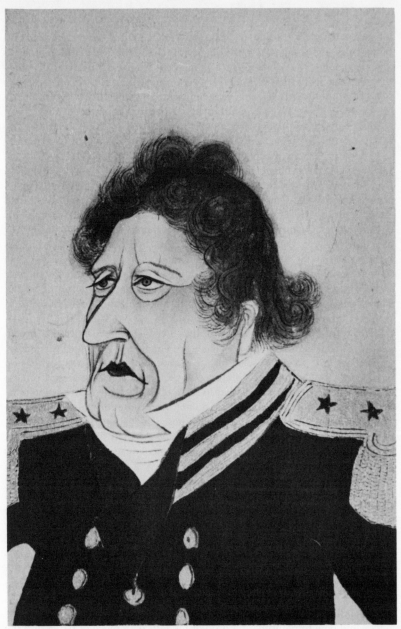

Fig. 48. *Portrait of Commodore Perry*. Norfolk Museum of Art, Norfolk, Va.

demic painter, as far as this matter is concerned, is that the modern painter is more willing to experiment and to try out new patterns. Leonardo in a famous passage[4] suggested beginning with patches of discoloration on walls and developing them into pictures. Some contemporary painters do something similar when they begin with a blot or doodle and develop these into more complex designs. The ultimate limit of this type of artistry is absolutely automatic and unconscious painting, analogous to automatic writing.

The charge made against such painting is that it becomes formless. The formless is one of the hardest concepts to clarify, even though it is constantly used by critics. And though we have little hope of defining it here to the satisfaction of everyone, we shall make an attempt to throw some light on it.

If a group of people in a room were to leave in single file and in the alphabetical order of their surnames, we should all be astonished and would recognize the order or form of their leaving as soon as we knew the initial letters of their names. If all the people whose names began with the vowels in their usual order, A, E, I, O, U, left first and then those followed whose names began with the consonants, B, C, D, F, G, and so on to Z, we should be even more astonished. Or, to take another example, if they left in order of their weight from the lightest to the heaviest or vice versa, or in order of height, similar gasps of wonder would be emitted. For in all such cases the pattern would be given a name and the order would be recognizable. But gradually the idea would begin to dawn upon us that they would have to leave the room in some order, whether we knew its name or not, and, if we could only predict it ahead of time, it would seem just as extraordinary as the order which we have cited. Hence the only difference in this particular case or sort of case between order and disorder is that in some of the examples we have a name for the pattern and in the others we do not. And those for which we do have names turn out to be more unusual than those which are nameless.

Moreover, to bring patterns about we have to plan first. We do not let chance take the place of intelligence. It is of course true that sometimes chance produces an order for which we do have a name and which can be easily spotted, but in general chance events seem disorderly and we call them random. But it is not impossible that such arrangements could be named if there were any need to do so. For instance, if two dice steadily came up to show a 1 and a 2, we should want to know why, just as we should if ten throws of a penny kept repeating the same series of heads and tails, for we should suspect something peculiar to be going on. The difference here between the random and the orderly is not the greater probability of one order's occurring rather than another, but the ease with which we recognize one rather than the other. For there is no greater or lesser probability of throwing ten heads in a row than in throwing any other series.

Turning now to painting, if a drop of ink falls on a piece of paper and the paper is then moved from side to side or circularly or otherwise, the ink will

4 See Edward McCurdy, ed., *Leonardo da Vinci's Notebooks* (New York, 1923), pp. 172 ff. This is quoted from MS 2038, Bib. Nat., 22 v.

roll about and finally settle down into what can only be called a blob. We do not have ordinary names for the different blobs, though some resemble recognizable objects more than others: butterflies, octopuses, leaves, human profiles. So clouds are often seen as islands, dragons, hands, and, as we all know from reading *Hamlet,* camels. Some people, and not merely children, seem to take a great pleasure in making such comparisons and a good bit of superstition has been based on them. Our point, however, is that to say that a blob looks like an octopus or that a cloud looks like a camel does not imply that blobs which do not look like octopuses or other familiar things are shapeless. It merely implies that we have no name for the shapes in question. Just as disorder seems to be nameless order, so the formless seems to be nameless form.

At the risk of overloading these pages with unnecessary information, we are inserting a word or two about an order which is very frequently used to arrange things, alphabetical order. Our alphabet, like the Greek, is derived from the Phoenician or Hebrew alphabet. The Hebrew alphabet runs *aleph, beth, gimel, daleth, he, waw, zayin, kheth,* and so on, the Greek names for the letters, *alpha, beta, gamma,* and so on being transliterations of these. Now each letter in the Hebrew alphabet is supposed to be the name of something: *aleph*—ox, *beth*—house, *gimel*—camel, *daleth*—door, though scholars are not agreed on what all the letters mean. But why should an alphabet begin with the name of *ox,* and proceed to *house, camel* and *door?* The passage from one to its successor seems utterly capricious and one would be inclined to think that the sounds came first and the names afterwards. That might have happened just as in the Naval alphabet during the second World War names were given to the letters so that they would not be confused when spoken over the radio or telephone: *Able, Baker, Charlie, Dog,* instead of A, B, C, D. In this case we happen to know why such names were chosen. But we do not know why *ox, house, camel,* and *door* were put down in that order. The order of the alphabet as we have it goes back at least to the sixth century B.C. and probably earlier. But by the force of custom we have come to look upon it as a "real" order and not as a random series.[5]

Let us suppose that an artist were to paint a frieze with the following objects on it moving from right to left: an ox, a house, a camel, a door, a blank space, a hook, some weapon or other, a fence or barrier, a ball, a hand, an open hand showing the palm, a rod, a blank space, a fish, an eye, a mouth, a nose, a monkey, a head, a tooth, and some sort of mark. Would anyone be likely to recognize this as a pictorial representation of the primordial Occidental alphabet? This seems very unlikely. On the contrary, it is more probable that such a frieze would be said to be a mishmash of things put down to confuse and bewilder the public. Yet in a way the artist would have hit upon a pattern which is the basic emblem for all serial order, for the earliest numerals we have in our culture were letters. Hence that which appears to be dis-

5 Our information about the alphabet is taken from David Diringer, *The Alphabet,* 2d. ed. (New York, 1953), pp. 219 ff.

orderly may well conceal a true order and that which appears to be made aimlessly may in reality be based upon a genuine and conscious purpose.

As a matter of fact, whatever design an artist may choose will be in part determined by forces over which he has little control, forces which are now called unconscious. Such forces by their very nature can only be guessed at unless one is a psychiatrist. Who really knows why Géricault was so interested in the faces of the insane (Fig. 49)? We know that he was commissioned to paint them, but he could always have refused the commission if the subject had repelled him.[6] Who knows what drove Goya to paint his nightmares (Fig. 50)? Why did Caravaggio and his followers become so fascinated by deep shadows and high lights (Fig. 51)? What really oriented the imagination of Rubens towards arabesques (Fig. 52)? Why did Delacroix feel drawn to Rubens (Fig. 53) and his contemporary, Ingres, to Raphael? To these questions answers lying on the surface of history can easily be given, but one would have to know more about each artist than is now knowable to give answers which would satisfy a psychologist. If one says that an artist picks up a style out of the ambient atmosphere, that answer will be partly true of some artists but not of all by any means. For in every period there is a variety of styles as well as of subjects. And some artists make definite breaks with the regnant styles of their time. The question then arises at once of why some men are resigned and submissive to tradition and others rebellious. It is the latter who redirect the current of art and the simple fact that they are able to do so means that their innovations "say something" either to their contemporaries or to their juniors. What they say to them may not be what they say to us. Courbet's *Stone Crushers* (Fig. 54) does not seem to us to be socialistic propaganda as it did to some of his contemporaries. To Huysmans Degas had seen in the ballet dancer (Fig. 55) the hard working girl constrained to earn her living by forcing her body into unnatural and angular postures. Little of this remains for us. This is not a matter of great importance. What is of importance is the rise of a new sensibility in certain artists and the public's reaction to it.

There are thousands of people today to whom non-objective painting says nothing and hundreds who do not see the design in representational paintings. There are some people who are willing to look at a picture and study its design and even admit that it has a design, but who also feel no emotional impact from it other than the emotion of disgust. The curious fact about all this is that lines moving in certain directions, the whole resembling no known object, and masses and colors related to one another as determined solely by the artist's fantasy, can occupy the hours of serious painters and evoke the praise and contempt of critics. One can infer from the intensity of the applause and disparagement that such canvases leave no one frigid.

For those who dislike abstract or non-objective art, the path is always open: they have only to say that the artists are insincere. Sincerity is not an aesthetic

6 See Klaus Berger, *Géricault and His Work* (Lawrence, Kansas, 1955), pp. 39-40 and Plates 91-94. Trans. by Winslow Ames.

Fig. 49. Jean Louis Géricault: *The Madman Kidnapper*. James Philip Gray Collection, Springfield Museum of Art, Springfield, Mo.

but a moral category and no one can tell by looking at a picture and knowing nothing more than what the picture tells him whether the man who made it was or was not sincere. People who are interested in sincerity would do well to confine their attention to anonymous pictures. When we know something about the non-aesthetic part of painters' lives, we are likely to stumble upon some highly distressing incidents.

From what we know of Fra Lippo Lippi, Sodoma, and Caravaggio, we should conclude that their religious paintings were drawn from the depths of insincerity. But the fact may well be that in them alone were the artists uniquely sincere. It may be supposed that a sincere person is one who has

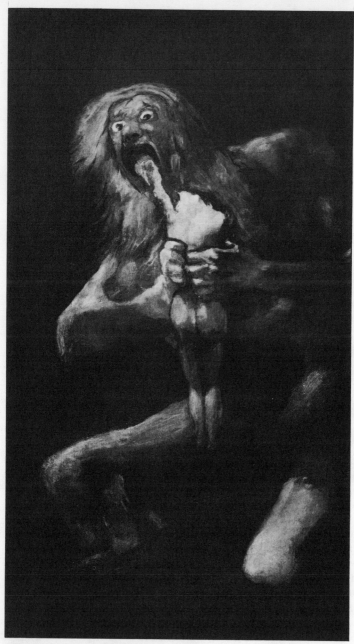

Fig. 50. Francisco José de Goya y Lucientes:
Saturn Devouring His Children. Prado, Madrid.

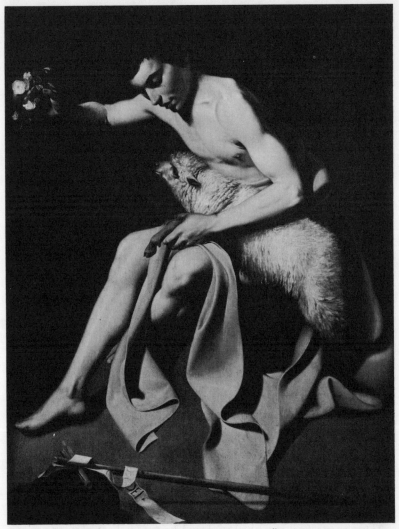

Fig. 51. Michelangelo Caravaggio: *Saint John the Baptist*. Öffentliche-Kunstsammlung, Basle.

certain principles of conduct and follows them. Such people may be utterly unprincipled in the ordinary business of living and yet be steadfast in their devotion to principle in some one field of interest, science, sport, art. The fact that a man cheats on his income tax return does not mean that he must also cheat when playing chess; he may rank chess above paying his income tax. Similarly because a man cannot be faithful to his lawfully wedded wife does not mean that he cannot be faithful, as Gauguin was, to his aesthetic

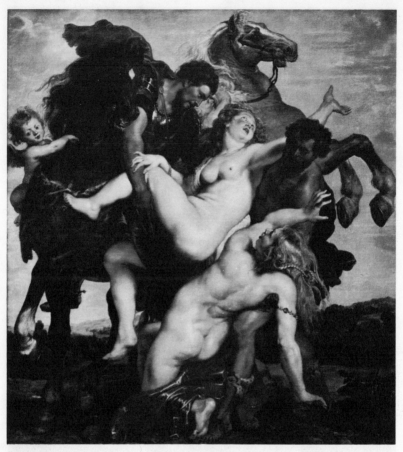

Fig. 52. Peter Paul Rubens: *Rape of the Daughters of Leucippus*. Pinakothek, Munich.

ideals. No one wants to be the victim of mystification, but at the same time the values which the observer gets from looking at a picture need not be those which its painter got from painting it.

There is one final remark that should be made about abstract or non-objective painting. The possibility of finding aesthetic value in pure linear design and by extension in pure design of any type is best exemplified by calligraphy. Much Moslem decoration is straightforward lettering and it is a platitude that Chinese painting is an elaboration of Chinese writing. For that matter Chinese calligraphy, even when not incorporated in painting, is valued highly for its sheer beauty of brushwork. In the Occident there have been times when a man's handwriting was appreciated regardless of what was written in it and, even today when the typewriter has taken the place of the pen, we still imitate handwriting for ceremonial purposes on engraved

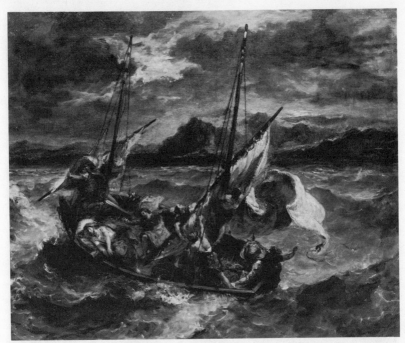

Fig. 53. Eugène Delacroix: *Christ on the Sea of Galilee*. Walters Art Gallery, Baltimore.

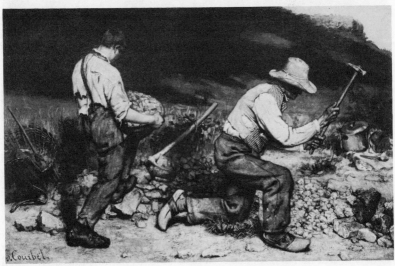

Fig. 54. Gustave Courbet: *Stone Crushers*. Museum of Dresden.

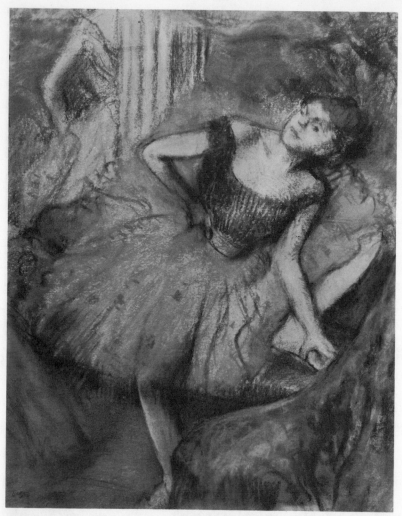

Fig. 55. Edgar Degas: *Ballet Dancer*. Cone Collection, Baltimore Museum of Art.

cards and congratulatory scrolls. This is manual skill and many a painter and critic as well has seen the beauty of a drawing in its line, just as a sculptor sees the beauty in a bit of carving or modeling without regard for what is carved or modeled. This may happen even when the enthusiast dislikes the total work of art. For the values of the product are different, or at least may be different, from the values of the artistry.

There are, to be sure, some critics who look down on virtuosity as a lower form of artistic activity. And one can see that to say nothing but to say it well or to say something trivial but to say it well is not so important as to say some-

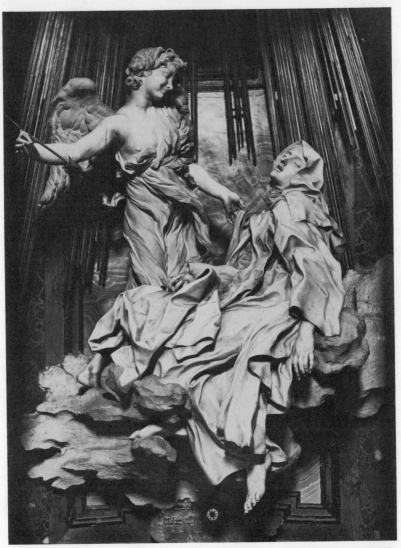

Fig. 56. Giovanni Lorenzo Bernini: *Saint Theresa in Ecstasy*. Church of Santa Maria della Vittoria, Rome.

thing or something of interest and to say it well. We cannot, however, bring ourselves to depreciate skill. One of the differentiae of art lies in the power of the human hand over the restrictions and limitations of matter. One may find, for instance, the sculpture of Bernini (Fig. 56) and the paintings of the Mannerists both bombastic and ostentatious. But one cannot deny the extraordinary skill such works of art exhibit to the eye which is willing to see it.

Similarly some of the coloratura arias in operas and oratorios may seem tiresome and downright silly to modern ears, but the composers of *Messiah* and *Fidelio* were not silly. Acrobatics, mountain climbing, and most sports are as useless as the accumulation of tremendous fortunes, fortunes so large that their owners have to give them away. But human beings have always admired the victory of the mind and body over obstacles. We see no reason why pure design should not be given at least this minimum of admiration.

But pure design, regardless of the virtuosity of its makers, may also stimulate, as Gauguin said, the same kind of feelings which pure music stimulates. We say "may" since no one knows whether it does or not. Judging from the violent emotions which are expressed by people who dislike non-objective and abstract painting, it is at least capable of stimulating frenzy and hatred. Unfortunately we have no way of knowing whether these feelings are stimulated by the painting itself or by the failure of the observer to find in it what he was looking for. We know that all perception is influenced by expectation, that what one sees is in part determined by what one expects to see. Consequently the denunciation of non-objective painting may simply be an expression of the observer's disappointment. It is like the reaction of a man who finds that someone has put salt in his coffee instead of sugar.

Chapter III Painting as Representation

Our illustrations of design in paintings have already suggested that both visual design and representation may be present in a single picture. In fact the great bulk of paintings from the earliest days of the art have been pictures *of* something and not merely designs. If one goes to the caves at Altamira, Les Eyzies, and Lascaux (Fig. 57), one will see on the walls and ceilings animals which are recognizable and whose species have been identified: mammoths, oxen, reindeer, cave bears, and horses. But two features of these paintings can have escaped no one who has seen them. The beasts are all drawn in profile and when human figures are involved, they are represented schematically, much like the drawings which children learn to make, or else they are represented as magicians disguised as animals. If one skips to another group of paintings which are also early, those uncovered in Egyptian tombs, the use of the profile will also be found (Fig. 58), although we can be fairly sure that the Egyptians were able to draw anything any way they pleased. Moreover, in many of these painting the eyes and shoulders of human beings are usually drawn in a frontal position, even when the rest of the body is in profile. This too can be attributed only to the force of custom, not to the artists' incapacity. Byzantine painting (Fig. 59) on the contrary is largely frontal. We have then in these three types of picture a combination of representation with a schematic pattern. There were apparently rules which the artists accepted and which governed the way in which things should be represented. These rules were not simply the laws of optics but were independent of optics. For reasons which one can no longer discover, the artists seem to have believed that there was a right way and a wrong way to depict their subjects and that the right and wrong ways were not based on the way in which things looked in general but on the way people preferred to see them.

Consequently it is safe to say, though we make no pretense to a complete proof, that we have no record of paintings which were purely representational in the sense that they were painted in any way in which the artist happen to see them or imagine them. The artists always restricted the free play of their imagination by a set of laws which were as binding as the rules governing a game, chess, bridge, or football. We no longer know the origin

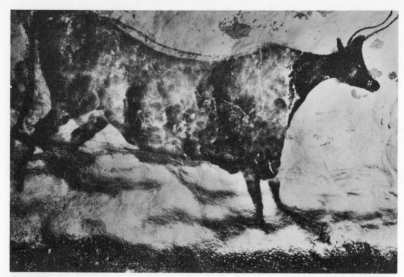

Fig. 57. Cave painting from Lascaux.

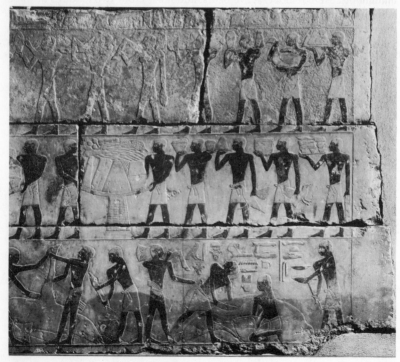

Fig. 58. Bas-relief, Mastaba of Ptah-Senkhem-Ankh, Vth Dynasty.

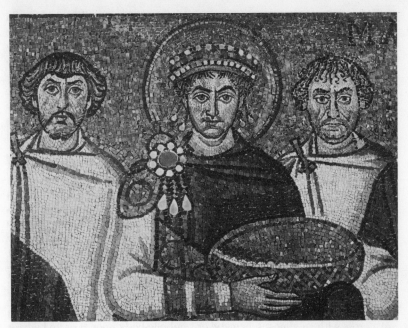

Fig. 59. Justinian flanked by Maximianus and a second figure. Byzantine mosaic. San Vitale, Ravenna.

of such laws nor even whether anyone was conscious of them. But for that matter, who knows why and when the rules of grammar were first laid down or when the first grammarian appeared in society to plague the young? Children learn to speak their mother tongue without the aid of books on how to speak and they usually soon learn to speak correctly, that is, in accordance with the grammar of their language, if their parents do. As far as paintings are concerned, neither logic nor the actual appearance of things nor the inability of the human eye to see things differently nor of the human hand to draw them differently can be invoked to explain these very early aesthetic customs. All that we know is that they exist and are observed with fidelity.

As for the cave paintings, anthropologists have maintained that they were made for magical or religious purposes and not for the simple pleasure which spectators might have in looking at them. The reason for this conclusion is simple. In the first place, the cave men were hunters and the animals painted were those which were hunted and, if one may judge from the bones left in the refuse piles, were also eaten. Second, in such a cave as that of Lascaux, there are vivid representations of animals being pierced by arrows and driven over cliffs or into what looks like traps. Third, it is well known that some preliterate people make little images of their enemies which they torture in the hope and belief that the people represented—or symbolized—will suffer from the same tortures which are inflicted on the images. So the cave man

65

may have believed that by painting an ox stuck with a spear he could obtain some power over the real ox. Fourth, the paintings are in those parts of the caves which were not inhabited and thus could not normally be seen; they were often painted one on top of another or overlapping another, as if the process of painting them was more important than the finished product. The conclusion is not foolproof, of course, but it is at least plausible. It does not explain why the animals are drawn in profile, but it does explain why they are all drawn according to one set of rules. For all magical and religious rites have to be performed according to a strict rule, a rule which must never vary. That is a cardinal principle of ritual.

Where magic ends and religion begins is not for us to determine. But just as preliterate man makes images for magical purposes, so civilized man makes them for religious purposes. A representation, however crude, may serve as an idol or as a focus before which the worshiper may concentrate his attention when praying. A person praying before a statue or picture may know that the physical object itself has no power of granting his prayer, but by fixing his attention upon it, as if it were identical with the being which it represents, his thoughts are less free to wander. Sometimes such images are the height of realism, sometimes they are far removed from realism. There are, for instance, crucifixes on which the body of Christ seems to be a real body with real blood flowing from the wounds; but there are others which are a cross with an almost schematic or symbolic body upon it or no body at all.

Not only have representational paintings served magical and religious purposes, but they have also served scientific purposes. For in the long run representation is the only way we have of communicating to others the visual appearance of things. The inadequacy of words to perform this task comes out when one tries to describe a person's face, a landscape, or a flower. It is much better to hold up a picture. Scientific drawings running all the way from the most meticulous literal reproductions of objects to diagrammatic devices are common. The scientist often resorts to pictures to illustrate a point which cannot easily be made in words. We are all familiar with the little men, each of which stands for a thousand men and the pies which are cut up in variously sized slices to show, for instance, how the national income is spent. But on the other extreme we are equally familiar with anatomical drawings in textbooks and colored photographs in seed catalogues. It may be that we resort to images in this way because we are so largely visual animals. If it is true, as is commonly believed, that all writing arose from pictograms—and we have already seen how our own alphabet so arose—then that would be added evidence of how communication relies on visual experience. We see another example of this in the sign language of the North American Indians as well as in the manual gestures with which deaf-mutes used to be taught to communicate. Whatever the truth may be, the visual method becomes simplified as it is practiced over the centuries and before very long as human history goes what was literal becomes symbolic.

Thus a map is a representation but a highly simplified one. We do not expect to see actual rivers and mountains drawn upon it in order to enable us to read it. A map does reproduce some of the features of the country which it represents, but some others are entirely omitted and all are put down in a symbolic, not a literal, fashion. This interplay between the literal and the symbolic is normal in all forms of communication. Even when we have words which stand for the cries of the various animals, we find that they differ in different languages. The cock cries *cock-a-doodle-do* in English and *cocorico* in French. Neither is the exact equivalent of what cocks actually cry, but either will do for practical purposes. Representation then will always be blended with an element of schematism or symbolism and we shall accept the blend as normal. But sometimes, just as superstitious people may think of the statue of a saint as the saint himself, we think of the symbol as that for which it stands. There may be, for all we know, some childlike souls who think that Anglo-American cocks really say one thing and French another.

Mr. William Ivins, in his history of prints, *Prints and Visual Communication,* has shown what happened when there was no way of duplicating visual images. Seals had been in use from early days in Mesopotamia, but apparently no one thought of using something similar to seals in illustrating manuscripts. Consequently even in scientific treatises, such as herbals, books on anatomy, and geographical studies, drawings would be copied from earlier drawings by a succession of scribes, each leaving out some detail, until a single highly simplified picture might stand for a variety of plants, organs, or places. This survived even into the beginning of printed books and Mr. Ivins shows how in the famous *Nuremberg Chronicle* a standardized city stands for almost any city from Troy to Paris. As long as there was a tight group of houses surrounded by a wall, it was a city. To quote Mr. Ivins, "One view does duty for no less than eleven separate towns" (p. 38). Figure 60 shows what it looked like.

The painter's delight in accurate representation, that is, representation as accurate as the human hand can make it and within the tradition established by custom, needs no proof. No one who has seen the reproduction of the drawings of Pisanello or Dürer or who has visited the Ingres Museum in Montauban would deny that a painter takes pleasure in drawing all sorts of apparently insignificant things and in drawing them as carefully as possible. It has been said that the camera makes representation unnecessary, but as a matter of fact the camera distorts and the photographer selects, choosing a point of view and the lighting which he thinks most effective, in other words not submitting himself entirely to his machine. Regardless of that, even painters like Matisse (Fig. 61), Picasso, and Braque, who are famous for their non-realistic paintings, often have begun with very literal drawings as studies for pictures in which representative realism seems to have disappeared almost entirely. Leonardo drew clouds and rocks as well as faces and the anatomical drawings attributed to Vesalius have always aroused the admiration of critics. To see even familiar sights in drawings and paintings has always been a pleasure to the observer, as it seems to have been a pleasure

Fig. 60. *Nuremberg Chronicle,* folio 100.

to the artist to draw or paint them. One has only to think of the genre painters of the Netherlands and Flanders to appreciate this (Figs. 62 and 63).

Audubon (Fig. 64) and Gould and Bewick drew not only exotic creatures but familiar ones as well. Bewick's little tailpieces are often scenes which anyone could and did see in the English countryside and they are certainly as delightful as the larger engravings of his birds. But painting has always given men a duplicate world, sometimes as elaborate as the *trompe-l'oeil* of Harnett (Fig. 65), sometimes rough sketches such as those which can be seen in the thousand and one drawings of Hokusai in the *Mang-Wa* (Fig. 66). Only a psychologist could tell why we enjoy this duplicate world, when a sceptic might point out that it is merely a reproduction of the world in which we live. But one might risk the guess that it is both more and less than a reproduction of the world of daily life. It is more in that the artist is always present as he heightens the emotional effect of the objects and scenes which he represents, just as a good raconteur knows how to emphasize details in his story which most of us do not even notice. It is less, in that he has to select certain details and therefore eliminate others.

This art is not confined to painting; it has its analogue in music and in literature. Ring Lardner's astonishing gift of catching dialogue, Gertrude Stein's similar gift in her *Willie and Brewstie,* may appear to be a denial of the creative power of the writer, but nevertheless cannot fail to arouse the admiration

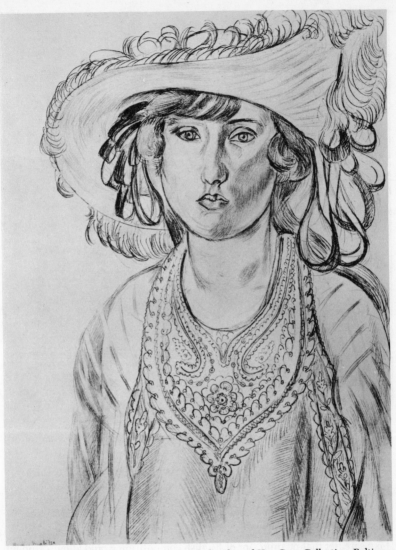

Fig. 61. Henri Matisse: Drawing for *Girl with the Plumed Hat*. Cone Collection, Baltimore Museum of Art.

of the reader for the very reason that they seem to reproduce conversation accurately. The digressions, the breathlessness, the ambling of fantasy, the very incoherence of talk, are something which it is next to impossible to catch, since we are all drilled from childhood to write in one way and to talk in another. Let us cite one example from Gertrude Stein. In *Everybody's Autobiography* occurs the following sentence:

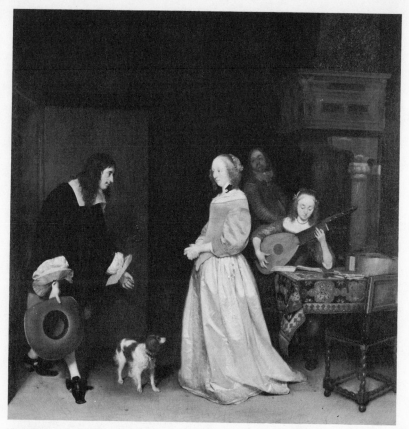

Fig. 62. Gerard Ter Borch: *The Suitor's Visit*. Mellon Collection, National Gallery of Art, Washington.

Bernard Faÿ had been appointed lecturer to the Collège de France which by the way had its four hundredth birthday just then, not that that mattered, not to him nor to us, but anyway we were very close friends then and we had talked about how you came to be appointed professor and he was and so we went to hear him.

It is a safe bet that no professor of English composition would allow a student to write a sentence like that one. He would insist that the irrelevancies be cut out and that the punctuation be seriously modified. He would reduce it to its logical essentials and hence eliminate its psychological overtones. But it is precisely those psychological overtones which give it life. When people talk, they do incorporate into their conversation bits which have no logical connection with the main subject of their talk and such phrases as "but anyway we were very close friends then," enter the conversation by the back door simply because the talker happens to think about them. No one ever got

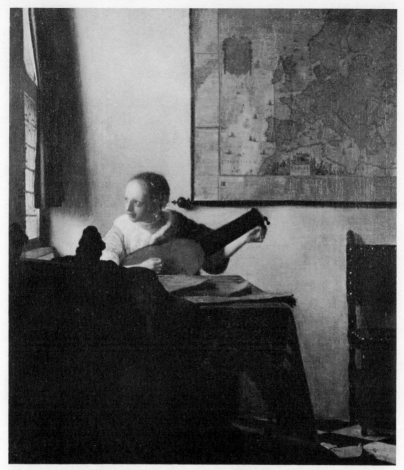

Fig. 63. Jan Vermeer: *Lady with a Lute*. Metropolitan Museum of Art, New York.

a clear idea out of anything that Gertrude Stein ever published. But that did not prevent readers from getting a vivid picture of a mind at work. Our point is not that Gertrude Stein could reproduce conversation accurately, but that to do so required self-discipline in the sense that she had to unlearn the rules of academic syntax.

But we can give another type of this sort of thing. No one would say that Shakespeare's greatness lay in the realism of his dialogue. We know perfectly well that no man ever talked in iambic pentameter blank verse. But when we see a play of Shakespeare's, we accept the convention of verse unconsciously, as if we were saying to ourselves, "This is the way people do talk in the Shakespearean world." We can then see a play in which the dialogue is a closer echo of ordinary speech and accept that too, regardless of what Shakespeare did.

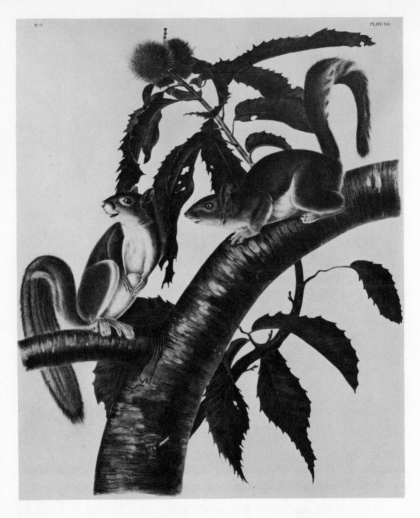

Fig. 64. John James Audubon: *Carolina Gray Squirrel*. Baltimore Museum of Art.

For every work of art establishes a world of its own with its own rules and laws.

In music there are dozens of examples of imitative sounds. When Beethoven wrote his *Sixth Symphony* and Rossini his overture to *William Tell*, they introduced passages reproducing the noise of thunder and rain. Thunder and rain are not normal musical sounds and the gods of the weather do not use drums and violins to express themselves. Nevertheless we overlook the obvious fact that convention and selection played their part in these compositions, for no storm was ever so submissive to the limitations of an orchestra

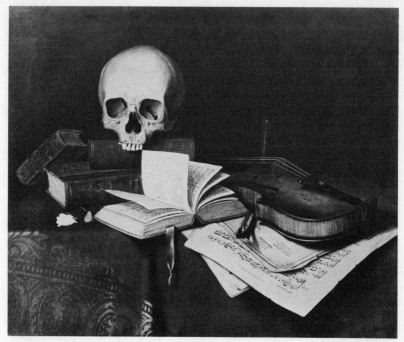

Fig. 65. William M. Harnett: *Mortality and Immortality*. Roland P. Murdock Collection, Wichita Art Museum, Wichita, Kan.

as these were. And no speakers were ever so selective of characteristic mannerisms as those of Lardner and Gertrude Stein. No artist can reproduce all reality.

For however self-denying he may be, he is always there. His contribution may be very great or very small, depending on how self-assertive he is. Sometimes he seems to withdraw and let Nature, as he will say, play the major role. Sometimes he frankly admits that he does the selecting and gives emphasis to the details which he wants emphasized and pours his material into a mold of his own devising. When Dickens made a hypocrite like Uriah Heep talk, he made every sentence hypocritical, though there must have been occasions when there was no call to be hypocritical. Similarly when Jane Austen brings Mrs. Bennett into the conversation, she has her say something which is invariably silly, though again no one can be silly twenty-four hours a day. But both Dickens and Jane Austen were simply following the ancient precept of consistency of character. That precept is a convention for establishing character and is no more true to life than any other technique of communication. Real people are not all of a piece, as we all know, and their mixture of qualities is one of the most difficult obstacles to surmount when we try to understand them. We should prefer them to be all good, all bad, all

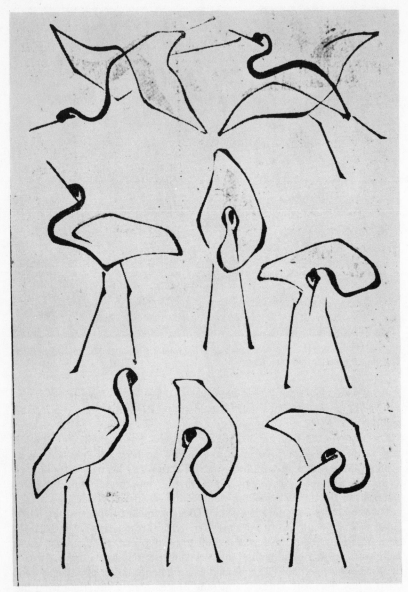

Fig. 66. Hokusai: *Cranes*. Courtesy of Miss Barbara Ivins, Jr.

wise, all foolish, so that we could classify them easily and make their be-
havior intelligible. But the moment we invent characters we have to sim-
plify them if only to make our narratives move along. To put down everything
that goes on in the mind of a human being would not only be confusing to a

reader but impossible. One of the longest novels in English is *Ulysses* and the action takes but a day.

A curious paradox arises from this. It is a platitude that we see Nature through art; the world becomes the justification of the artist's eye. We not only see the Greeks and Romans as their sculptors portrayed them—how else could we see people who died two thousand years ago?—but we have begun to see our contemporaries as they are depicted by whoever happens to be the most popular recorder of the times. A few years ago undergraduates began to look like advertisements for Arrow collars, clubwomen looked like Helen Hokinson's, and their mothers in their youth looked like Gibson girls. Now a ride in the New York subway shows one Modiglianis (Fig. 67) and even Soutines. This phenomenon is due to a multiple cause. First, the people tend to imitate the paintings when they admire them. Second, our eyes begin to see what the artist's eyes see.[1] One of the main roles of representational painting may well be that of stimulating our powers of observation, showing us things which we are not used to seeing. To use an old example, shadows have always been colored, but they were painted either gray or brown until the nineteenth century. If we now see them as colored, it is thanks largely to the Impressionistic painters of France.

In spite of the contribution of painting to accuracy of perception, there have at all times been men to point out that literal representation was not enough. Assuming that the purpose of painting was to produce something beautiful, various schemes were worked out which told the artist how he could be both faithful to Nature and yet represent her in an idealized manner.

One of the earliest of such schemes in modern times has been studied by Professor Erwin Panofsky in his essay on ideal proportions.[2] Proportions in this context are geometrical relations and the tradition that the human body must fit certain geometrical patterns goes back at least to the Greek sculptor, Polyclitus, whose Canon was supposed to exemplify the ideal human body. Both the mediaeval architect Villard de Honnecourt and the German painter Albrecht Dürer (Fig. 68) had their special theories of the correct way to represent the most beautiful proportions. The influence of this tradition has been to make us expect that a canvas, whether a human body is represented on it or not, be so divided that a discernible order may be found in it. The antiquity of this idea has been attested by numerous writers. The Egyptians are said to have had a fixed system of relations between the parts of their temples and these relations are supposed to have had a religious significance. "In the fifth century B.C.," says Eduard Sekler in his lecture, *Beliefs behind Architecture*, "the whole design of the Doric temple became governed by the strict application of a coherent system of proportions." But in more recent

1 The problem of visual perception is extremely complicated. Of recent years the traditional solution, that only an object is needed—in the long run light rays—has been almost entirely rejected. We now know that the perceiver's expectations count at least for as much. The artist helps build up our expectations and forms our habits of seeing things.

2 Now easily found in his *Meaning in the Visual Arts* (New York, 1955).

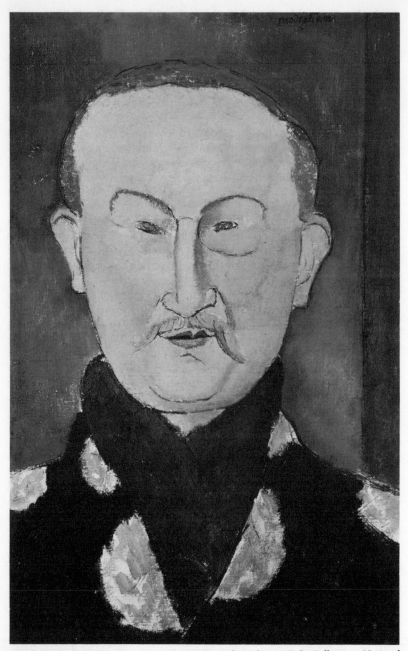

Fig. 67. Amedeo Modigliani: *Portrait of Léon Bakst*. Chester Dale Collection, National Gallery of Art, Washington.

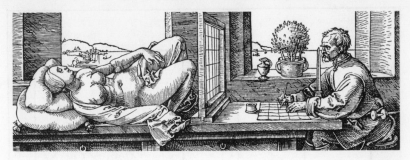

Fig. 68. Albrecht Dürer: *Artist Sketching a Recumbant Woman*. Baltimore Museum of Art.

times too we find a man like Degas reported by Paul Valéry as seeing in art "certain mathematical problems, subtler than real mathematics, problems which nobody had been able to elucidate and the existence of which few people surmise. He liked talking of 'scholarly art' saying that a painting was the result of 'scholarly art' while to the innocent eye works of art seem to be born of the happy encounter of a *subject and a talent*."

One of the most famous examples of the mathematical definition of the ideal is that given by the German psychologist Fechner in what he popularized as the Golden Section. The Golden Section could be represented by a line which is so divided that the shorter section is to the longer as the longer is to the sum of the two. This formula could be embodied in the sides of a rectangle, the façades of buildings, or presumably in any object whose short axis could be so related to its long axis. Fechner derived his formula from answers given by subjects in his laboratory to questions of preference which he had put to them.

Professor Jay Hambidge of Yale published in 1920 a book called *Dynamic Symmetry: the Greek Vase*, in which by detailed measurements he discovered a set of spatial relations based upon the "whirling square" which will also be found in paintings (Fig. 69). An analysis of some of the most famous paintings—and we illustrate a few of them here—provides material for demonstrating that whether the artist is aware of it or not, he will use dynamic symmetry in building up his composition. If he is conscious of what he is doing, as George Bellows was in his triple portrait, *Eleanor, Jean and Anna* (Figs. 70a-b), there is of course no argument. But when an artist like Daumier draws a picture and presumably by his eye alone organizes it in accordance with what Hambidge's theory demands, then the aesthetician has a very serious problem on his hands (Figs. 71a-b).

This relationship is mathematically expressed in the Fibonacci series, 3, 5, 8, 13, 21[3]. . ., though 118, 191, 309, 500, 809, 1309 . . . approximates it more closely. In other words, any member of the series divided into the succeeding

3 For a recent discussion of this, see *Symmetry*, by the late Hermann Weyl. The part which is of interest here is reproduced in James R. Newman's *The World of Mathematics* (New York, 1956), pp. 718 ff.

Fig. 69. Diagrams of pictorial construction.

member approximates 1.618 which is the Golden Section. Members divided into alternate members, for instance 500 into 1309, give a quotient which approximates the ratio 2.618 or what is known as the root 5 rectangle ($\sqrt{5}$).

André Lhote, the French painter, in his *Treatise on Landscape Painting*, as well as Hambidge, speaks of how those familiar with morphology find this proportion in nature. He goes on to say, "Minds trained in the study of natural forms . . . know that natural plastic manifestations: whirlwinds, waterspouts, shell or plant-structure, etc., contain in them the most felicitous proportion of those exciting and reassuring elements of which I have been speaking. Since then the art of drawing and painting, subservient to the art of feeling,

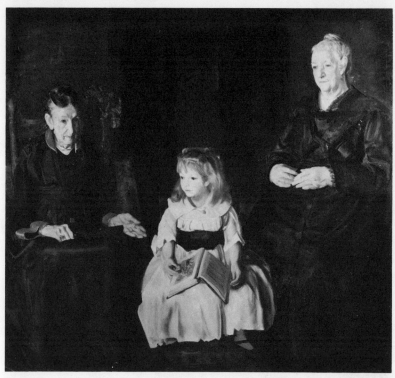

Fig. 70a. George Bellows: *Eleanor, Jean and Anna*. Albright Art Gallery, Buffalo, N.Y.

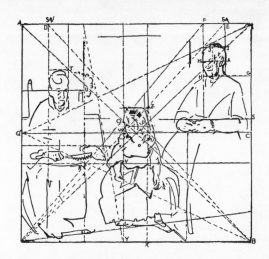

Fig. 70b. George Bellows: Diagram of *Eleanor, Jean and Anna*.

79

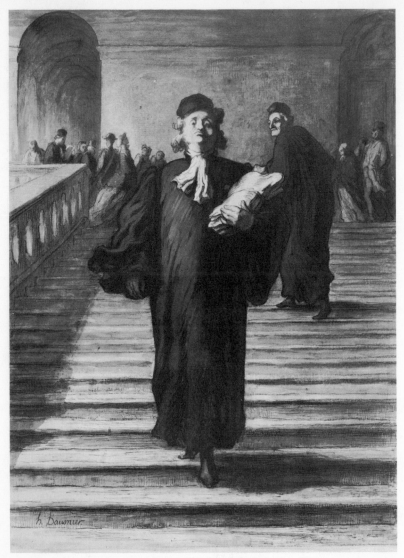

Fig. 71a. Honoré Daumier: *The Staircase of the Palais de Justice*. Baltimore Museum of Art.

derives its profound laws from morphology." Lhote, moreover, believes that primitive peoples assume the rhythm of natural form instinctively and therefore have much to teach modern man. For in his opinion such forms are more vital than the mechanical proportions of the machine.[4]

4 Cf. André Lhote, *Treatise on Landscape Painting* (London, 1950), pp. 38-43. Trans. by W. J. Strachan.

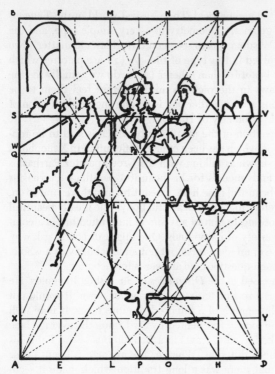

Fig. 71b. Diagram of *The Staircase of the Palais de Justice.*

ABGH—a whirling sq. rectangle with GH the long side being the total height of the picture.
EFCD—overlapping whirling sq. rectangle, same size.
AG & FD—diagonals of whirling squares.
P_3—point where diagonals cross.
AQP_3P & PP_3RD—2 whirling sq. rectangles.
QR—top of stairway.
LL_1KD & AJO_1O—overlapping squares, forming rectangle LL_1O_1O.
LMNO—contains the lawyer's body.
JK—the top of the shadow and the bottom of lawyer's hand.
SBNU & UMCV—overlapping whirling sq. rectangles.
SV—the top of balcony and lawyer's shoulders.
WG—whirling square diagonal, which parallels SN and follows the line of ramp & lawyer's cap.
XSVY—two whirling square rectangles, divided by the center line at P_1.
XY—lawyer's toe and lower part of his shadow.
AN & MD—cross at top of lawyer's forehead (MD runs through his thumb).
XP_4—parallels AN following shadow and edge of cap.
P_4—on the horizontal of the top of the moulding.

The notion that beauty was the embodiment of certain mathematical ratios is as old at least as Plato's *Timaeus,* one of his few dialogues which has been widely known since its composition and surely one of the most influential documents in Occidental history. To Plato the beautiful was the intelligible

81

and the intelligible was the geometrical. The physical world in the *Timaeus* was the embodiment of geometry, geometry of a very simple type, and the problem of the Lover of Wisdom was to see geometrical laws in matter. Two problems are always involved in this type of theory: (1) are pictures which embody these laws more beautiful than others? (2) or do we actually see the exemplification of the laws in the pictures and therefore feel them to be beautiful? These questions arise whether one is meditating on the Canon of Polyclitus or the dynamic symmetry of Hambidge.

There is a second conception of the ideal beauty which is said to be represented by the painter and which has been equally influential. In Xenophon's *Memorabilia* Socrates is shown as talking with the Greek painter Parrhasius and asking him how he finds models for his beautiful paintings. Parrhasius replies that he chooses a beautiful nose here, a beautiful arm there, and so on, and then fits them all together to make a beautiful body. The ideally beautiful body is never found according to him in any single individual but is a composite collected from a variety of individuals. One might of course ask why one can find an ideal nose or an ideal torso but not an ideal body as a whole. But, alas, as to so many such questions, no answer is forthcoming.

A similar notion is expressed in the *Discourses* of Sir Joshua Reynolds. He maintains that the ideal is a sort of statistical average or norm. It would not be unlike a composite photograph of a hundred or more faces. It may well have been true that in the society frequented by Sir Joshua the average face was beautiful. But if he had lived to travel in a London bus or the Tube, his impression might have been different. Whether the average is beautiful or not, it must be granted that there was a long tradition which made it seem reasonable to look for it and represent it. For instance, when one reads a book on botany, one hears about "the" rose, "the" lily, "the" dianthus, and not about "this" rose or "some" lilies or "a" dianthus. The scientist is interested in talking about what he would call typical or standard or perfect specimens and to get them he has to generalize. But in order to generalize, he has to overlook individual differences or peculiarities. His specimens can be only what are known in statistics as the mode, those most frequently found. And we all know that in literature criticism often objects to a character or incident on the ground that it does not seem real in the sense of not seeming normal. Is the critic here turning into a sort of scientist? It would seem so.

The tradition that the artist, whether painter or writer, is representing the ideal is clearly seen in the doctrine of consistency of character. Aristotle's famous pupil, Theophrastus, seems to have been the first to argue that human beings, like everything else, fell into certain classes or types. He advanced this thesis to explain why the Greeks, who all spoke the same language and had the same education and descended from the same primordial ancestors, were nevertheless so different from one another. His *Characters,* the Grandiloquent Man, the Slanderer, the Flatterer, were apparently doomed to be such from birth, and if a man is to be presented in a novel, his innate character must first be discovered—or decided upon—by the novelist, whereupon he

must be "true to himself" all through the story. So Horace in the *Ars Poetica* wrote,

> If again
> Honor'd Achilles' chance by thee be seiz'd,
> Keep him still active, angry, unappeas'd,
> Sharp and contemning laws at him should aim,
> Be nought so 'bove him but his sword let claim.[5]

There must, however, have been moments when even Achilles was not angry or bloodthirsty, but such moments did not count when one was estimating his character. So firm was the belief that each man exemplified a type of man, that in the eighteenth century the Swiss mystic Lavater published a book on physiognomies attempting to correlate character with facial types. The influence of Lavater on painting must have been very great (See Fig. 72). It has been shown to be great on the way novelists have described their people.

5 Translation of Ben Jonson.

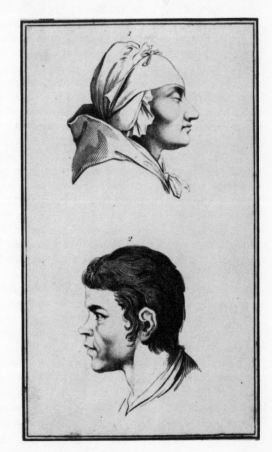

Fig. 72. Johann Kaspar Lavater: Physiognomies.

Though we are perhaps more interested than our forefathers were in individual rather than class traits, we too have to face the problem of how it happens that thousands of individuals, not merely human but also vegetable and animal, can be so much alike. One of the most famous answers is that of Plato to the effect that to each natural class of things there corresponds an "idea" or archetype in accordance with which it is formed. In Saint Augustine these ideas became the divine patterns in the mind of God the Creator. These archetypes were eternal; their particular exemplifications were temporal. The archetypes were immutable; the exemplifications changeable. The archetype was symbolized by an abstraction, let us say, *Humanity,* while its individual exemplifications were concrete things. The differences between the two were so great that some philosophers believed there must be two worlds, one of which was called the Intelligible World, the other the Perceptual World. And then since most men wanted to identify the real with the everlasting, it was inferred that only the Intelligible World could be called real in any serious sense of that word. Oddly enough, the artist who wanted to paint the real would according to this way of thinking have to turn away from what he saw with his eyes to what he believed to be ideal. And it was sometimes maintained that artists had the peculiar faculty of seeing the ideal in the particular spatio-temporal things and of reproducing it in paintings. Realism thus became the very opposite of copying ordinary visual objects.

Sometimes the ideal in this context was called the essential. If now one asks why it is better to reproduce the essential rather than the non-essential, the answer is given in still another meaning which was attached to the word "idea." The ideal was not only that which a class of things had in common or the pattern in accordance with which they had been created by God, but it was the ideal also in the sense of what ought to be. In common speech we often hear people say that no circle drawn on paper is a perfect circle and no flesh and blood man a perfect man. If one wishes to identify reality with perfection, then it is obviously what ought to be, not what is. Like the definitions at the beginning of a book on plane geometry, it expresses the standards which actual things approximate but never reach. They are like mathematical limits. This gives rise to a shocking dilemma: "We want absolute perfection and live in an imperfect world. We have to choose between perfection and imperfection, between certainty and plausibility. If beauty were a perceptual revelation of perfection, the ideal, then it would be that link between the two worlds to which we aspire. But we know perfection through the reason, not through the senses. Beauty, however, is revealed to us through the senses, not through the reason."

This gave the artist a noble and indeed an indispensable task to perform, a task which the camera could never do so well. If a portrait, for instance, presented to the human eye the essence of the person portrayed, then the onlooker saw something more than an image of a particular man, a sort of map; he was being shown what the person *really* was, not what he seemed to be. The artist is still representing something, but he is putting into material form

something which in its true nature is not material. If it is true that artists have that kind of insight and that they can put it down in visual form on canvas, then they are depicting things as they ought to be, not as they are in the Perceptual World. There would always be some resemblance between, let us say, a statue of a beautiful woman and the beautiful woman herself, but whatever imperfections might exist in the flesh and blood woman would disappear in the statue. Who decides what are imperfections is usually not stated by the men who adhere to this theory.

To go into all the details and ramifications of such a doctrine would involve us in the history of Platonism and Neo-Platonism and that would befog the issue. It is enough to say that all such theories of the artist's purpose are based ultimately on philosophy, not on psychology. Nevertheless they gave rise to a split in the camps of painters and critics as early as the seventeenth century when Cardinal Bellori attacked Caravaggio for turning his eyes away from the Ideal to the Natural. The Naturalist maintained that all one did was to look at things and paint them; the Idealist that one looked at things and painted their ideal or essential traits. By the time of Ingres, in the early nineteenth century, the breach widened and on the one hand there were the academic painters who said that they were painting ideal beauty and on the other the Anti-Idealists who were inclined to ridicule such claims and satisfy themselves with copying nature as it appeared to them.

This latter program was more easily stated than carried out. When Courbet came along and boasted of copying nature without embellishments, it did not take him long to realize that the artist's temperament would never be eliminated and that, as Zola said, he would always be seeing the world through it. If this was true, then it was impossible for a man simply to see objects-as-they-are; one can see only objects-as-they-seem-to-oneself. The personal equation is always there, so that each painter has a visual world of his own. There was immediately let loose upon the aesthetic public a series of manifestoes expounding the supposed nature of vision.[6] For instance, in Cézanne the object became a construction of geometric solids with colors determining their distance. With the Impressionists, on the other hand, the object dissolved into light, since what we see, they quite correctly said, is colored surfaces. A painter like Monet (Fig. 73) soon woke up to the fact that if a visual object was a pattern of colors and if the painter was confined to reproducing the visual object, there would be no permanent object to paint. For the visual surface changes with the illumination and the sun as it moves from east to west modifying the colors which can be seen. Hence he followed the doctrine to its logical conclusion and set down a series of impressions of the same forms—haycocks, cathedral façades, poplars, water lilies—at various hours of the day. The object, having become the purely visual object, is a shimmering surface of spots of color, something which changes from moment to moment, something which the painter must catch on the wing. If in addition to this the artists each saw things in their own personal

6 Some of these are discussed in Gauss, *Aesthetic Theories of French Artists*.

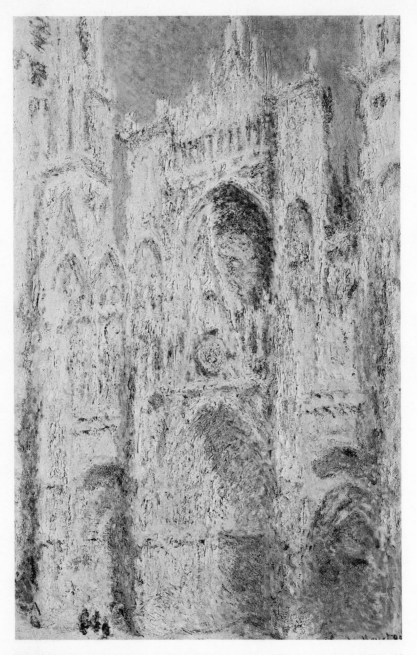

Fig. 73. Claude Monet: *Rouen Cathedral*. Chester Dale Collection, National Gallery of Art, Washington.

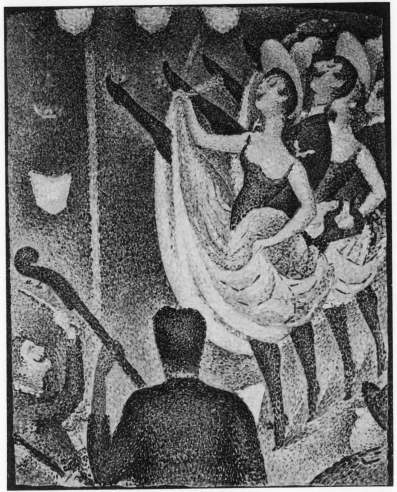

Fig. 74. Georges Seurat: *Le Chahut*. Albright Art Gallery, Buffalo, N.Y.

way and if what they saw was fleeting, then it would be folly to talk about a single world which would be the world of *The Painter*.

This would seem to imply that the artist is nothing more than a machine for recording impressions of color and shape and few artists wanted to turn into cameras. When Seurat entered the scene (Fig. 74) he was willing to accept the visual theories of the Impressionists, but he reintroduced the notion that the artist must also organize what he saw when he came to putting it down on canvas. Few painters were ever more conscientious than Seurat in designing their pictures and, as is also true of Poussin, his canvases were constructed in accordance with the laws of the Golden Section. If one were

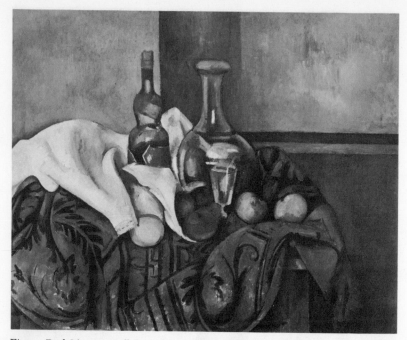

Fig. 75. Paul Cézanne: *Still Life*. Chester Dale Collection, National Gallery of Art, Washington.

to eliminate the recognizable objects in a painting by Seurat and leave only the structural lines, one would have a non-objective painting similar to those of our own times.

But instead of immediately following Seurat, painting followed Monet and Cézanne (Fig. 75), taking from Cézanne his theory of spatial perception and from Monet his theory that the object was the purely visual and not tactile object. In such a painter as Matisse the tactile qualities of the object all but disappear. It becomes flattened and modified to fit a visual pattern which may be suggested by its skeletal shape and movement but which is supposed to be free to elongate itself or compress itself as the painter's imagination desires. The fact that people, jugs, flowers, tables, and chairs are solid objects which can be moved about in space is irrelevant to him. Probably no painter was ever more faithful to Denis' dictum that the painting is first of all a flat surface divided into colored areas. He created a new visual world, a world which was derived to be sure from the world of three dimensions, but one in which the artist's eye and imagination were the dominant sources of order.

This world was also explored—and with quite different results—by Picasso and the Cubists (Fig. 76). Reverting to what they had been interested in taking over from Cézanne, they openly admitted that they were not copying

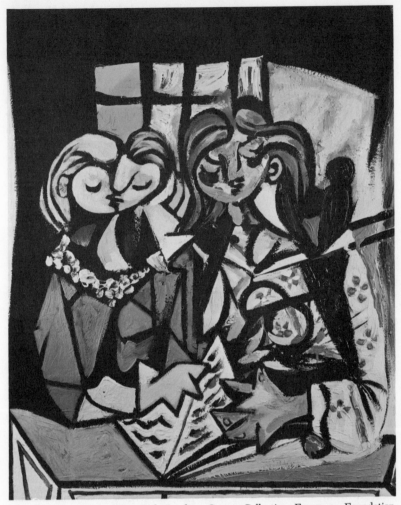

Fig. 76. Pablo Picasso: *Two Girls Reading*. Garrett Collection, Evergreen Foundation, Baltimore.

the world as it seems to the eye but as it is known to thought. An object, they said, may seem flat, for the eye can see only one side of it at a time, but after all we know that it is solid, occupying three dimensions, and it is folly to turn one's back on knowledge. Hence the cylinders, cubes, and prisms were brought back and, regardless of naturalistic vision, were organized on the canvas. This was one of the greatest revolutions in painting that had occurred since the Italian Renaissance. If Matisse rejected physics for the sake of vision, the Cubists might be said to have rejected vision for the sake of physics, though both statements are exaggerated. At any rate both camps

liberated the artist's imagination from what they believed to be slavery to tradition and yet both were representational. Matisse maintained that lines, movement of forms, and colors could stimulate an emotion which could be stimulated only by painting. Picasso maintained that by presenting the world as it was known to be through physics a similar emotional shock could be stimulated.

Ever since the beginning of the twentieth century painters have been divided into what, in order to avoid the standard labels, we shall baptize the Visualists and the Intellectualists. One of the most ironical aspects of the two approaches is that they reproduce the conflict between Ingres and Delacroix who held respectively that structure and color were the two essential marks of a good painting. For Ingres, as for David before him, painting was colored drawing; for Delacroix it was above all color. Yet no one nowadays looking at a Delacroix would fail to see the structure emerging out of the color; no one looking at an Ingres would fail to see more than drawing.[7] This is inevitable, for all objects, unless they are transparent, have some color and all colored areas have some shape.

The Visualist camp now raised again the question of vision. And the outcome was that they asserted what is probably true, that we see with our whole minds and not merely with our eyes. But the whole mind includes the unconscious as well as the conscious, our emotions as well as our sensations, and it might be argued that the purest form of vision is that of dreams where the laws of physics seem to have little jurisdiction. But for that matter we know that we do not see all that is to be seen in waking life. The eye is selective and the selection may be made by what we are looking for, what our interests dictate, just as our rejections may be made by what repels us, what we hate, what we do not want to see. In dreams, as we have learned from psychoanalysis, the inhibitions of waking life are often released as they are in fantasy, and though there are also laws which govern our dreams, they are the laws of psychology, not of physics and chemistry. The eye awake suffers from the discipline of speech, of science, of morals, of social custom. We are constantly correcting our vision by what we know to be the facts, saying, as it were, to ourselves, "This cannot be so." When we look down a street or a railroad track, we see the curbs or the rails converging in the distance, but we know that they do not so converge as physical objects. When we look at a solid object, we see only the side facing us, but that does not prevent our saying that we are seeing something solid.

If the artist, it is claimed, is not to turn his back on his personal vision, he must forget these corrections, this discipline of knowledge, and be open and above board in seeing things freely. His personal reality must become a super-reality, his own individual vision of the world unlimited and uncorrected by either reason or logic. To free the painter from the chains of rationality was the problem, just as for Matisse and his group it was to free

7 The difference is of course one of emphasis. It corresponds with certain modifications to what Eduard von Woelfflin called the linear and the *mahlerisch*.

him from convention. But exactly as our dreams and fantasies are self-propelled and proceed without regard for the laws of physical science, so our paintings will reproduce objects which have been transmuted into psychological rather than physical objects. The kind of picture which would result might be horrible rather than beautiful, but at least it would be faithful to the artist's personality.

The Intellectualists soon saw on the other hand that if they were to reproduce the world as they knew it to be and not as the eye saw it or the mind imagined it, the essential features would be lines, flat surfaces, shapes, organized according to some system of order. Popular expositions of physics had said that physical objects are electric charges whizzing about in empty space and that our belief in solidity is due to human frailty. A painter would be hard put to it to paint electric charges, but he could give an observer some idea of the whizzing by drawing lines moving rapidly in this direction and that. The lines of course do not actually move, but they could be so drawn that they would look as if they were moving. According to the German aesthetician Theodor Lipps, our bodies tend to take on the pattern of what we see in paintings, sculptures, and architecture. We "feel ourselves into" such objects. We make incipient movements when we see the reproduction of a dynamic pattern, stretching ourselves upward with verticals and expanding with horizontals. So when we hear highly accented music or verse, we tend to beat time with our fingers or feet. No one doubts any longer that musical rhythms are emotional. And it may well be that visual rhythms are also. The truth may be that sensitivity to such things varies from person to person and that just as music leaves some people unmoved, so does the dynamic force of paintings.

We have tried to suggest in this chapter how ambiguous the simple sentence is that says that a painting is a representation of real or imaginary objects. The ambiguities are not our invention nor is the list of them complete. It is derived from both the history of painting itself and from that of aesthetic theory. The point is that the word "object" means and has meant a variety of things: the object as described by physics, the visual object supposedly seen by all men in common, the object as it ought to be (the ideal object), and so on. If we do not always recognize the objects which we see in pictures, we should never forget that the camera itself distorts (Fig. 77). To state flatly what an object looks like without including the conditions of observation is then impossible.

Yet we often do criticize paintings on the ground that they have distorted the objects represented. We are like the child who thinks that there is "a way to draw a man," or a house or a cat or dog. Upon examination it turns out that we assume a standardization of vision. The child speaks as if he thought that what has a standard name, man, horse, dog, or cat, must have a standard appearance. In a sense he is right, for historically appearances do become standardized. But the artist may be expected to see things in his own way.

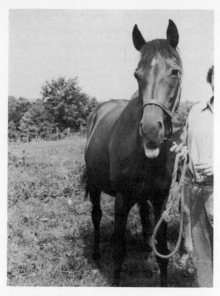
Fig. 77. Photograph of a horse.

We see such standardization when we look at religious paintings, paintings of the Annunciation,[8] the Crucifixion, the Deposition, where changes in the manner of illustrating these events have occurred very slowly. Standardization need not cramp the artist's imagination any more than grammar and syntax cramp the writer's. For, as we have said, *all communication demands a standard code or language.* In fact, no sooner does an innovation occur in the history of an art than it too becomes conventionalized. The great innovators are likely to be called unintelligible since they break away from the customary modes of expression. But their disciples may follow obediently in their footsteps and carry on their master's innovations as standard operating procedure. If one were to be utterly individual, individual in choice of subject matter and in the manner of presenting it, clearly one would be also utterly unintelligible. For there would presumably be nothing in common between oneself and one's fellows. Such complete individuality would of course be impossible, since we happen to be all human beings, and even the simplest gesture of a child can be interpreted by those who know him. We may never succeed in accurately reading an artist's intentions, but we can certainly make some sense out of practically everything. For nothing made by a human being will be without some traces of his humanity.

Such then are the problems of representational painting. They vary from what the artist believes to be the most literal reproduction of his subject matter to the freest interpretation of it. As the artist moves away from literalness he will move in the direction of interpretation. Our next chapter will deal with that aspect of paintings.

8 See Chapter IV.

Chapter IV Painting as Interpretation

Though we may have the impression that when we look at the world we see it objectively and simply note "the facts," it is more likely that all perception contains an element of what we can only call "interpretation." The very selection of detail is determined by the observer's interests and expectations. We do not merely see, we look. And looking, as contrasted with undirected seeing, is guided by curiosity or by a desire to find out whether an idea is true or not. Moreover we are often aware of situations in which we unconsciously interpret what we see or hear. When we are talking with a friend, we read into his facial expression or his tone of voice or his choice of words or his gestures indications of his state of mind and character which are not on the surface. When we say that someone looks pleased or happy or angry or hostile or worried, we are interpreting what we see. For we obviously cannot see the pleasure or unhappiness or worry or anger or hostility. And sometimes we make serious mistakes in our interpretation of the outward signs.

We do the same sort of thing when we are dealing with animals whose states of mind are even more concealed than those of human beings. We have no way of really knowing what a dog feels when he wags his tail or what a cat feels when he switches his. But we interpret their gestures as signs of inner feelings nevertheless. Sometimes we even extend the technique to landscape, as when we indulge in what Ruskin called the pathetic fallacy and speak of smiling meadows, frowning mountains, angry seas, majestic trees, and laughing brooks. How conscious we are of what we are doing in such cases depends on how sophisticated we may be.

Some of us are more aware of our perceptual interpretations than others and would admit that the extension of human emotions to animals, plants, and natural scenery at least gives us a feeling of kinship with the universe, if it does nothing more. It is probable that anyone, if confronted with the question, "How do you know that Mr. Soandso was hostile to you?" would answer, "Well, he looked hostile," or, "He spoke in a hostile manner." It is very seldom that a hostile person introduces the subject of his hostility himself. Indeed if he really is hostile to you, he might try not to show it. Speech may not exist for the exclusive purpose of concealing thought, but it frequently does conceal

it. And when a person conceals his thoughts in his words, he may in spite of his intentions reveal them in his looks.

In painting we have not simply interpretations which are unconscious, but also many which are deliberate. The best examples are to be found in the field of portraiture, where the artist presumably studies his subject and tries to bring out his character. A flattering portrait is by definition an idealization of the sitter, but the artist who paints a flattering portrait first makes the decision that his sitter is the kind of person who wants one. John Sargent was said to be a portrait painter who read people's souls and put them down for all to see. The sitters did not always approve of what they saw, if one may judge from the disputes which arose over the portrait now called *Madame X* (Fig. 78) in the Metropolitan Museum in New York or of those of the Wertheimer Family which were given to the National Gallery in London. How fair we are in interpreting character through facial expression and bodily stance may be questioned. But it has usually been admitted that the portraits of Van Eyck (Fig. 79), Holbein (Fig. 80), Titian (Fig. 81), and Goya (Fig. 82), not to mention a hundred other serious portrait painters, are character studies. Goya's portrait of Queen Maria Luisa of Spain is famous for the revelation it makes of that woman's self-satisfaction and immorality. Titian's portrait of Paul III justifies historians who call Paul shrewd, calculating, tenacious, overcautious, and irresolute. To appreciate the difference between purely ritualistic and standardized faces and facial expressions and interpretations of character, one should study the difference between the faces of Raphael's Madonnas (Fig. 83) and those of his portraits (Fig. 84). The former are formulas, the latter interpretations. But one could see the same difference in Raphael's great disciple Ingres, when one contrasts the face of the Madonna in his *Vow of Louis XIII* (Fig. 85) and that of *Mme Rivière* (Fig. 86).

How this is done is the artist's secret. Sometimes he leans upon what he knows of physiognomy, but sometimes he calls upon color, line, and the general composition to bring about the effect he wants. The stance of Goya's *Luisa* is almost enough to communicate to us what the artist thought of the lady and the crouching figure of Titian's *Paul III* is almost as revealing. In fact the way people carry themselves is one of the most usual indications of what we believe to be their character: they slouch, they stand erect with head held high, their arms hang limp or are firm, they peer at us from under their eyebrows, they look the world straight in the face. Their timidity, despair, audacity, pomposity, their open-mindedness or secretiveness, their self-esteem or modesty, all seem to be betrayed by their habitual pose as well as by their facial expression. We say "seem," for the simple reason that no one really knows what is signified by the bodily attitude of others. In such matters we react, as we are likely to say, instinctively. And our instincts may well be unjust, cruel, and downright wrong.

They may be wrong since they are based on our limited experience and are not really instincts at all. And we often forget that there are styles in

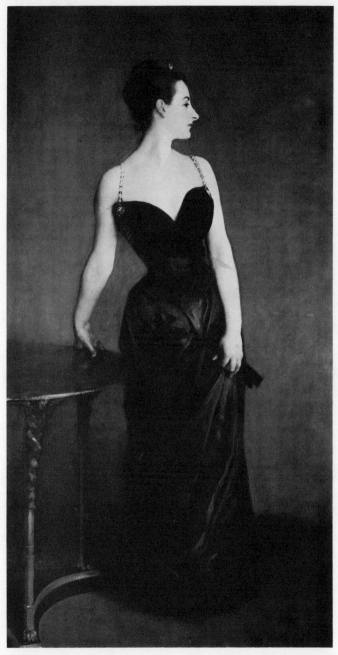

Fig. 78. John Singer Sargent: *Madame X*. Metropolitan Museum of Art, New York.

Fig. 79. Jan van Eyck: Arnolfini. Detail from *Arnolfini and Wife*. National Gallery, London.

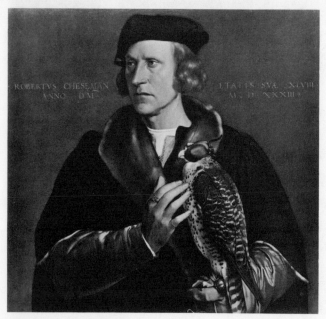

Fig. 80. Hans Holbein the Younger: *Robert Cheseman*. Mauritshuis Museum, The Hague.

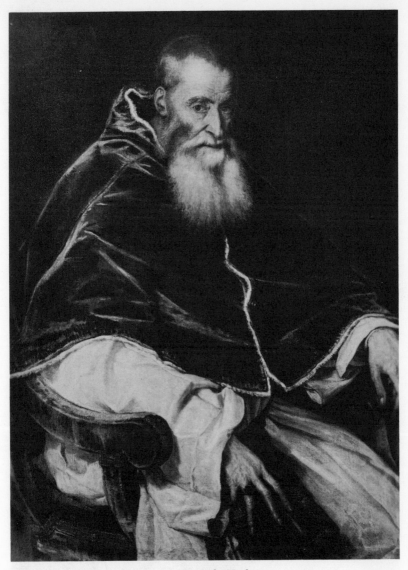

Fig. 81. Titian: *Pope Paul III*. Museo Nazionale, Naples.

faces and manners as there are in clothes and speech. The elaborate etiquette of the courtier would seem nonsensical to most Americans and even the normal politeness of a generation ago seems too stilted to our juniors to be sincere. Americans laugh at Frenchmen who shake hands on meeting and leaving people, even if the meeting lasts but a moment or two, and they

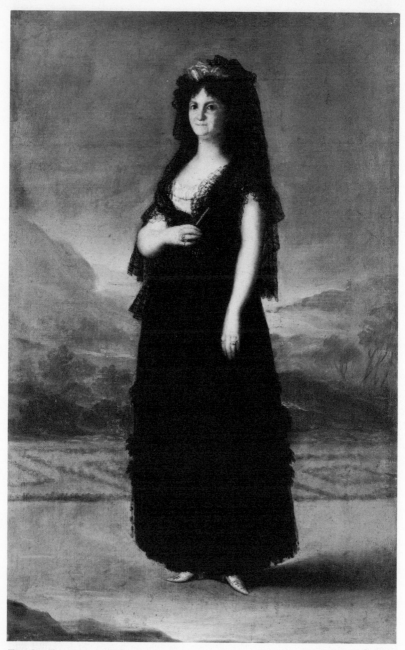

Fig. 82. Francisco José de Goya y Lucientes: *Queen Maria Luisa*. Mellon Collection, National Gallery of Art, Washington.

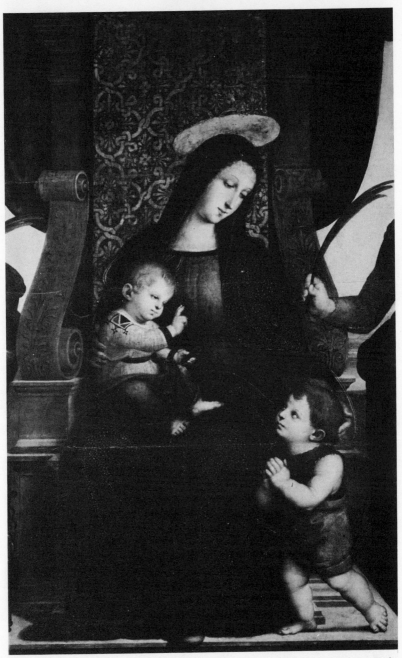

Fig. 83. Raphael: *Madonna and Child Enthroned*. Metropolitan Museum of Art, New York.

Fig. 84. Raphael: *Emilia da Pia Montefeltro*. Jacob Epstein Collection, Baltimore Museum of Art.

Fig. 85. Jean Auguste Dominique Ingres: *Vow of Louis XIII*. From an engraving in the Bibliothèque Nationale, Paris.

Fig. 86. Jean Auguste Dominique Ingres: *Mme Philibert Rivière*. Louvre, Paris.

think the Continental habit of kissing ladies' hands is absurd. But a Frenchman thinks that Americans are a bit cavalier in their greetings, if not rude. The habit of the American businessman of putting his feet on his desk still seems reprehensible to some people and we have never yet seen a portrait of the president of a corporation in shirt sleeves with his feet thus disposed. Yet whether the feet are on the floor, on a cushion, or a hassock, or on a desk

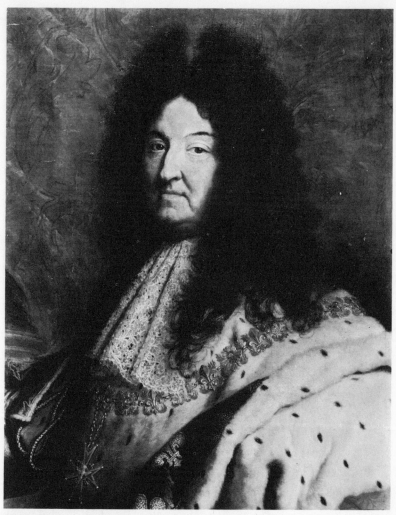

Fig. 87. Hyacinthe Rigaud: *Louis XIV*. Detail. Louvre, Paris.

is not a reliable indication of the character of the person who owns them. The same may be said about costume. What was merely decent a few years ago now may seem needlessly formal. What is worn, for instance, by undergraduates now, T-shirts and blue-jeans, would have been shocking in 1920. This is one of those obvious observations which are sometimes overlooked. A young man in a shirt without a necktie may be quite as serious as one more ceremoniously clothed and whether he greets his teachers with a "Hiya," or with a "How do you do?" is no indication of anything except a change in etiquette.

103

Fig. 88. François Hubert Drouais: *The Duc de Berry and the Comte de Provence.* Sao Paolo Museum, Sao Paolo, Brazil.

If we see the subjects of portraiture dating from the time of Louis XIV (Fig. 87), we are likely to interpret them as much more ceremonious than they really were. The elaborate costumes of that time look to us like fancy dress, but they were normal enough in the early eighteenth century. Drouais's double portrait of the Duc de Berry and the Comte de Provence (Fig. 88), like Velazquez's portraits of various Spanish princesses (Fig. 89), are pretty heavily loaded with flounces and furbelows, but who can say how bizarre all this looked to the people of the time? A few years ago, and perhaps even today too, it was possible to see the peasants of Jugoslavia working in the fields in elaborate costumes hung with jewelry of the most intricate kind. Did they themselves see anything inappropriate in this? Clearly what people wear is more the effect of tradition than of anything else and what tradition dictates usually seems fitting. Contrast the battle dress and the full dress uniforms of the Army and Navy.

But fashions in costume, pose, and speech are not the whole story. There is also a fashion in bodily beauty. Few men today seem to find the Venuses of Rubens (Fig. 90) as attractive as Rubens did. One hears the comment that they are too fat. But surely Rubens, whose eye was always on his public, did not find them too fat. It is not only possible but probable that our descendants will find our Venuses too scrawny and too athletic. For that matter one has only to compare a Venus of the school of Cranach with one by Titian (Fig.

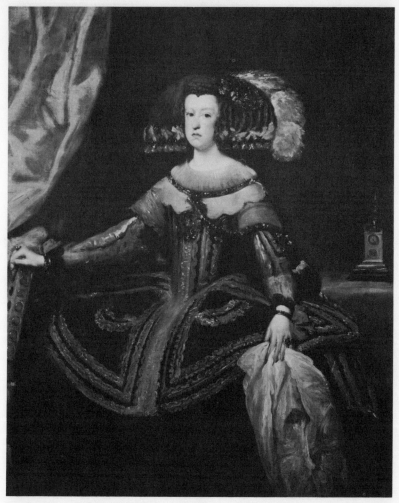

Fig. 89. Diego Rodriguez de Silva y Velazquez: *Anna Maria, Queen of Spain*. William Rockhill Nelson Gallery of Art, Kansas City, Kan.

91) or Botticelli (Fig. 92) to see how styles in feminine charm can shift. And yet if there is one kind of beauty which one would think of as universal and eternal, it is the beauty of the opposite sex. It is too bad that there have not been enough women portrait painters to register what women through the ages have thought of manly beauty. For most portraits of men, like those of women, have been painted by men.

The contribution of the painter in the form of comment may vary from something close to zero to the point where it leaves the sitter unrecognizable. Here are four portraits of men painted by Fouquet in the fifteenth century

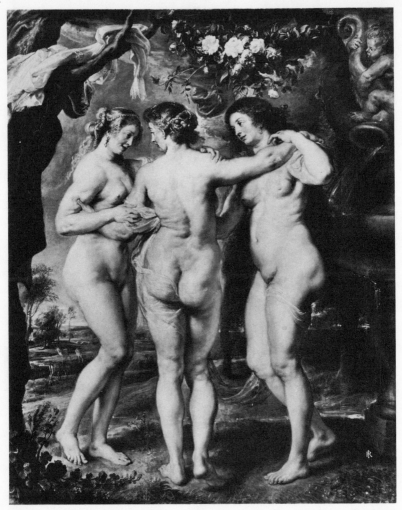

Fig. 90. Peter Paul Rubens: *The Three Graces*. Prado, Madrid.

(Fig. 93), Clouet in the sixteenth (Fig. 94), Marsden Hartley in the twentieth (Fig. 95), and Miró later in the same century (Fig. 96). None of these four paintings is straight scientific recording. To each the painter has added his own remarks. But by the time one reaches Miró, one is aware of the comment but has no idea about whom it is made. If neither Fouquet nor Clouet injected their own opinions into their portraiture to the extent that Hartley and Miró did, it is not merely that they were individuals with their own styles, but also because the general style of painting had changed during the period between their day and ours. This does not mean that every painter of

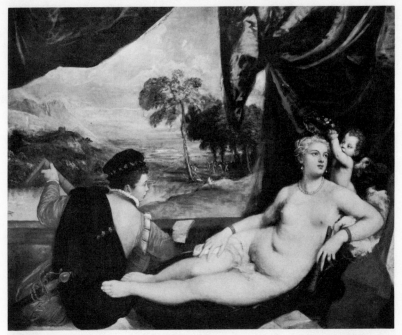

Fig. 91. Titian: *Venus and the Lute Player*. Metropolitan Museum of Art, New York.

the twentieth century can be expected to paint after Miró's manner, but it is doubtful whether one could find a painter like Miró before the days of twentieth century psychology. For it is to be noticed that neither Hartley nor Miró pay much attention to the faces of their sitters. To them other things are more important.

Styles may be described as the ritualized tastes of a time, whether they are styles of dress, speech, manners, looks. Their compulsiveness varies from individual to individual, some of us being more submissive than others to the taste of the group to which we belong. It would be an interesting experiment to show a dozen or so *Judgments of Paris* to a group of our contemporaries and see to which of the goddesses they would award the prize. It is more than likely that if they were confronted with those whom Cranach—or his follower—stood up before his judge, it would be a matter of indifference who got the apple. For the predominant group in our society would undoubtedly find them all equally unattractive. Now no one is entirely identified with any group, except possibly in certain primitive societies, or in a society in which a rigid caste system prevails. But whether one is submissive or recalcitrant, one knows automatically what the style is. Nowadays it is rubbed into us every time we open a magazine. We absorb a set of values unconsciously from conversation, from reading, from listening to the radio, from looking at television, from going to the movies. Even unconventional people

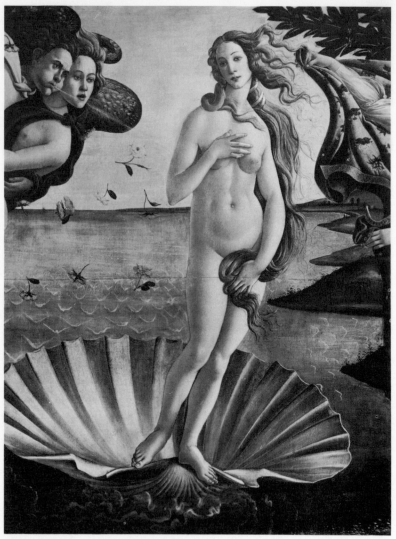

Fig. 92. Sandro Botticelli: Venus. Detail from *The Birth of Venus*. Uffizi, Florence.

have their own ways of being unconventional and all of us, whether we know it or not, are guided in our behavior by the approval or disapproval of others. Even when we consciously rebel, we have to know what we are rebelling against and that suffices to set up the form of our rebellion. If a child rebels against eating with a knife, fork, and spoon, he will have to eat with his fingers. When an artist rebels against representational painting, he can only turn to non-representational painting. As the child may also choose to

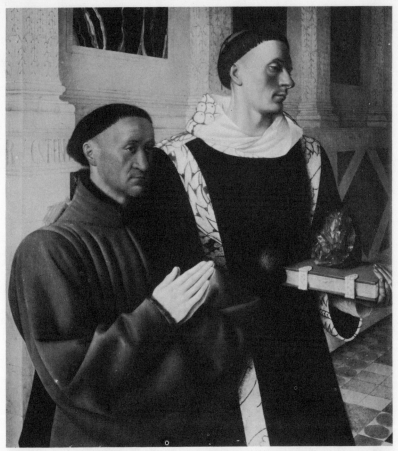

Fig. 93. Jean Fouquet: *Etienne Chevalier and Saint Stephen*. Kaiser Friedrich Museum, Berlin.

die of starvation rather than eat with the traditional utensils, so the artist may always choose to stop painting. This is one solution to be sure.

One of the great scandals in the history of American art was provoked by Horatio Greenough's statue of George Washington (Fig. 97). Washington was of course a general and it was customary to represent generals in military uniform and usually on a prancing horse. But he was also a statesman and Greenough thought that a statesman should be represented as a lawgiver. But to make a statue of a lawgiver was a bit of a problem, for lawgivers have no distinctive costume or pose which could be easily interpreted by spectators. Consequently the sculptor hit upon the idea of representing him as the Olympian Zeus, seated upon a throne, torso nude, legs draped. There is no doubt that to his way of thinking he was honoring the Father of his Country,

Fig. 94. François Clouet: *Guillaume Budé*. Maria DeWitt Jesup Fund, Metropolitan Museum of Art, New York.

pater patriae. But the public thought the statue indecent and it had to be removed from public gaze and set up indoors where it still remains. If we ourselves find that statue indecent or ridiculous or noble or imposing, we had best recognize how much we ourselves are reading into it and ask ourselves why.[1]

The costume in which an artist presents his people is often an indication of how he is interpreting the scenes in which they figure. One of the best known facts about the history of illustrative painting is that for generations

1 The same Greek original was used by the French sculptor Denon on a medal celebrating Napoleon's visit to Schoenbrunn in 1809. Should anyone be surprised by the nude torso, he should remember Canova's *Napoleon* now in the courtyard of the Brera in Milan.

Fig. 95. Marsden Hartley: *Portrait of a German Officer*. Stieglitz Collection,
Metropolitan Museum of Art, New York.

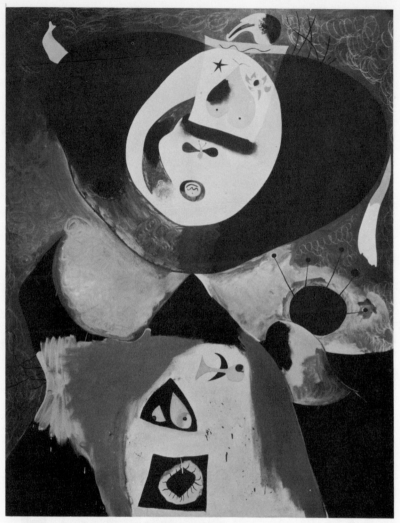

Fig. 96. Joan Miró: *Portrait No. 1*. Saidie A. May Collection, Baltimore Museum of Art.

artists represented ancient events in the costume and setting of their own times. This is strikingly exemplified in illustrations of events in the Bible. Crucifixions, Last Suppers, Nativities, and Annunciations seemed to be depicted without any suggestions of what later generations called an historical sense. But if a fifteenth-century painter depicted the Virgin being greeted by the Archangel Gabriel in a Roman or at any rate Italian villa, dressed in Renaissance court costume, does this mean that the artist had no historical sense or that to him such an event was non-historical? A deeply religious

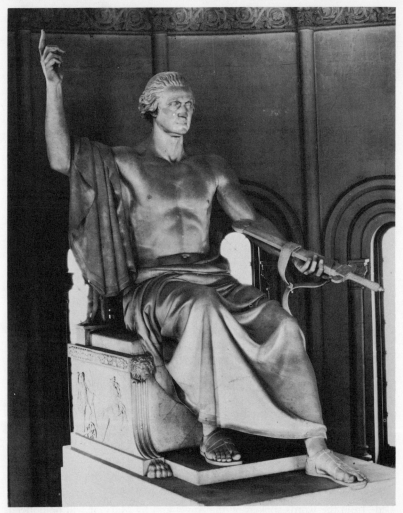

Fig. 97. Horatio Greenough: *George Washington*. Smithsonian Institution, Washington.

person may not feel the pastness of Biblical stories; he may feel them as if they were taking place now. Their reality may be so great to him that it would seem sacrilegious to represent them as if they were over and done with. Such a person might well maintain that Christ is crucified every day and if the centurions are replaced by modern soldiers, let us say Nazi storm troopers, that is because the Crucifixion is a timeless thing and should be represented as such. When a person repeats a *Hail Mary*, is he addressing someone dead and buried two thousand years ago or a sacred person as alive today and active as ever she was? Such a man might say that historically the Annuncia-

tion took place twenty centuries ago, but that on the eternal level it is always taking place. The eternal is the ever-present. Consequently a *Crucifixion* such as that of George Bellows in "modern dress" might very well be a much more sincerely religious painting than one in which scrupulous care had been taken to get every detail of costume and setting archaeologically correct.

Since we have brought up the subject of the Annunciation, a subject which has been painted over and over again and discussed as often, it might be well to illustrate how it has been interpreted over the years.[2] The Scriptural text which is the original basis for the paintings is found in Luke, I, 26-38. It runs as follows.

26. And in the sixth month the angel Gabriel was sent from God unto a city of Galilee, named Nazareth.

27. To a virgin espoused to a man whose name was Joseph, of the house of David; and the virgin's name was Mary.

28. And the angel came in unto her, and said, Hail, thou that art highly favoured, the Lord is with thee: blessed art thou among women.

29. And when she saw him, she was troubled at his saying, and cast in her mind what manner of salutation this should be.

30. And the angel said unto her, Fear not, Mary; for thou has found favor with God.

31. And, behold, thou shalt conceive in thy womb, and bring forth a son, and shalt call his name Jesus.

32. He shall be great, and shall be called the Son of the Highest: and the Lord God shall give unto him the throne of his father David:

33. And he shall reign over the house of Jacob for ever; and of his kingdom there shall be no end.

34. Then said Mary unto the angel, How shall this be, seeing I know not a man?

35. And the angel answered and said unto her, The Holy Ghost shall come upon thee, and the power of the Highest shall overshadow thee: therefore also that holy thing which shall be born of thee shall be called the Son of God.

. .

38. And Mary said, Behold the handmaid of the Lord; be it unto me according to thy word. And the angel departed from her.

Aside from the words spoken by the Angel and by Mary, it will be noticed that no indication is given in this text of where the meeting took place, of what the two personages looked like, of how they were dressed, of what Mary was doing at the time, or of any attendants who might have been present. There is, however, a suggestion of Mary's state of mind in the words, "And when she saw him, she was troubled at his saying," and in Gabriel's reply,

2 The feast of the Annunciation was already recognized as early as the seventh century and may have been celebrated a bit earlier. For a detailed study of the aesthetic problems which confronted painters attempting to illustrate it, see Lucien Rudrauf, *L'Annonciation* (Paris, 1953). For an historical account of how painters represented the scene, see P. Ladoué "*Scène de l'Annonciation vue par les Peintres,*" *Gazette des Beaux-Arts,* May 1952. We make no attempt in our text to do more than sketch briefly the theme and its variations.

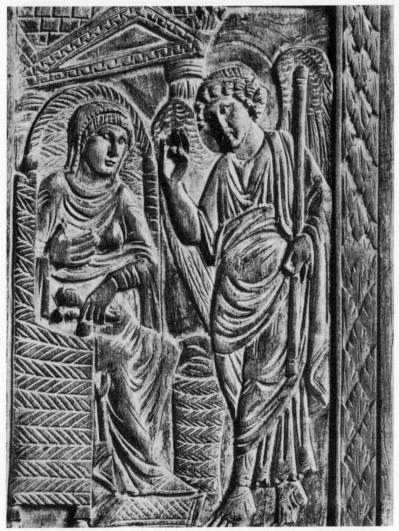

Fig. 98. *Annunciation.* Ivory plaque from the Throne of Maximianus, Ravenna.

"Fear not, Mary." Nor is there any supplementary information for the artist in the other Gospels.

However, in the *Protevangelium,* the apocryphal Gospel of James, it is related that the meeting took place at a well where Mary had gone to fetch some water. "And becoming afraid, she went away to her home, and set down the waterpot; and taking the purple"—which the priest of the Temple had given her to spin—"she sat down on her seat and spun it. And, behold, an

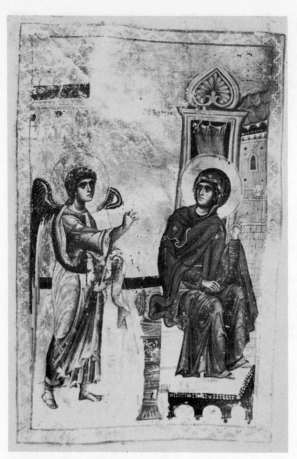

Fig. 99. *Annunciation*. Byzantine MS,
14th century. Walters Art Gallery, Baltimore.

angel of the Lord stood before her, saying, Fear not, Mary, for thou hast
found favor before the Lord of all, and thou shalt conceive from his word."[3]
The Annunciation here is broken into two scenes, one at the well, the other
in the house. Artists could learn from it what Mary was doing when the Angel
met her and what her attitude might have been. In the ninth chapter of the
Gospel of Pseudo-Matthew, the same division into two scenes is made, but the
second takes place a day later than the first and the Angel is described as "a
young man whose beauty could not be told." And Mary again is represented
as spinning. In the *Gospel of the Nativity of Mary* (Chapter 9) a new element

3 Translation by B. Harris Cowper in *The Apocryphal Gospels* (London, 1910), pp. 12-13.
The date of the *Protevangelium* is unknown, but it is early. All quotations from the
apocrypha are from this translation.

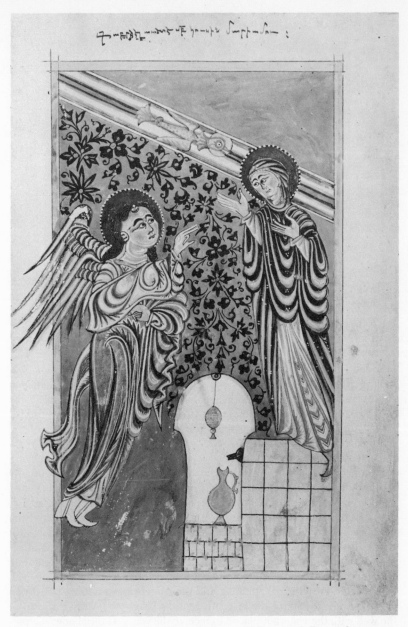

Fig. 100. *Annunciation*. Armenian MS, 15th century. Walters Art Gallery, Baltimore.

Fig. 101. *Annunciation*. French
Book of Hours,15th century.
Walters Art Gallery, Baltimore.

is added: Mary is not at all afraid. "The virgin," says the author, who was
writing after the fifth century, "who already well knew the countenance of
angels, and was not unused to heavenly light, was neither terrified by the
angelic vision, nor stupefied by the greatness of the light, but was troubled
at his word alone." It is upon these foundations that the paintings of the
Annunciation were constructed.

The earliest Annunciation which we show is not a painting but an ivory
plaque from the Throne of Maximianus in Ravenna (Fig. 98). It is usually
attributed to an Alexandrian artist of the sixth century. Here Mary is seated
on a throne with her distaff at her side, her right hand on her breast, as if to
show her trouble. The gable over her head probably tells us that she is within
her house. Gabriel is carrying a long staff and holds his right hand in an atti-
tude of blessing. These very simple details are noted here by way of contrast
to the *mise-en-scène* which later artists introduced. A similar interpretation
of the scene is given in a fourteenth-century Byzantine manuscript (Fig. 99),
where again the Virgin is spinning and the Angel carries a long staff. In an
Armenian manuscript of the fifteenth century (Fig. 100) Mary is shown at
the well with the waterpot placed to receive the water. Gabriel now is repre-
sented as if he were flying and overhead we see the Holy Ghost in the form of
a dove flying towards Mary. If the Virgin is troubled, her trouble appears only
in the attitude of her hands. In a French Book of Hours dated about 1410–15,

the Virgin is no longer spinning but embroidering; there are three angels present; and the costume of Mary appears to be that of the painter's century (Fig. 101). A hundred years earlier Giotto had painted the scene in his set of frescoes in Padua (Fig. 102). Here the Virgin is neither drawing water nor spinning, but is kneeling before the Angel with a book in her right hand, while Gabriel, symmetrically placed to the observer's left, also kneels and carries a scroll. Light emanates from Gabriel and pours down on Mary from above. No dove is shown, no attendants, and it is interesting to observe that the curtains to the house or room have been drawn back in a loop as if Giotto had deliberately chosen to emphasize the lack of illustrative realism.

By the end of the fifteenth century, however, more detail began to appear. Piero della Francesca (Fig. 103) gives us a regal Virgin with the book in her left hand, a finger inserted as if to mark the place, standing in a colonnaded porch with the Angel outside, one knee bent, and God the Father directly above him in the skies, His hands in a pose of one releasing something, in this case no doubt the dove. Van Eyck (Fig. 104) also shows us the Virgin out of doors, but now she is at the door of a church which she is apparently leaving, a vase of lilies at her right, Gabriel with rainbow wings about to kneel before her and carrying a sceptre in his hand. Piero showed the scene in front of an Italian Renaissance building; Van Eyck uses a Gothic church. God the Father does not appear in the Flemish version but in His stead we see the descending dove with rays of light shining from him. More details of setting are given, a broken wall in the background, a worn-down stone at the entrance to the church, a garden overgrown to the left. On the doorstep are carved the words, "*Regina Celi et. . . .*" Is one reading too much into this if one sees the church as the Temple and in the crumbling wall and the overgrown garden a symbol of the old faith which is to be superseded by the new? Grünewald (Fig. 105) also puts the scene in a church or perhaps in a Gothic house and opens a curtain upon it. Mary here had been at her prayers; the book lies open before her and we can read the words of Isaiah VII, 14, in the Latin of the Vulgate, "Behold a virgin shall conceive." Gabriel is descending sceptre in hand from above and the dove is hovering over the Virgin's head.

One of the most intricate presentations of this episode was painted by Crivelli (Fig. 106), whose love of detail is famous. The Virgin here is in a palace; a hole in the cornice has been provided as an entrance for the dove; and lest his path from Heaven be overlooked, a fine oblique ray of light comes down behind him. Mary is once more at prayer. A peacock with drooping tail is perched on the balcony above her; white doves flutter and play about the dovecote; a little girl is peering round a wall to see what is going on; Gabriel accompanied by Bishop Emidius of Ascoli is kneeling outside the barred windows of Mary's palace; and numerous other people stand about presumably to fill the empty spaces. On the ground lie a gourd and an apple. A rug hangs over the balcony both above Mary and in the background. There are dozens of other details which are obvious. Crivelli, as was his custom,

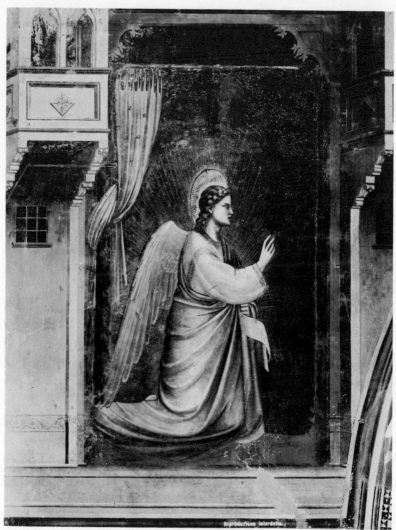

Fig. 102a. Giotto: *Annunciation*. Left panel, Angel Gabriel. Arena Chapel, Padua.

spared no pains to make the scene as lifelike as possible and to show off his skill as a draftsman.

The elaboration of detail became more and more important in the sixteenth century. An altarpiece of the Danube School (Fig. 107) winds a scroll with the opening words of the *Ave Maria* about Gabriel's sceptre, clothes the angel in flowing garments with puffed sleeves, shows us Mary with the dove above her head before a *prie-Dieu*, and in general forgets everything but the decorative effects. Joos van Cleve (Fig. 108) with typical Flemish realism

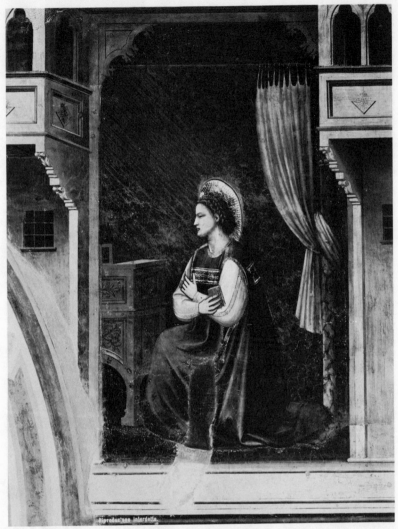

Fig. 102b. Giotto: *Annunciation*. Right panel, Virgin Mary. Arena Chapel, Padua.

combined with symbolism restores the scene to a domestic interior, giving us the Virgin's bed, the vase of lilies, a covered altar in the background, candles, furniture, even a picture of Moses—the Old Law—pinned to the wall above the radiant dove, and a half-opened diptych showing part of the Sacrifice of Isaac above the altar, the prefiguration of the Crucifixion. Time has telescoped in this picture and we have come a long way from the heraldic simplicity of the Byzantine miniatures.

But we may take another step in another direction when we look at Tinto-

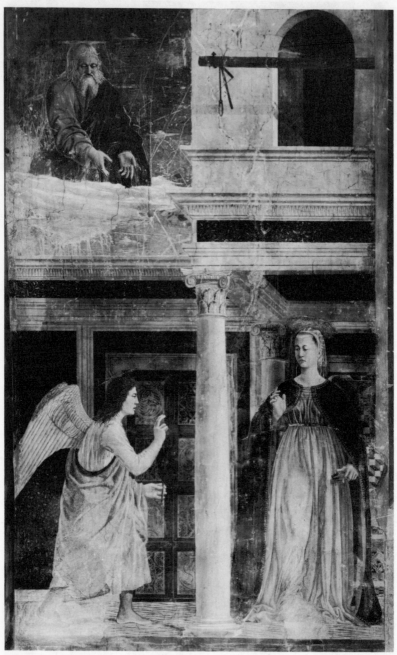

Fig. 103. Piero della Francesca: *Annunciation*. Church of Saint Francis, Arezzo.

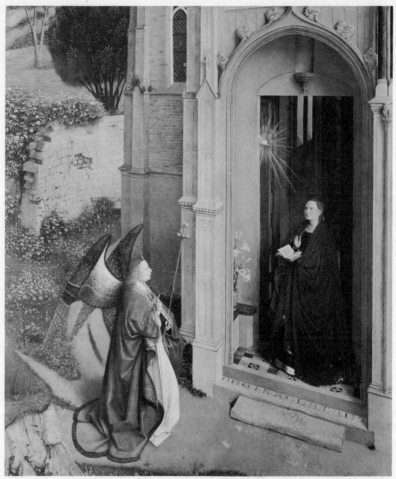

Fig. 104. Jan van Eyck: *Annunciation*. Metropolitan Museum of Art, New York.

retto's version (Fig. 109), in which Mary is back again in a carpenter's house with a chair at one side in a state of dilapidation. The stucco has fallen off the outer walls in patches and the Virgin is no longer a youthful princess. She is clearly alarmed as Gabriel comes flying at her accompanied by a retinue of *putti*. All is action here. Even the dove is darting at her, not hovering above her. Tintoretto, like his contemporary Caravaggio, seems to have attempted to think out for himself exactly how the event looked on the earthly stage and to present it in an historical manner. It took a certain imagination to divest the incident of all the trappings which it had accumulated through the centuries, but in doing so Tintoretto may also have divested it of some of its supernatural significance.

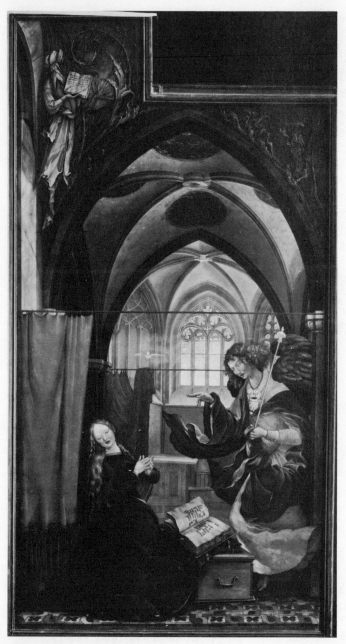

Fig. 105. Matthias Grünewald: *Annunciation*. Eisenheim Altarpiece, Colmar.

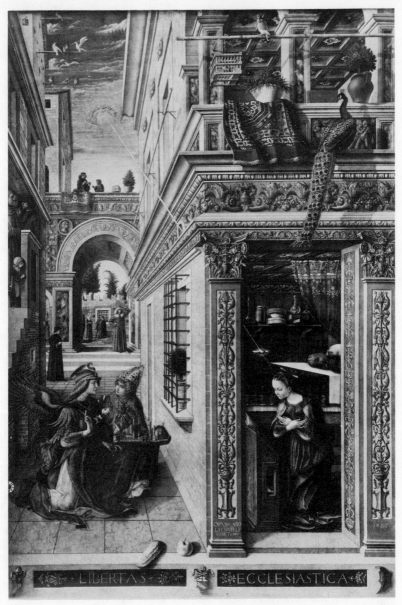

Fig. 106. Carlo Crivelli: *Annunciation*. National Gallery, London.

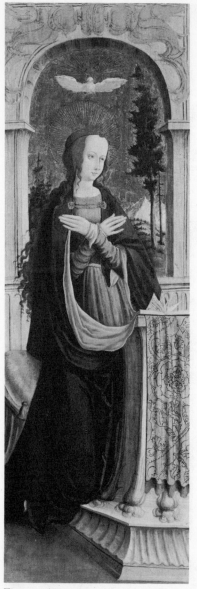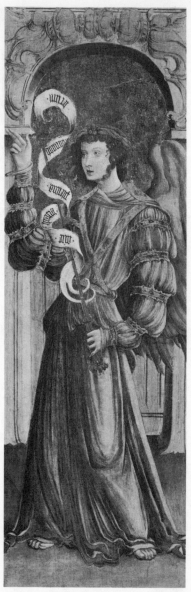

Fig. 107. *Annunciation*. Austrian School. Samuel H. Kress Collection, National Gallery of Art, Washington.

One has a continuation of Tintoretto's manner in El Greco's *Annunciation* (Fig. 110) in which there is the same swoop of the Angel Gabriel, but accompanied by a quiet ascent of the Virgin. Mary was apparently sewing

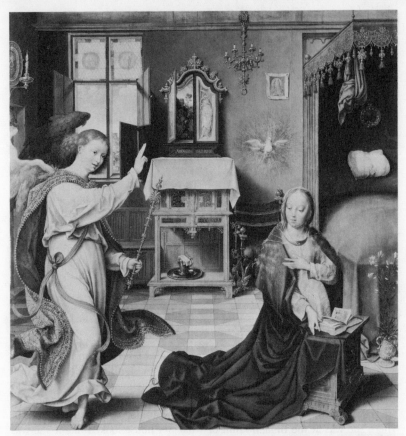

Fig. 108. Joos van Cleve: *Annunciation*. Michael Friedsham Collection, Metropolitan Museum of Art, New York.

when the word was brought to her for one sees a basket of sewing with scissors lying upon it at the bottom of the picture. She holds in her hand a partly open book. At the lower right one sees a vase of flowers so flamelike in their arrangement as to resemble the Burning Bush. As in the Tintoretto the Angel is descending from Heaven, but is not kneeling before Mary who in her turn is ascending towards the celestial light which pours down from above. The whole scene is one of momentarily arrested action.

Perhaps the most extreme interpretation of the story is Rossetti's *Ecce Ancilla Domini* (Behold the Handmaid of the Lord) (Fig. 111) in which the Virgin cowers on her bed while a somewhat effeminate Gabriel stands before her with a lily in his hand. This version is perhaps closer to the text of Saint Luke than most of the others which we have reproduced, but it is questionable whether the cowering Virgin of Rossetti or the majestic Virgin of Piero is truer to the spirit of the incident.

Fig. 109. Tintoretto: *Annunciation*. Scuolo di San Rocco, Venice.

Here then we have a series of paintings, all of which illustrate the same
story and all of which differ from one another in significant details. These
details did not come from the literary source of the incident. Insofar as that
source is Saint Luke, it would give the artist no hint of precisely what the
Virgin was doing, whether drawing water or spinning or praying, no hint of
where she was at the time, no hint of what her house looked like if she was
in her house. There is no mention of this in either the apocryphal Gospels or
in the Golden Legend of the book which Mary is sometimes shown holding
or reading.[4] As for the interior of the house, the church in which or before

4 The earliest literary source we have found which would authorize the book is Saint
Bernard's *De laudibus Virginis Matris*, in Migne's *Patrologia Latina*, vol. 183, col. 71.
Saint Bernard is discussing the phrase, "And the angel came in unto her," and he adds,
"Whither did he come? I think it was in the recesses of her modest chamber where with
the door closed behind her she was praying to her Father in solitude." If she was praying,
it would be normal to give her both a prayer-book and a *prie-Dieu*. That the book is
open to *Isaiah* VII, 14, is of course simply the use of Old Testament prefiguration—
or perhaps it would be better to say prophecy in this case. No one would have imagined
the Virgin to have been reading Saint Jerome's Latin translation of the Bible. For a brief
summary of the transformations in the early iconography of the Annunciation, see Emile
Mâle, *L'Art religieux au XIIe siècle* (Paris, 1924), p. 118 and the same author's *L'Art reli-
gieux du XIIIe siècle* (Paris, 1919), pp. 288-89. The early Gabriels carried, says Mâle, the
ancient herald's staff. The lilies appeared later when it was decided that the Annunciation
took place in the spring, "in the time of flowers." In Saint Bernard's third *Sermon on the
Annunciation*, ch. 7, *ibid*, col. 396, we are told that the name Nazareth means "flower"

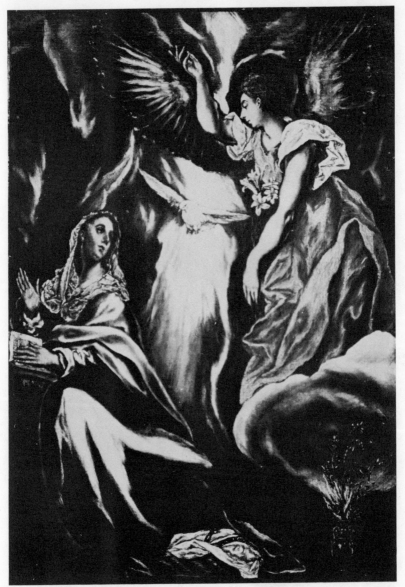

Fig. 110. El Greco: *Annunciation*. Sao Paolo Museum, Sao Paolo, Brazil.

and flowers are a symbol of "beauty, fragrance, and the hope of fruit." But in his *Sermon on the Nativity of the Blessed Virgin Mary, ibid.,* col. 447, he uses the symbolism of the *Song of Songs,* and after citing Ch. II, 16 of that poem—"My beloved is mine and I am his; he feedeth among the lilies," he adds that lilies are the adornment of virginity, the sign of humility, the outstanding mark of charity.

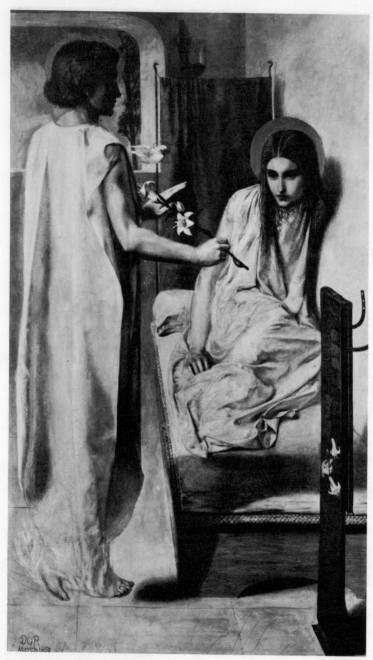

Fig. 111. Dante Gabriel Rossetti: *Ecce Ancilla Domini*. Tate Gallery, London.

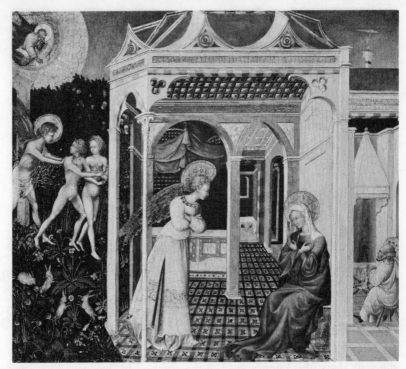

Fig. 112. Giovanni di Paolo: *Annunciation*. Samuel H. Kress Collection, National Gallery of Art, Washington.

which the Annunciation is made, the furnishings and the costumes, all this is left to the artist's imagination. And one could arrange the paintings which we reproduce and which are selected out of hundreds of others, from the stark almost hieroglyphic quality of the early miniatures to the heavily loaded complications of the Crivelli.

When we say that something is left to the artist's imagination, this is but a partial explanation. For the imagination never operates at random even when we are daydreaming. For instance, in Giovanni di Paolo's *Annunciation* (Fig. 112) we see two naked figures fleeing in the background, a detail which can also be seen in a Fra Angelico in the Prado, with the simple amendment of clothing on the figures (Fig. 113). These two people are Adam and Eve being expelled from Eden. It is only in a figurative sense that Adam and Eve may be said to have fled when Gabriel announced to Mary that she would bear the Redeemer. But the idea that sin would leave the world when redemption entered was clear enough and a painter had merely to ask himself, "What was the meaning of the event for the history of the human race?" to add such a detail. We do not deny that the idea may well have been suggested to Giovanni, as was customary, by whoever commissioned the paint-

131

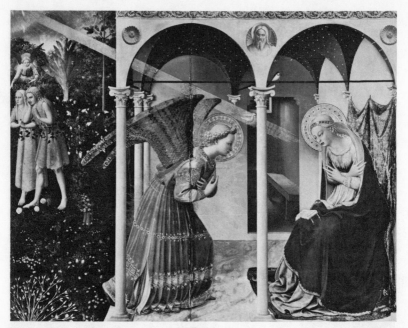

Fig. 113. Fra Angelico: *Annunciation*. Prado, Madrid.

ing, but the principle remains the same. Similarly the picture of Moses on the wall above the Virgin's head in the painting by Joos van Cleve was surely not put there merely in order to fill the space, for any shape of the same size would have done as well. On the contrary, Moses stands for the Old Law and the Annunciation is the beginning of the New. When Tintoretto gives us a Judean peasant woman in her cottage as the Virgin, can it not be concluded that he was emphasizing the fact that the Incarnation was a real incarnation, that if God was to be made man, it must be an ordinary earthly man? If our belief is right, then in such pictures historical incident takes on an unhistorical, indeed an anti-historical, meaning.

But every event which is recorded has at least a double meaning to some minds. In American history alone the Revolution soon became a symbol as well as a dated historical event. It became a symbol of man's right to self-government and the justice of a cause. Even the British have adopted this point of view and a statue of George Washington stands in front of the National Gallery in London looking out on Trafalgar Square and Nelson. The Civil War, to take another example, is a symbol of the liberation of the slaves to Northerners and to Southerners a battle—lost—for states' rights. No major historical event has but one single cause. Economic causes mingle with ideological causes and sometimes mere national pride contributes to catastrophic upheavals. The simple-minded man who wants one cause alone will interpret an historical event in a simple-minded way.

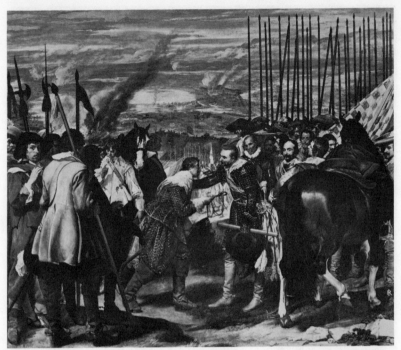

Fig. 114. Diego Rodriguez de Silva y Velazquez: *Surrender at Breda*. Prado, Madrid.

If he is also a painter, he will represent a battle with the commanding general in the middle occupying the most prominent place. Battles, however, are fought by soldiers as well as by generals, though both victory and defeat are attributed to the commanding officer. The general ceases to be a single person and becomes the symbol of the forces which are under his command. He receives the surrender of the vanquished and, if conquered, he bows the knee before his enemy commander. The most famous example of this is no doubt Velazquez's painting of the surrender at Breda (Fig. 114). But this technique is not confined to battle pictures. A country is symbolized by its government, be it a monarchy or a republic. This is true whether the monarchy, like that of the United Kingdom, is so attenuated that the monarch has almost no power whatsoever, or whether it is an absolute monarchy in which the monarch has all the power. Thus people can turn into symbols and into symbols of a very forceful kind.

But sometimes symbols turn into people. When Delacroix, for instance, wanted to paint the defeat of the Greeks in their struggle for independence from the Turks, he produced *Greece Expiring on the Ruins of Missolonghi* (Fig. 115) and Greece became a woman in contemporary Greek costume. Similarly in his celebration of the revolution of 1830, he introduced a woman's figure to symbolize France fighting alone with the men in the cos-

Fig. 115. Eugène Delacroix: *Greece Expiring on the Ruins of Missolonghi.* Bordeaux Museum.

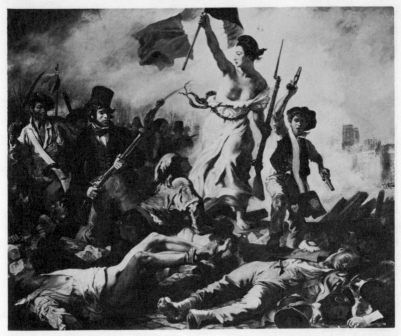

Fig. 116. Eugène Delacroix: *Liberty Leading the People*. Louvre, Paris.

tume of the day (Fig. 116). In what sense were these two countries or people women? What interpretation would onlookers give of these two pictures if their titles were lost? The French might guess that the figure of Marianne represented their country since she wears a tricolored cockade in her headdress, a Phrygian cap. But only a person knowing something of early nineteenth-century Greek costume would be able to associate the figure of Greece with the country she stands for. The fact is that the painter feels that he can count on his public's sharing a certain fund of information with him which will permit them to read his pictures correctly.

But what would one do with Brueghel's *Slaughter of the Innocents* (Fig. 117)? This event is represented as taking place in the Netherlands, the houses being those of a Dutch village, the women fleeing with their babies being Dutch women, snow lying on the ground—which seems unlikely to have been the case in Bethlehem—and the soldiers who are engaged in the slaughter being in Spanish uniform. Is all this because Breughel had no historical sense or because he hated the Spanish occupation of his country? Just what was he "saying"? Was he vivifying the scene which preceded the flight into Egypt? Was he saying that just as Herod had had the infants of Judea slaughtered, so Alba was murdering the Dutch? Was this a bitter protest against the Spaniards or a really religious picture or both at the same time?

When Veronese first painted the picture now called *Supper at the House*

Fig. 117. Pieter Brueghel the Elder: *Slaughter of the Innocents*. Kunsthistorisches Museum, Vienna.

of Levi (Fig. 118), he called it *Supper at the House of Simon.*[5] It makes little difference, as far as its appearance goes, which event it depicts; everything almost without exception—the exception being a halo—could have been found in Venice during the painter's lifetime. Many of the details seemed irreverent to the Inquisitors, details such as men dressed as Germans (heretics), a man whose nose is bleeding, a buffoon with a parrot on his wrist, Saint Peter carving the lamb, a man picking his teeth, and so on. Veronese's answer to the questioning was simple: "We painters take the same license the poets and jesters take. . . . If in a picture there is some space to spare, I enrich it with figures according to the stories. . . . I paint pictures as I see fit and as well as my talent permits." He seems mainly to have been interested in producing a magnificent work of art and gave little thought to the irreligious overtones which his picture might strike. But the Inquisition was thinking of Protestant attacks on the Church and was far from zealous in encouraging artists to exhibit their virtuosity.

At the last session of the Council of Trent (1563) it was decreed (1) that images should not be painted and adorned with seductive charm; (2) that no unusual image should be exhibited unless it had been approved by the bishop of the diocese; and (3) that no new miracles could be accepted and

5 This is the painting which was the cause of Veronese's trial before the Inquisition. Some of the testimony can be conveniently found in Elizabeth Gilmore Holt, *Literary Sources of Art History* (Princeton, 1947), pp. 246 ff.

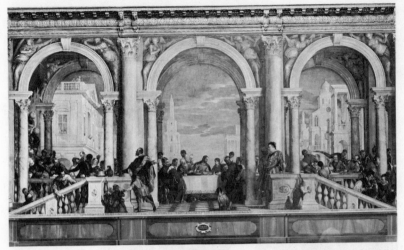

Fig. 118. Paolo Veronese: *Supper at the House of Levi*. Accademia, Venice.

no relics recognized unless they had been investigated and approved by the same bishop.[6] The result of this was that artists were to be confined to including only such details as had Scriptural or traditional precedents. But there is no Scriptural evidence for the costumes or table settings for even the Last Supper. Scripture is more a record of acts than of *mise-en-scène*.

If then a painter dressed up his people in handsome clothes, that may well have been because he saw them vividly and thought by giving them fine raiment he would honor them. So when Van Eyck paints the Virgin as a queen (Fig. 119), he is probably thinking of her as Queen of Heaven (*Regina Coeli*), a title which was confirmed by Pope Pius XII. Yet whatever else she was on earth, she was certainly not the Queen of Judea. There is nothing in the New Testament to warrant such regal adornment. Nevertheless, when painters moved towards greater realism, they fell into equal disfavor. When Caravaggio painted the *Death of the Virgin* (Fig. 120) and represented her more as a peasant than as royalty, his painting created a scandal. "His new dish," said Vicencio Caducho in his *Dialogues on Painting*, "is cooked with such condiments, with so much flavor, appetite, and relish that he has surpassed everybody with such choice tid-bits and a license so great that I am afraid the others will suffer apoplexy in their true principles, because most painters follow him as if they were famished. They do not reflect on the fire of his talent which is so forceful, nor whether they are able to digest such an impetuous, unheard of and incompatible technique, nor whether they possess Caravaggio's nimbleness of painting without preparation. Did anyone ever paint, and with as much success, as this monster of genius and talent, almost

6 See Holt, *Literary Sources of Art History*, pp. 243-44. Veronese's trial took place ten years later than the publication of this decree. See also Anthony Blunt on "The Council of Trent and Religious Art," in his *Artistic Theory in Italy, 1450-1600* (Oxford, 1940).

Fig. 119. Jan van Eyck: *The Virgin*. Detail from the Ghent Altarpiece. Cathedral of Saint Bavon, Ghent.

Fig. 120. Michelangelo Caravaggio: *Death of the Virgin*. Louvre, Paris.

without rules, without theory, without learning and meditation, solely by the power of his genius and the model in front of him which he copied so admirably." And then follows the great condemnation of this master. "I heard a zealot of our profession say that the appearance of this man meant a foreboding of ruin and an end of painting, and how at the close of this visible world the Antichrist, pretending to be the real Christ, with false and strange miracles and monstrous deeds would carry with him to damnation a very large number of people moved by his works which seemed so admirable (although they were in themselves deceptive, false, and without truth or permanence)." Caravaggio thus became the Antichrist of painting who caused artists to turn their backs upon true art.[7]

It should be obvious that one cannot interpret a set of symbols without a key and usually the key is acquired by study and learning. Any child can recognize a portrait of Washington or Franklin or Lincoln, for traditional ways of representing them have been developed. But the same is true of pretty nearly everything else. From the early Renaissance to our own times it has been taken for granted that painters would obey "the laws of perspective," though for a thousand years before a different set of laws had been followed. Perspective was simply one way of depicting things, not the only right way. Yet custom has made it seem right. Similarly we expect to see kings represented in royal robes, scholars in academic gowns, scientists with microscopes or other laboratory apparatus, businessmen in business suits, westerners in ten gallon hats. The United States is Uncle Sam, England John Bull, and France Marianne. American cities must be shown with skyscrapers, even though Central Park is as much Manhattan as Radio City is and there are still thousands of Americans who live in small towns without a single skyscraper in them. If a painter paints the portrait of a surgeon, it is safe to guess that he will paint him in white clothes with surgical instruments lying about more or less discreetly in the background. But no man works at his profession twenty-four hours a day. We all spend some time reading, playing, drinking with our friends, or just sitting. But it has been a long tradition to identify a man with his profession and the chances are that both he and his friends will want to see him painted as a symbol of that profession. When Sargent painted his famous *Four Doctors* of the Johns Hopkins School of Medicine, he put them in academic robes; though they represented four different branches of the medical profession, they were all great professors

7 Our quotation is from Holt, *Literary Sources of Art History*, pp. 437-38. We have not checked it with the original which is not accessible to us, and acknowledge its obscurity. For details of the history of *Death of the Virgin*, see Roger Hinks, *Michelangelo Merisi da Caravaggio* (New York, 1953), pp. 114-15, where the author himself says of it, "Caravaggio seems to delight in choosing the shabbiest and grubbiest denizens of that squalid region [Trastevere] to represent St. Joseph and his friends and relations, and to lay the scene in some sordid tenement. No wonder the clergy rejected the picture as indecorous, and pious persons were outraged at its cynicism." Cf. *ibid.*, p. 26. One would do well to ask oneself, if not Mr. Hinks, for the evidence of the painter's delight in showing shabby and grubby denizens of that squalid region.

and scholars. When we ask what a man is and are answered, a butcher, a baker, a candlestick maker, it is assumed that a man is what he does as his main occupation in life. To so classify people is accepted as right; it is our way of giving individuals a meaning which, it seems to be understood, will explain them.

Perhaps the most familiar examples of simple clues to identifying people are found in the pictures of the saints. Here a code has been developed which prescribes what attributes a saint should have. A nude male body with arrows sticking into it is Saint Sebastian; a lion at the feet of a man in the wilderness means Saint Jerome; a dog is sure to indicate Saint Roch; a woman beside a toothed wheel is Saint Catherine of Alexandria; keys mean Saint Peter and a sword Saint Paul. Such a code of symbols is almost like the names which cartoonists sometimes write at the feet of their figures, a practice which goes back at least to the Greek vase-painters. Sometimes the very colors which the individuals wear are prescribed: blue for the Virgin, red for Mary Magdalen. With such a code in one's mind, one can recognize the various saints at a glance and that is presumably what the artist wants. It makes interpretation easier.

But the practice of using standardized ways of representing things extends far beyond the limits of religious painting. For years artists painted scenes from ground level with the horizon near the middle of the canvas. But in the Baroque period the point of view shifted and today we have pictures painted in which the scene is observed from above or, as in some illusionistic ceiling paintings (Figs. 121 a-b), from below. Many of Degas's theatrical scenes are painted as if the painter were up in one of the balconies (Fig. 122); some critics have sneeringly said that he peeked through transoms. And when we come to abstract and non-objective painting, we frequently are not in three dimensional space at all.

Sometimes a color scheme, regardless of actual color, is prescribed to give a unity of tone to a painting even when the painting is representational. The fixed palette of the late Denman Ross is a case in point.[8] Ross maintained that it developed from the practice of the Italian painters of the Renaissance. But real things, except when so planned, do not have unity of tone. They may well present a hideous jumble of colors. The demand for unity is an aesthetic demand; its satisfaction is one of the contributions of the artist, not of nature. Sometimes it has been said that colors have emotional value, as Van Gogh insisted. If that is so, the artist will modify local color to suit the emotional effect which he would like to stimulate. No one really knows whether or not colors have an intrinsic emotional overtone or whether we feel certain emotions because of long associations. In the Occident mourning has become associated with black and darkness of tone would perhaps seem more depressing to most Occidentals than lightness of tone. In Korea, we are told, mourning dress is white and on the Gold Coast it is red. Some people also associate

8 Denman Ross, *On Drawing and Painting* (Boston and New York, 1912).

Fig. 121a. Gaulli: *The Triumph of the Name of Jesus*. Ceiling of the Church of Gesu, Rome.

sadness with the minor keys in music and happiness with the major; but much folk music, whether gloomy or gay, is likely to be in a minor key. It has even been said that blue is a depressing color and to prove it one of Picasso's paintings of the Blue Period (Fig. 123) has been used. But such pictures are not only colored; they have line, movement, and subject matter. If blue were depressing, the blue sky on a summer day ought to be the gloomiest sight in the world.

Though we have emphasized the influence of tradition on the artist's inter-

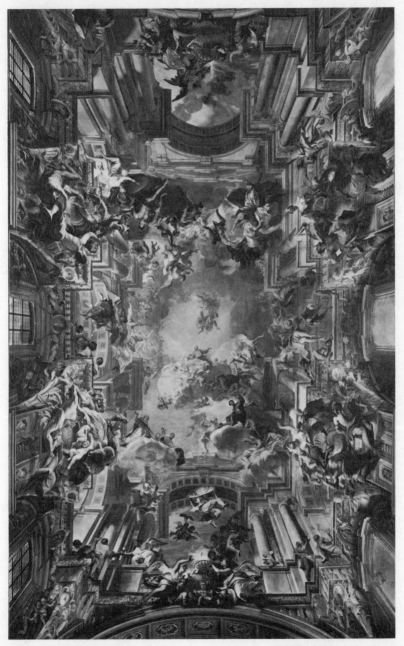

Fig. 121b. Andrea Pozzo: *Entrance of Saint Ignatius into Paradise*. Church of Saint Ignatius, Rome.

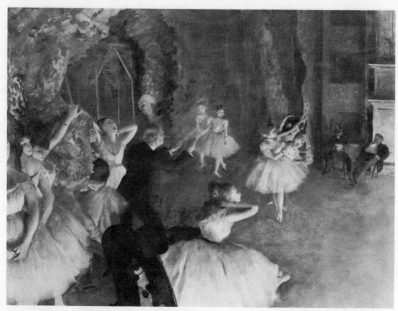

Fig. 122. Edgar Degas: *Rehearsal of the Ballet on the Stage*. The H. O. Havemeyer Collection, Metropolitan Museum of Art, New York.

pretative methods, we must not be understood as suggesting that it is all-powerful. There have been periods in the history of all the arts when tradition was very compelling and others when it was neglected. Innovation is just as frequent in the history of art as elsewhere. Artists are neither all submissive nor all recalcitrant; they vary as other people do. Certain subjects, such as that of religious and political history, lend themselves to more traditionalistic treatment than others, but even landscape painting followed a general pattern for generations. On the other hand, painters such as Giotto, Leonardo, Caravaggio, El Greco, Rubens, Delacroix, Matisse, and Picasso emerged out of a tradition and reoriented the course of painting. These are great names, but it might be disputed whether such men are really any greater than scores of others who stuck to tradition. Nowadays we put a high value on originality, but there have been times and places, in Egypt, Greece, and China, for instance, when conformity was more highly esteemed. Our business here is not to award medals but to indicate what has actually happened. And the fact of the matter is that no one has ever been 100 per cent original since all painters are human beings living with other human beings and subject to the same influences. So each man's eye will see the world in its own way and since perception is always influenced by what one is looking for, all representational painting will include an element of interpretation along with design.

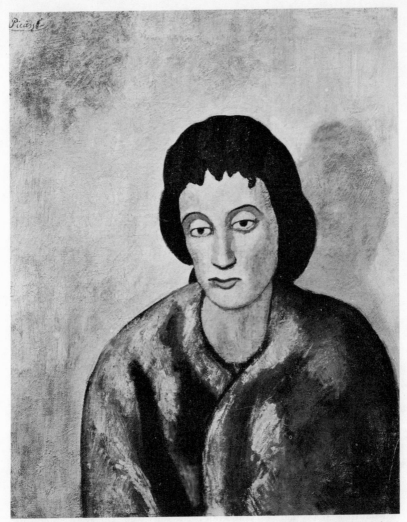

Fig. 123. Pablo Picasso: *Woman with Bangs*. Cone Collection, Baltimore Museum of Art.

Chapter V Painting as Allegory

As the artist's contribution to his picture grows, literal representation is left behind and a new element enters. He no longer finds his satisfaction in interpreting his subject matter as evidence of character, as good and bad, but wants to express a more recondite symbolism. We have seen something of this in the development of the Annunciation in art from the bare illustration of the Biblical text to the elaborate intricacies of Crivelli and Joos van Cleve. To say in so many words that the Redemption was necessitated by the Fall and that the Crucifixion was prefigured in the Sacrifice of Isaac would not have been to paint a picture; it would have been to write a treatise. The accumulation of symbols in the Crivelli was the presentation in visual, not verbal, form of a compact metaphor. Such paintings are close to being allegories. They make no sense if one means by "sense" literal or historical truth. We know that if the Virgin read Isaiah, she did not read him in the Vulgate. We also know that she could not have been in or near a Gothic church, worn mediaeval or Renaissance clothes, nor a crown. If one is going to insist on that kind of truth, then such pictures become either naive or foolish. But the artists who painted them were neither naive nor foolish. Our interpretation of their works must rest on other foundations. They are introducing allegorical elements into their interpretations.

Some of the Greek philosophers whose respect for Homer and Hesiod was as great as that of the Christian philosophers for the Bible realized that much of what these poets had said could not be literally true. The stories about the gods were often scandalous and, as Plato pointed out, gods who did some of the things related of them were not fit to be worshipped. How could a serious man believe in the persistent jealousy of Hera, the adulteries of Zeus, or the thievery of Hermes? If such beings were gods, then they behaved like wicked human beings. Was it not equally absurd to believe that the waves were literally ruled by Poseidon or that the thunder was literally caused by thunderbolts hurled by Zeus? The divine beings were represented in the great epics as plotting against one another, having favorites on this earth, and doing all the things which human legislators condemned. One could always flatly reject these stories, label them superstition, and outlaw people

who told them. But it seemed better to preserve the poetic heritage of the race and interpret the myths as allegories.

Similarly in the last pre-Christian century Philo, a Jewish philosopher of Alexandria, maintained that the five books of Moses were also allegories, since it could not be believed that God had a body and could walk and speak. His three books on allegorical interpretation became classic and established a pattern for biblical exegesis. His method was taken over by the early Christian fathers and, since Christ had talked in parables, they had good precedent for maintaining that the whole Bible was a parable. Among these early allegorizers was Clement of Alexandria (late second century) and he added to the practice the theory that every passage in Scripture had both literal and allegorical meaning. It was this theory which in the later Middle Ages gave men the idea of "layers of meaning," an idea which is still in vogue in the interpretation of poetry.

Now almost any sentence which can be written has a figurative element in it. If we consider a simple statement like, "It is raining," we know perfectly well that there is no "it" to do the raining. For all we know, the "it" may refer back to some cause once supposed to produce the rain, a god or demi-god or spirit of some kind. For just as the Romans had their Jupiter Pluvius who made it rain, so they had their Aeolus who made the wind blow and indeed each wind had its name and presumably a lesser god to rule over it. Whatever the facts may be, no one other than a philologist would bother to ask what "it" is. The rest of us take the sentence as it stands, as the assertion of what we call literal truth. But one has only to open a dictionary at random to see how figurative most of our words are. The word "figurative" is itself a figure of speech. A figure is a shape—something which has been fashioned or molded —and it is through shapes that we usually recognize things. When we see a face and say, "There's John," we know that John is not his face but that his face "stands for" John. But to "stand for" is also a figure of speech and the phrase "a figure of speech" is a figure of speech too. Before one knows it, one has greater trouble in explaining what one means by a literal statement than one has in explaining what a figurative statement is.

As time passes new turns of phrase have to be invented to cover new situations. Sometimes a word is made up, like *kodak*, which as far as anyone knows is composed of two nonsense syllables. Sometimes a Greek derivative, like *telephone*, is invented or a Latin and Greek mixture, like *automobile*, or a purely Latin derivative, like *radium*. A telephone is a "far speaker," an automobile a "self-mover," radium a metal which "shoots out rays," and so it goes. When such words get into common use, they lose their figurative meaning and become literal. No one using the word "camera" today thinks of the original *camera obscura*, the dark chamber. And only verbal chauvinists would prefer a purely Anglo-Saxon word for "telephone." We may say "loud-speaker," but not "far speaker." A child will speak about a bow-wow instead of a dog, substituting the noise which the animal makes for the animal itself, or he will talk about the choo-choo instead of the train. But even adults will

substitute, if not the characteristic noises, some other traits of what they are talking about instead of naming the thing or person to which they are referring. They will speak of Providence instead of God, The Flag instead of the United States, The Crown instead of the Queen. They will say that blood is thicker than water, that a rolling stone gathers no moss, and that it never rains but it pours, when they are talking neither of biochemistry nor mineralogy nor meteorology. Our daily talk overflows with metaphors—which is itself a bad one—and we are seldom aware when we are using similes and metaphors and when we are talking literally.

It would seem as if almost anything could become metaphorical. When we call the founders of an institution its fathers, we are moving well beyond literal fact. We know what a father is, even if we do not know the origin of the word. We know that George Washington was not the literal father of his country, nor Chaucer the father of English poetry, nor Lincoln Father Abraham. Such phrases, however, seem to add a new flavor to the literal statements, a flavor which resides in the emotional aura surrounding real fatherhood. The Father-image is very old and is used even by very primitive people, just as the Mother-image is. God, or the chief god, is often referred to as a father, just as Nature has become Mother Nature. Saint Francis could speak of his brother the Sun and his sister the Moon; indeed he felt so deep a kinship with the natural order that he often spoke like a Pagan. For the Pagans invested almost everything with personality, rivers, springs, trees, winds, as well as the heavenly bodies, and so vivid was their imagination that they could even make pictures and statues of these beings.

By the time a river, for example, becomes so thoroughly identified with a god that it can be represented in statuary, it obviously ceases to be simply so much water running down hill and can become the source of fertility, the kindly protector of mankind, a raging tide in time of flood, and in one of the epigrams in the Greek Anthology, it becomes a test for the legitimacy of infants.[1] We find the River Nile in sculptured form, a bearded god reclining on an elbow, holding a horn of gushing water, surrounded by a number of little children. The god looks like the statues of Zeus the Father, the children probably stand for the fertility which the great river brings to the land—or are they perhaps the little streams which empty into the river?—and the gushing water is the one literal reference of the whole complex. But there are also statues of hamadryads, nereids, and wood nymphs, as well as of the various gods who were supposed to rule the planets, the Moon—for the moon like the sun was supposed to be a planet—Mars, Mercury, Venus, Jupiter, and Saturn. It became common practice in Latin poetry to refer to the presiding gods instead of the realm over which they presided, to Ceres instead of cereals, to Bacchus instead of wine, to Boreas and Zephyr instead of the north and west winds, to Mars instead of war. By the time of Varro (first century B.C.) there were several thousand of such divinities and Saint Augustine a few centuries later holds them all up to ridicule. But the habit of talking as if

1 Book IX, no. 125.

they existed lingered on into our own times, specially in poetry, and indeed many of the earlier Christian saints were represented in the fashion of the gods. Thus Saint Christopher is seen to be the Hercules-type, Saint Sebastian the beautiful young Apollo, and Saint George on his horse, Bellerephon on Pegasus. We are not saying, it should be observed, that the saints were merely the gods under new names nor that the services which the gods rendered to man were assigned to those saints, but simply that the artists had to have some models for the sculptures and paintings and clearly went to Pagan art to find them. The history of this transformation, however, is now pretty well forgotten except by professional iconologists, but one suspects that certain habits of thinking became so ingrained in the popular mind that the substitutions were easily made. The outer symbol will often live on when its original meaning is lost and a new one is acquired. The fact that one of the earliest symbols, the swastika, has been used universally in both hemispheres does not mean that the ancient Indians were Nazis nor does the antiquity of the Cross mean that the Egyptians, for instance, anticipated Christianity. The fact that the celebration of Christmas contains many elements of the Roman Saturnalia and comes at the same time and that the Nordic Easter resembles the Feast of the Resurrection and also comes at the same time, is no evidence that these two feasts are nothing more than survivals of heathen practices. After all, we still speak of people as being sanguine, melancholy, choleric, and phlegmatic without committing ourselves to the truth of the doctrine of the four humors. And we also speak of people as lunatic, jovial, mercurial, martial, and saturnine while giving no credence to astrology.

If the question now be asked what value is found in figures of speech and allegory, the answer is none too easy. A simile may clarify an idea which is obscure and is the usual means of doing so. Thus we say that something moves clockwise and we hit upon a comparison which is much more vivid than a geometrical account of what "clockwise" is. Many of our names for colors are derived from such similes: orange, violet, snow white, pitch black. When Homer, to take a literary example, speaks of the goddesses walking with the dignity of pigeons, he was presumably describing accurately how they walked, more accurately than if he had simply said "with dignity." The dignity of pigeons may seem a bit laughable to us, but it can hardly be surmised that it was so to Homer. Let us therefore omit the emotional power which such a simile may have and credit it simply with vividness.

But vividness is exactly what a good representational painting has too. Whether it be a bit of scientific illustration or a *trompe-l'oeil* still life, it heightens the sharpness of the visual impression and fixes it in our memory. When there is added to this sharpened impression an emotional force, it will tell us more than the simple image tells us. It will be a comment on something or an interpretation of it. The comment may be satirical or idealizing, making the subject more ridiculous than it normally seems or more admirable. Daumier, who was probably one of the great cultural forces of the nineteenth century, in his drawings of bathers, classical tragedies, art connoisseurs, and

lawyers, seems to get his effects by literal statement. But it is to be noticed that he is ridiculing *The Lawyer* (Fig. 71 a), not some particular lawyer, *The Cult of the Nude,* not this or that nude body. His figures become types which are no different in essence from Bunyan's Christian or Greatheart or any of his other characters who bear the names of virtues or vices. The process of creating such characters is of course simplification. Not all lawyers are so self-satisfied as the lawyer descending the stairs in Daumier's *Escalier du Palais de Justice* (Fig. 71) nor are all nude bodies so gnarled and twisted as those in his *Fourpenny Baths.* But Daumier was gunning for the corrupt lawyer and the sentimental Hellenist, and if the target was to be hit, he had to paint it in clear colors. Thus his pictures became allegories, whatever was in his mind, just as the abstractions in Milton's *L'Allegro* and *Il Penseroso* are allegories. When Milton writes,

> Hence loathed Melancholy
> Of Cerberus, and blackest midnight born ...
> _____
> Hail divinest Melancholy,
> Whose Saintly image is too bright
> To hit the Sense of human sight ...

he obviously is thinking of a state of mind as if it were a person. When Daumier caricatures a person, the person becomes a state of mind.

Many of the better known allegories developed out of ancient myths. The story of Cupid and Psyche, Love and the Soul, as told by Apuleius, may be read as simply a good narrative and it has been so read by hundreds. But there is no denying its allegorical character. The story of the Rape of Proserpine by Pluto again has been interpreted as an allegory of the change of seasons, the six months under the earth being winter, the six above summer, the daughter of the Goddess of the Grain being in the land of the dead in the winter and rising into the land of the living in the summer. Even the Homeric stories turned into allegories, the wanderings of Odysseus becoming the search of the soul for its home or, in Christian terms, for salvation. The earlier myths of Plato are equally allegorical and Plato interprets them for us.

"Of the nature of the soul," he says in one of his most famous myths,[2] "though her true form be ever a theme of large and more than mortal discourse, let me speak briefly, and in a figure. And let the figure be composite— a pair of winged horses and a charioteer. Now the winged horses and the charioteers of the gods are all of them noble and of noble descent, but those of other races are mixed; the human charioteer drives his in a pair; and one of them is noble and of noble breed, and the other is ignoble and of ignoble breed; and the driving of them of necessity gives a great deal of trouble to him."

Plato then goes on to explain his allegory, pointing out that the ignoble horse is the passions and the noble one the reason. The charioteer naturally has the greatest difficulty in controlling them since they pull in different directions. Why is it better to describe this struggle in such terms than it would

2 *Phaedrus,* 246, Jowett's translation.

be to put the whole matter in straightforward psychological language? The answer does not lie merely in the vividness and ease of recollection which the mythological form adds to the idea. It lies also in the poetic quality of the myth which presents abstract thought concretely. Logically Plato is saying simply that the individual's life is under the guidance of two conflicting tendencies. But Plato is not neutral. He is preaching. And to a horseman the chariot hitched to two steeds, one of which is always pulling the chariot away from the charioteer's proper course is familiar and emotionally effective. A soldier might choose an image from warfare and a farmer from wheat and tares. The problem becomes that of making the unfamiliar familiar and, while doing so, making it as compelling as possible. The parables in the New Testament are a living demonstration of the power which allegories have over the human mind.

Sometimes the key elements of an allegory remain as symbols when the story as a whole is forgotten. The role played by the sun, for instance, in Plato was developed six or seven hundred years after his time by the Neo-Platonists until the notion of light streaming from a central fire became the nuclear figure of much Christian philosophy. Though the light of God's countenance is spoken of in the Old Testament, the Fathers developed the metaphor: God as the source of all light, light as knowledge, knowledge as illumination or enlightment—these are only a few effects of this figure of speech. The presentation of a source of light with rays streaming from it is enough for Occidental man to know what is symbolized. On a less lofty plane we have the bows and arrows of Cupid, the strutting peacock, the mourning dove, the pelican feeding her young on her own flesh, Time's sickle, the broken column, all of which are condensed allegories, abbreviations of narratives, signs which indicate commentaries.

When an allegory becomes condensed into a single symbol, the narrative steps are inevitably dropped out and the remaining symbol is a center from which the imagination proceeds outwards to endow it with properties which it may never have had for its originators. There are certain words, like Heaven, which expand as one thinks about them, which seem to grow like plants and to flower and even to bear fruit. The word itself literally names nothing but the sky above us, but as early as the Book of Revelations it had come to take on a new significance as the abode of God and the angels. The detailed description of Heaven in Revelations provided material not only for artists but for allegorists as well.

But there are certain paintings, such as Piero's *Resurrection* (Fig. 124) which, though they may follow a well known iconographic tradition (Fig. 125), take on new "meanings" as they are seen by successive generations. One of the most recent of such interpretations of Piero's picture is that of Sir Kenneth Clark who sees in the risen Christ the god of vegetation. This can hardly have been Piero's idea. Nor was the original story of the entombment as related by Saint Matthew in his mind. For in that story, it will be recalled, Joseph of Arimathaea took the body of Christ and "wrapped it in a

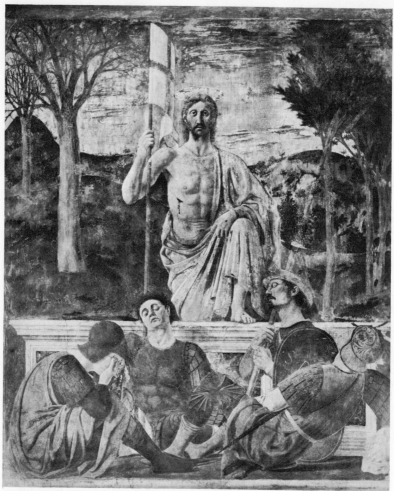

Fig. 124. Piero della Francesca: *Resurrection*. Palazzo Communale, Borgo San Sepolchro.

clean linen cloth. And laid it in his own new tomb, which he had hewn out in the rock: and he rolled a great stone to the door of the sepulchre and departed." But to Piero the sepulchre in the cave was unimportant and the grave from which Christ rises is a sarcophagus such as might have been found in Rome and in the hand of Christ is the triumphant banner of victory. Nor is the body wrapped in a shroud. Yet on the face are all the marks of death, the sunken haggard eyes which no longer have terrestrial sight and which have been in Hell. No one looking at this painting even in a black and white reproduction and on a very much reduced scale can fail to feel a strong emotional shock which comes from the majesty of the composition.

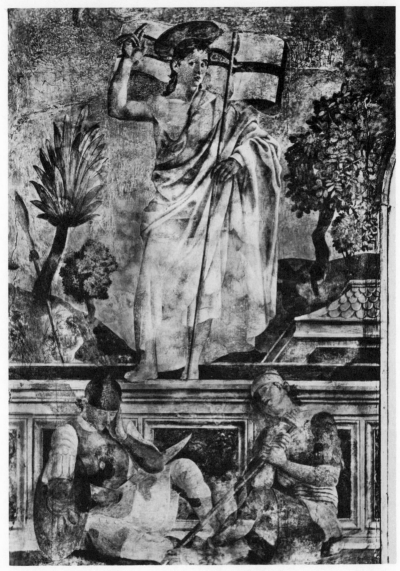

Fig. 125. Andrea del Castagno: *Resurrection*. Museo di Andrea del Castagno, Florence.

And yet other painters had represented this scene in the same way, and the tradition was to continue (Fig. 126). But to a modern eye it is not the fidelity to an iconographic tradition which counts: it is the force of the conception of what the Resurrection meant. And that meaning seems to be, whatever the artist's own intention, the emphasis upon the humanity of the Redeemer

who really died, went to Hell, and now is at the moment of rising. One might even see in the bodies of the soldiers at the foot of the sarcophagus, lost in sleep, a symbol of man's willful ignorance of what was taking place. One has only to let one's imagination play over such a picture to realize the possibilities of its acquiring new significance. If it was possible for Sir Kenneth Clark to read into this picture the allegory of vegetation's coming into new life and thus joining it to the ancient pagan interpretation of spring as a resurrection, it was because the Feast of Easter as it is celebrated today, is a renovation, as we have said above, of the old Germanic spring festival.

Such reinterpretations of painting are not infrequent. The "meanings" which Théophile Gautier and Walter Pater found in the *Mona Lisa*[3] were surely not present to the mind of Leonardo. The smile which has stimulated so much poetic prose in the nineteenth century as a symbol of enigmatic womanhood was seen simply as a piece of very clever realistic painting before that time. As a matter of fact women were not supposed to be enigmatic until the German romantics said they were. If one looks through a dictionary of quotations, one will see that women were tremulous, frail, deceitful, without discretion, gentle, needing good company, ruinous, inconstant, lachrymose, lovely, and so on, but never enigmatic. The quotations, to be sure, come from works written by men and what man would admit that he did not thoroughly understand the sex traditionally known to be the weaker? Women became enigmatic when they began to be liberated. But now that the *Mona Lisa* has taken on a mysterious smile, she will keep it until new interpretations are made.

If the abstractions, Fortitude, Prudence, Wisdom, Truth, Hope, Despair, and Folly, which figure so largely in eighteenth-century English poetry, had been given proper names, even Greek and Latin translations of their meanings, as so many of them appear in the *Faery Queene,* their power to stir later generations might have been greater. The key to the *Faery Queene* was furnished by Spenser himself in a letter prefixed to it. Pointing out that his Arthur stands for the perfectly virtuous man, as described by Aristotle, he continues by saying that each of the books of the poem represents a deed springing from one of the twelve virtues: holiness in the person of the Knight of the Red Cross; temperance in that of Sir Guyon; chastity in Britomart; with the other nine to follow later. The Faery Queene herself is Queen Elizabeth and every incident in this marvelous poem takes on equally symbolical meaning. But the poem can be read and has been read simply as a wonderful narrative of the battles between good and bad knights, the rescue of ladies in distress, the machinations of wicked magicians, and so on. This is always possible. The story induces the reader to explore and before he knows it he has absorbed a moral lesson.

Certainly the boys who read *Pilgrim's Progress* a generation or so ago were more interested in the story than in its religious significance.[4] The plays of

3 See G. Boas, *Wingless Pegasus: A Handbook for Critics* (Baltimore, 1948). Appendix II.
4 We disagree on this point. G.B. was one of those who read the book for the story; H.H.W. saw through it at once—and didn't read it.

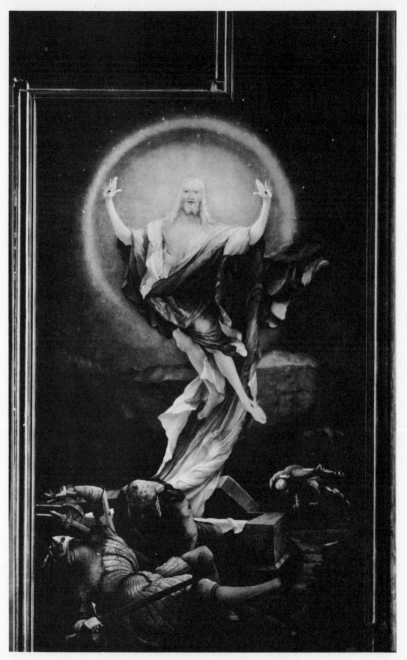

Fig. 126. Matthias Grünewald: *Resurrection*. Eisenheim Altarpiece, Colmar.

Ibsen became sophomoric to some playgoers because of a heavy load of symbolism. Whatever significance one was to derive from a drama ought to be in part created by the imagination of the spectator and few like to be "preached at" in the theatre. Such preaching might have been good for children, one felt, but hardly for adults. *Sanford and Merton, The Shepherd of Salisbury Plain,* the Rollo books, became downright funny, like the temperance dramas of the nineteenth century. Even Bernard Shaw, whose impudence alone might have been expected to keep his plays alive, is more easily read in his prefaces than in his dramas.

Among the more famous allegorical paintings still accessible to the public, is the series of murals which Rubens painted to celebrate the marriage of Marie de' Medici and Henri IV. These grandiloquent allegories have all the bravura of grand opera and like grand opera can be seen from two points of view, if not more: that of the music and that of the drama. How many spectators of these canvases ever bother to *read* them? Is it not likely that more people simply look at them, either to admire the composition and general workmanship, or turn away in boredom? Consider as a specimen the painting of *Henri IV Receiving the Portrait of Marie de' Medici* (Fig. 127). The King, in armor but with helmet and shield on the ground as playthings for two little Loves, gazes on the portrait, with the goddess of war, Bellona, behind his back. Whether she is whispering encouragement to the warrior or attempting to dissuade him from the marriage is left to the observer. But in any event here is the union of love and war, Venus and Mars. In the sky, appropriately seated on clouds, are Jupiter and Juno complete with eagle and peacocks. This far from ideal couple for once seem agreed on something, in this case that the marriage of the terrestrial king may be happier than that of the celestial. The portrait of Marie in the center of the frame is borne by Hymen whose torch is glowing as it should, while on the ground below smoke rises from what looks like a burning city. In the scene of Marie's *Debarkation at Marseilles* (Fig. 128) Fame is blowing her trumpet over the head of the prospective bride, a figure representing France comes rushing up the gangplank to meet the new queen, arms outstretched, Nereids are pulling at the hawsers, and Neptune himself is giving orders for the landing.

But no such prosaic translation of these allegories into words can do justice to the vigor which pulsates through these pictures. Rubens paid little if any attention to the actual state of affairs; Henri IV and Marie de' Medici were hardly as enthusiastic about this match as they are represented as being and if the bride was welcomed by a mythological figure, it was because the groom was otherwise engaged. The whole series seems ridiculous to the modern eye and it is worth noting that in the guide to the Louvre, where the paintings hang, the French scholar Louis Hourticq can not resist poking fun at it all. For instance, in his notice of the painting of Henri receiving the portrait of his bride, Hourticq says, "The figure of Henri IV is charming in its vivacity and naturalness. But what an historical lie!" On the other hand, no one could be in any doubt that a royal marriage in those days—and perhaps in our own

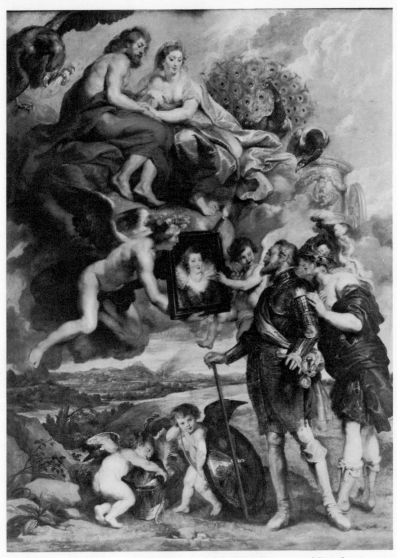

Fig. 127. Peter Paul Rubens: *Henri IV Receiving the Portrait of Marie de' Medici*. Louvre, Paris.

too—is an affair of state and that its significance is precisely that of an allegory. Whatever we may think of the inflated rhetoric of such paintings, this was the sort of occasion which demanded oratory of the most gorgeous sort so as to invest the incident with more than natural atmosphere. This man and this woman who were to be joined in matrimony stood for policies and were

157

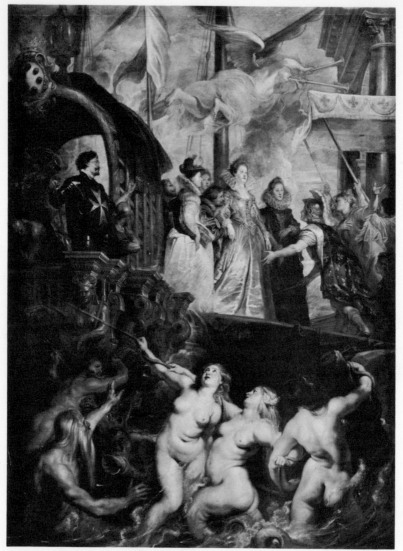

Fig. 128. Peter Paul Rubens: *Marie de' Medici Debarking at Marseilles*. Louvre, Paris.

not simply individual human beings. By allegorizing them and their deeds, Rubens was able to emphasize the political significance of the marriage and subsequent occurrences and to give them a more sweeping importance than a literal representation would have done.

Sometimes, however, a painter may give us what looks like an illustration to history and it is remembered for the lesson which it is supposed to teach.

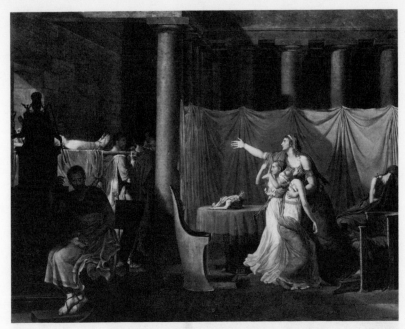

Fig. 129. Jacques Louis David: *The Lictors Returning the Bodies of His Sons to Brutus.* Wadsworth Atheneum, Hartford, Conn.

David's *The Lictors Returning the Bodies of His Sons to Brutus* (Fig. 129) is painted without any of the symbolic figures which inhabit the canvases of Rubens. It may be looked at as literal historical painting, an illustration of an event believed to have occurred in Roman history. The story as told by Livy has always been thought of as typical of the Roman sense of duty. The two sons of Brutus were involved in a conspiracy to restore the Tarquinian dynasty to the Roman throne. Brutus ordered them to be executed and they were killed in front of their father. David has chosen to show the scene in which their bodies are brought home, with their mother weeping on one side and their stern father on the other. It has become a symbol of the conflict between civic duty and parental affection. But now that classical education has more or less gone by the board, how many tourists wandering through the Hartford Atheneum even know what is being illustrated in this painting?

This loss of significance is to be expected. Illustrations of the various Greek myths, such as the story of Actaeon (Fig. 130) or even of the Three Graces or Apollo and Daphne or of the Judgment of Paris (Fig. 131) have lost their allegorical significance for most moderns simply because we are no longer educated by means of them. The disasters that arose because a Trojan shepherd chose Love, rather than Wisdom or Power, are no longer present to our minds and most of us have forgotten that the mother of Paris dreamt before his birth that she would be delivered of a firebrand, a son who would bring

159

Fig. 130. Jacopo del Sellaio: *Actaeon and the Hounds*. Jarves Collection, Yale University Art Gallery, New Haven, Conn.

Fig. 131. Peter Paul Rubens: *Judgment of Paris*. National Gallery, London.

ruin upon his country. In fact, it is questionable whether many of the painters who depicted the event thought of it as more than an occasion to paint three divine beauties with all their charms exposed. But for that matter, to take an example of a less lofty kind, when Landseer painted his *Diogenes and Alexander* (Fig. 132) with dogs in the roles of the philosopher and king, he was acting as a pictorial Aesop. In the original story the Cynic philosopher Diogenes with characteristic rudeness refused to be impressed by a visit from

Fig. 132. Edwin Henry Landseer: *Diogenes and Alexander*. Tate Gallery, London.

Alexander the Great and merely told him to get out of his light. The theme of the philosopher's caring nothing for regal power is not a humorous one. The fact that Landseer could play upon the supposed double meaning of the word "cynic," said by some to be derived from the Greek for "dog," and show us two great men as dogs, was in itself evidence of the decline in the prestige of the ancient legends. How many people who have seen this picture are able to explain its title?

But one does not have to know the hidden meaning of an allegorical painting to enjoy it. Few of us know anything about the significance of Chinese paintings and yet growing numbers of Occidentals admire them. Yet to a Taoist with his belief in the simplicity, selflessness, and humility revealed in Nature, the landscape may be a symbol of a way of life (Fig. 133). So a generation brought up on the poetry of Wordsworth was bound to feel a religious significance in landscapes to which a later generation became insensitive.

> Little we see in Nature that is ours;
> We have given our hearts away, a sordid boon!
> This sea that bares her bosom to the moon;
> The winds that will be howling at all hours,
> And are up-gather'd now like sleeping flowers;
> For this, for everything, we are out of tune;
> It moves us not.

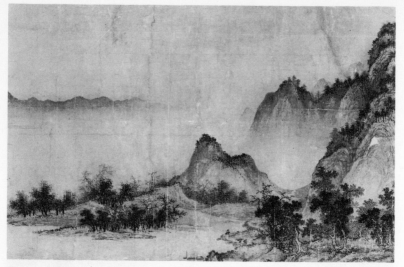

Fig. 133. Tung Yuan: Landscape scroll. Museum of Fine Arts, Boston.

But the fact is that when we no longer think of the sea as baring her bosom to the moon, we may invest it—or her—with other almost magical properties. For it is normal that a symbol will be retained even though its original meaning is lost.[5]

When an American sees the seal of his country with the eagle surmounting it, does he feel the sting of being represented by a bird of prey? Does he wonder about the arrows and olive twigs clutched in the bird's claws? Does he ponder over the fact that the stars and stripes were originally part of the coat of arms of the Washington family? Could he translate *E pluribus unum* without a dictionary? It is probable that if he can interpret the seal, it is because he has learned the correct interpretation in school; it does not come to him as a discovery of his own. If a symbol is to live, then every generation will make its own interpretation of it; indeed every individual will make one for himself. Thus language grows and so grow paintings and other works of art. Those that once were serious, such as the Rubens murals in the Medici room, may become funny; and those that once were funny may become simply flat and dull. Architecture that once was "correct" may become quaint and amusing, as much Victorian architecture became a few years ago. We doubt whether any painter today would paint little cherubs in the sky above a pair of lovers, except in fun, nor have any of the generals of the two World

5 The original meaning of the Cross may have been, as some ethnologists say, the rays of the sun. But who remembers that now, or cares? For the diffusion of symbols and their acquisition of new meanings, see Goblet d'Alviella, *The Migration of Symbols* (London, 1894), which, though published over a half-century ago, still contains more information on the subject before us than most later books. Perhaps the best example of how symbols acquire new meanings is found in the history of words.

Wars to the best of our knowledge been represented in the likeness of Mars.

In short, there is no law which demands the death penalty for allegories, no law which explains the rise of new meanings, no law which predicts when a fact will become a symbol and a symbol literal fact. The paintings of Harnett, the vogue of which was revived a few years ago, seemed like literal paintings of sheets of music, five dollar bills, skulls, and other things, the charm of which lay in the difficulty of painting them. Harnett gave them fanciful titles, such as *Mortality and Immortality* (Fig. 65), but no one knows whether this was to make them more palatable to his sentimental public or to express some deeper significance which the artist found in the arrangement of the objects painted. Whatever Harnett may have had in mind, the interpretation of the spectator will be made independently, for nine times out of ten he knows nothing of the artist. If a picture has no meaning for him, "leaves him cold," that may be due to his ignorance. A painting of Saint Nicholas, of Laocoon and his sons, of the temptation of Saint Anthony, of the Madonna of Pity, would only bewilder a person who had no knowledge of what such pictures stood for. And often it is only because a picture has the power to stir a spectator to wonder that it remains alive. It is this simple psychological fact that helps explain shifts in taste, the submergence of some works of art and their re-emergence later.

Chapter VI The Picture as an Emblem

As certain symbols become traditional, they are used as so many words to indicate ideas, abstract qualities, persons, divinities, and the like. The most ancient of such symbols have little resemblance, as far as modern man can see, to that which they symbolize, though originally they may have been pictograms. For instance, if we may indulge in a bit of fantasy, the letter O resembles the shape of the mouth when one is pronouncing the sound which it names. But no one thinks of it as a picture of anything. Hence the first thing to be noted about emblems is that whatever their origin, they may be immediately read as a sign of something "beyond" themselves. National flags are a good example of how we immediately can identify a ship or consulate or automobile flying them without paying the slightest attention to the history of the symbol in question. They are also a good example of how a material object may arouse one's emotions because of its meaning and regardless of its design or color. We recognize our flag to be sure by its design and color, but whatever patriotic sentiment it stimulates comes from our knowledge that it is our flag and not that of another nation. It has actually gone through a long development since it was first designed, star after star being added and arranged in different patterns, but it may be assumed that it was just as moving to the men who fought under it when it had only thirteen stars as it is to our contemporaries when it has fifty.

As allegorical pictures grow old, they become harder to read. And if a spectator does not know the symbolism which they offer him, he will find himself staring at a collection of odds and ends which may actually seem meaningless to him. Yet like literary allegories they may still be read as a straightforward representation of an event or scene. A child can read Aesop's fables as short stories in which the characters are animals, much as he would read Kipling's *Just So Stories*. He could read about the Fox and the Grapes, for instance, without realizing its significance for human affairs, if he does not wish to see the moral. And in fact most fables of that type have a moral tacked on to them lest a reader miss their point. Similarly an anchor with a dolphin twisted about it, the emblem of the Venetian printer Aldus (Fig. 134), or a snake with its tail in its mouth (Fig. 135), must look like puzzles to the uninitiated,

Fig. 134. Aldus's printer's mark.

Fig. 135. Symbol for Eternity, as described by Horapollo.

and as a matter of fact such emblems were deliberately intended to appeal only to the educated classes.[1] But an allegory usually makes sense on two levels, the literal and the figurative. Kingsley's *Water Babies*, for instance, can be read as one would read *The Sleeping Beauty* or *Cinderella*. To one accustomed to emblem literature, the emblems make sense too. But to interpret them requires special training in the meaning of the symbols involved.

It was in fifteenth-century Florence that emblematic pictures began to captivate the imagination of both artists and spectators. The vogue continued well into the sixteenth and seventeenth centuries. But the main difference beween the visual emblems of the Renaissance and those which had been current before that time was their novelty. After all the Cross too is an emblem. All the meanings which have clustered round that visual pattern of two straight lines intersecting at right angles are so numerous that only a treatise on Christian theology could elucidate them as a whole. It represents an actual material object, primarily an instrument of torture, but there is little likelihood that every girl who wears a gold cross on a chain round her neck thinks of it as an instrument of torture. It has become a condensation of a whole religion and in the minds of most thoughtful Christians stands for redemption through the vicarious atonement of Christ. But the doctrine of the atonement is, there is no need for us to point out, a complicated set of ideas which only specialists in dogmatics know thoroughly. The Cross then as an emblem is a visual substitute for a body of doctrine.

Similarly the four Hebrew letters signifying the name of God (Fig. 136) formed an emblem. Letters are only marks on a piece of paper or scratches in a stone. But the name of God, which no one knew how to pronounce, took on as much sanctity in the minds of pious Jews as the idea for which it stood. But again the complex of ideas which first identified a name with its meaning, which rendered knowing the name something holy, which kept God as a

1 For a brief account of the vogue and purpose of such emblems see George Boas, Introduction to *The Hieroglyphics of Horapollo* (New York, 1950).

Fig. 136. The Name of God.

being who must not be represented in images, which shrouded His being in mystery, these would require volumes to elucidate. The emblem is not merely a visual or auditory pattern; it expands in the imagination of those who believe in it into a body of thoughts.

Emblems may have their origin in a simile or metaphor. The meaning of the Aldine pressmark of the dolphin entwined with an anchor is, "Make haste slowly" *(festina lente)*. This verbal paradox, attributed to Augustus by Suetonius, is pictured by joining the fastest of animals with the symbol of stability. If one should ask what the paradox means, the heavy-handed answer would be an essay on the general theme that haste makes waste, that the tortoise may get to his goal faster than the hare, and so on *ad nauseam*. Whatever explanation would be given, it would be in the form of a series of sentences more or less logically united. Such an explanation wearies the quick of wit who prefer to *see* in the emblem its meaning rather than to talk about it. One of the most striking uses of emblems is in primitive Chinese characters which were really little pictures of the object they stood for. The character for *man* had a head, arms, and legs; that for the *sun* was a circle with a dot in the middle; that for *rain* was an arch—perhaps the arch of heaven—with drops falling; that for a *mountain* was a plain horizontal line with three peaks rising above it. As the characters developed, they became simplified. Eventually all that was left of the man was his legs; all that was left of the mountain was a horizontal line with three verticals at right angles to it. Emblems of this sort are technically called *icons*, of which a map is a stock example. Just as one has to learn how to read a map, so one has to learn to read an emblem. What could a Chinese who had never met a Christian make of a crucifix?

Emblems then communicate something, just as words, maps, and other symbols do. Clearly the normal means of communication between human beings is language. But verbal expression has always been supplemented by things which are not words, by gestures, by facial expressions, by intonations, and in books by diagrams and other forms of visual illustration. Language sometimes strives to arouse in readers and listeners visual images so as to vivify the message which one is trying to communicate. In other words, we do not always limit ourselves to the communication of ideas, opinions, assertions;

166

sometimes we want our listener or reader to see what we saw, to hear what we heard, to feel what we felt.

Though we have to rely on all our senses as we go through life, it is probably true that we are more visual than auditory, more auditory than olfactory. A dog, whose nose is more informative to him than his eyes, would describe the world in terms of odors and if the only sense we had was our sense of touch, our language would be that of textures and shapes. Like Helen Keller we should have to feel things with our finger tips in order to experience them. Now, as everyone knows, there was communication between people long before there was any written language. And there are still occasions when we cannot use even spoken words to communicate. For instance, in infantry warfare a whole set of arm signals has been developed to take the place of spoken commands; in radio studios and on the ramp of an airport we see men who make signals with their hands and arms rather than with their voices. But even in less peculiar situations we retain some of the primitive gestures, such as "Thumbs down," waving farewell, saluting, threatening with the fist, shrugging the shoulders, turning down the corners of the mouth, winking with one eye, shaking hands, to say nothing of the more vulgar manual gestures, such as thumbing the nose. No one bothers to think about the origin of such things, for their meaning is obvious and the more sophisticated the person, the less he indulges in them. But we know that most of them vary with cultural patterns and are not congenital. Gestures of greeting, for instance, vary greatly from culture to culture, some people shaking hands, some bowing with hands folded palm to palm, and simply inclining the head, some, it is said, rubbing noses. Were such gestures represented in a picture, we should be able to read them without any difficulty. In Velazquez's famous *Surrender at Breda* (Fig. 114), we need know little history to see who is victor and who is vanquished. The pose of the bodies tells us. In the various *Annunciations* which we have reproduced in Chapter IV, we do not have to be told that the Virgin kneeling is at prayer.

But once again such interpretations cannot be made unless the interpreter is aware of the key. One has to know beforehand what *Thumbs Down* means before one can interpret a picture in which the Roman Emperor is shown with his thumbs down. That kind of knowledge is given us in the schools we attend and in the books we read, but we pick it up so gradually and indeed so quietly that we sometimes forget how conventional emblems are. The Ancients were so used to using a snake with its tail in its mouth as a sign of eternity, so accustomed to putting one round the figure of a king or other monarch, that we find it on engraved gems as a matter of course. We have signs for the several planets and for the chemical substances with which they were once supposed to be associated, for the days of the week, for male and female plants and animals, for phases of the moon, for the signs of the zodiac, and in fact there is little in human life which does not have its symbolism.[2]

2 Dover Publications has brought out an inexpensive edition of Rudolf Koch's *The Book of Signs* which contains 493 such symbols.

Emblems of this sort are easy to read for they are usually fairly simple and in common use. But in the fifteenth and sixteenth centuries it was hoped to express more complicated ideas in visual form. It must not be forgotten that this was a period in which there was a consuming interest in our visual experience. Hence it was not strange that the men of that time also became interested in translating thoughts into pictures and expressing complicated ideas in visual form. The notion that things seen could mean something unseen was a familiar one, for from earliest times people had thought that dreams could mean something which was not simply the obvious subject matter of the dream. There was an old dream book, the *Oneirocriticon* of Artemidorus, which catalogued the meaning of typical dreams and anyone who has read his Bible knows of the dreams which were interpreted by Joseph, of Jacob's ladder seen in a dream, and the various appearances of God and angels in dreams. Dreams were apparently cases of seeing something which had a significance different from that which it seemed to have. It was a two-level experience. Moreover, in dreams things do not behave as they do in waking life. In one of Pharaoh's dreams seven lean cattle ate up seven fat cattle, though cattle are neither cannibalistic nor carnivorous, and moreover, "when they had eaten them up, it could not be known that they had eaten them; but they were still ill-favored as at the beginning." Nebuchadnezzar's dream in the Book of Daniel (Chapter II, 31-46) is as fantastic as any scene depicted by Salvator Dali. It is true that words are spoken in dreams and actions occur, but it is nevertheless the visual element which seems to predominate, which is perhaps why they are so often referred to as visions. The seven lean cattle which ate up the seven fat ones in Pharaoh's dream did not look like seven years of famine, and this of course is why his wisemen failed to make the correct interpretation of them. But after all the words which we pronounce do not resemble the things which they mean except in a few cases where they mean sounds, as "screech," "ha-ha," and "buzz."

Plotinus, a third-century Greek philosopher, had maintained that the Egyptians had expressed such complicated ideas in their hieroglyphics. He was wrong, as we now know, for the hieroglyphics had become letters. But like Chinese characters, they were also little pictures, pictures of seated children, of faces, of eyes, of mouths, of birds, of fish, of various tools, and apparently by the third century A.D., if not earlier, people had forgotten how to read them. Plotinus maintained that they were visual symbols, each of which, he says, is "a science and an insight, substantial and complete and neither a matter of reasoning nor deliberation." He was thinking of two things: the apprehension of a complex set of ideas, such as the idea of justice or eternity or beauty, and the presentation of it in visual form. In the fifteenth century a manuscript turned up on the island of Andros which purported to be a book by one Horapollo and which interpreted the hieroglyphics in much the same fashion. Here one found the interpretation of the serpent with his tail in his mouth as meaning eternity, a hawk as meaning a god, a vulture a mother, and so on to more elaborate devices. The Italian translator of Plotinus,

Marsilio Ficino (1433–99) explained Plotinus' reference to the hieroglyphics by means of Horapollo and this seems to have launched the vogue of paintings which looked like pictures of birds, beasts, and fishes—to say nothing of other things—but which were really a sort of rebus which had to be read. The following centuries went in heavily for hieroglyphic paintings and it is only recently, thanks to scholars such as Säxl, Panofsky, Wind, Gombrich and their colleagues in the Warburg Institute, that we have full interpretations of such paintings. The complication of detail is extraordinary and no one who has not been trained in iconology can hope to see the whole meaning of most of the Renaissance and Baroque pictures.

The accompanying painting by Jacopo del Sellaio, now in the Norfolk, Virginia, Museum is a case in point. (Fig. 137).[3]

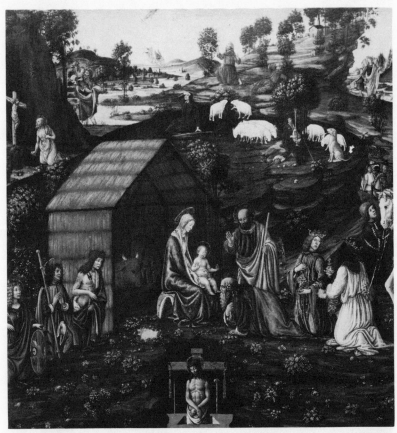

Fig. 137. Jacopo del Sellaio: *Adoration of the Magi*. Norfolk Art Museum, Norfolk, Va.

3 It should be compared with an Adoration of the Child Jesus by the Madonna by a follower of Pesellino in the gallery of Yale University (Fig. 138).

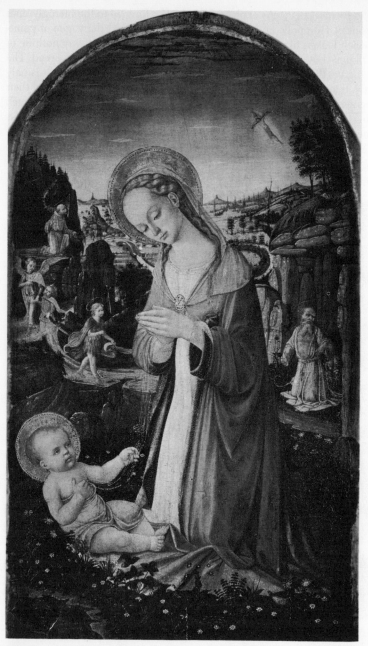

Fig. 138. A follower of Pesellino: *Virgin and Child.* Jarves Collection. Yale University Art Gallery, New Haven, Conn.

This picture is catalogued simply as an *Adoration of the Magi*. And indeed the central figures are the familiar Holy Family with the Three Kings on their knees before them. That in itself is traditional and signifies how the kings of the earth humble themselves before the newborn King of Heaven. But there is also a garland of other scenes round the central image which are neither historically related to the Adoration nor contemporary with it. Immediately below the Mother and Child is a figure of Christ rising from the tomb with the Cross behind Him. It is at once both a crucifixion and a resurrection. And right above the head of the Child is the Star of Bethlehem, which seems to be shining out of a bush and which sends a single ray down to the head of the Child. Above the star is a shepherd looking upward at an angel who is flying towards him. This is clearly an Annunciation to the Shepherds. Hence on a vertical axis we have the whole story of the Redemption from the annunciation to the shepherds to the resurrection. But there is also a circle of saints about the central figures. In the upper right hand corner is the Angel Raphael with the young Tobias. Moving from right to left we come upon Saint Francis receiving the stigmata, Saint Christopher carrying the Christ Child on his shoulder, Saint Jerome praying in the wilderness, and finally down in the lower left hand corner three kneeling saints, Catherine of Alexandria, Roch, and Sebastian.

If ever there was a picture to be read and not merely stared at, this is it. All the saints depicted have some connection either with children or with the cure of sickness or with safety in travel. There is a fusion of two ideas here, both suffering and rehabilitation, accompanied by the idea of protection from the dangers of traveling. Each of the three kneeling saints was prayed to for cures and both Raphael who holds the hand of the little Tobias and Saint Christopher were patrons of children and travelers. Saint Francis is receiving the same marks of unmerited punishment as the crucified Christ and Saint Jerome succeeded in releasing himself from the torments of the flesh while living in the forest, just as he had relieved the sufferings of the lion. The longer one looks at this picture, the more one is absorbed in its details. It is probably an *ex voto* commissioned by the parents of a child who either was going on a journey or had been cured of a sickness. Unfortunately we know next to nothing of the artist and of course have no idea who commissioned the painting or on what occasion. But we can tell at least roughly why it was painted and that it is a complicated emblem whose meaning if put into words would require a long article to be fully explicated.

Again, there are several paintings by Memling—and indeed others—in which the Madonna is shown with the Child on her lap (Fig. 139). She is holding out an apple to Him. He is reaching for it. This could be seen simply as a charming study of a mother holding out a brightly colored fruit to a baby. But the apple has always been a symbol of the Fall of Man and if all Memling wanted was to show a mother amusing her child with something bright, he could have put in her hand a dozen different things, such as the goldfinch which is frequently painted in similar pictures. But if the apple stands for the

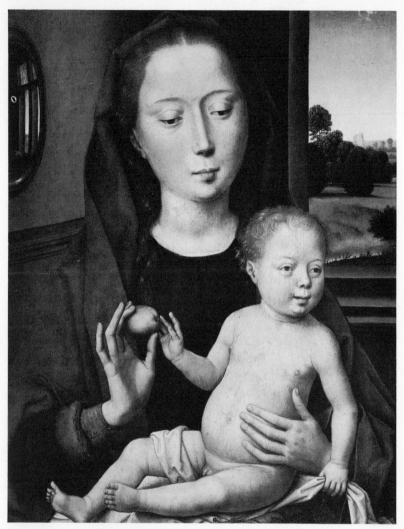

Fig. 139. Hans Memling: *Virgin and Child*. Martin A. Ryerson Collection, Art Institute of Chicago.

primordial sin of our original parents, why is the Madonna holding it out to the Christ Child and why is He reaching for it? The answer is that in the Middle Ages the Madonna was often spoken of as the Second Eve, just as Christ was spoken of as the Second Adam.[4] The first Adam and Eve brought about the Fall of Man, the second his redemption from sin. In the Mass Christ is addressed as the Lamb of God who bears the sins of the world (*qui tollis*

4 Cf. Fig. 112, where Adam and Eve are being expelled from the Garden.

peccata mundi). The whole dogma of the Redemption rests upon the willingness of the incarnate God to take these sins upon Himself. No one in the fifteenth century, that is, no one likely to be interested in paintings, would have been ignorant of this; it was common knowledge. Such people seeing the picture would have known automatically what it signified; they would have *seen* the message and would have needed no iconological interpretation. It would have been a kind of hieroglyphic which could be grasped concretely, exactly as one reads words without spelling them out.

These two pictures present no insuperable difficulty to the spectator. But let us now turn to one which has not as yet been successfully interpreted and which illustrates beautifully how different people see different meanings in an emblematic painting. In the Uffizi hangs a painting by Giovanni Bellini which is entitled—by the cataloguer—*Allegory of Purgatory* (Fig. 140). On the surface of things this picture represents a group of people on a tesselated terrace on something which may be an island in a lake. On the terrace is a group of four *putti,* three of whom are playing with fruit from a tree set in a pot, the trunk being held by the fourth. To the right are two male figures, one of which is clearly Saint Sebastian, next to whom is an old man. To the left is a woman on a throne to the right of whom is a kneeling woman wearing a crown and to whose left is another woman bareheaded. Behind the railing which separates the terrace from the middle ground are two elderly gentlemen in togas, one of whom is bearing a sword in his right hand. To our far left is a robed figure, its head covered in what may be a turban, walking out of the picture. Though the potted tree on the terrace is in full foliage, there are five denuded trees, either not yet in leaf or else dead. In the background, possibly the mainland, we see, reading from right to left, an old man carrying a long pole coming down a flight of steps, a centaur, some goats lying down, a man—the goatherd?—in a cavelike shelter, and another goat. Above the centaur and the first group of goats is a crucifix. In the rocky background is a landscape with a cluster of farm houses, a traveler, a man beating a donkey, and a couple meeting, the whole surmounted by a castle. The three women on our left, the old man leaning on the railing, and the old man beside Saint Sebastian are praying. Finally it may be of some importance that the tiles in the floor form a cross at one end of which stand the two male figures, at the other the throne with the seated woman in prayer, and at the intersection of the arms the potted tree.

What is most certain about the subject matter of this painting is the identity of the two nude men at the right. They are obviously Saint Sebastian and, less obviously but no less certainly, Saint Job. The figure of the latter is a duplicate in reverse of the Saint Job by Bellini in his great *Madonna of Saint Job* in Venice. Both saints are men who suffered for their religion. But now let us turn to what the authorities say about this.

Frank Jewett Mather, Jr., in his *Venetian Painters,* basing his opinion on an article of the late Professor G. Ludwig, says that the central symbolism of this picture ultimately derives from an old French poem by Guillaume de

Deguilleville called *The Soul's Pilgrimage*. The woman on the throne is iden-
tified as the Madonna, the woman with the crown as "a princess saint," the
two men outside the railing are Saints Peter and Paul. The tree is the tree of
good and evil and the *putti* are "souls seeking salvation." Mather continues,
"What makes the picture is the contrast of this scene of devout contemplation
and celestial security with a romantic background revealing a world of
change and peril. On the nearer bank a Saracen strolls out of the picture.
Beyond a river of Lethe steeped with velvety reflections from clouds and
barren cliffs is an outlook on the probationary world of struggle. On the
nearer headland, where there are hermits' caverns, is a hermit with wild
deer and a centaur. Beyond this headland the river makes up into a bight with
formidable cliffs and a barren mountain at the left, and a great castle rosy
against the sky, symbol of habitation farther beyond. The head of the bight
is occupied by a little church with its buildings and peasants' huts. On the
strand the great Thebaid saints, Anthony and Paul, greet each other, near
them a corpse lies in its bier ready for burial."[5]

5 This is more or less the same interpretation as that given in Mather's *A History of
Italian Painting* (New York, 1938).

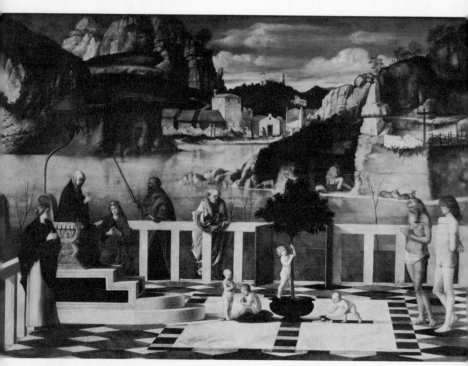

Fig. 140. Giovanni Bellini: *Allegory of Purgatory*. Uffizi, Florence.

In a popular guide for tourists, the *Wonders of Italy,* by G. Fattorusso, Florence (1930), the picture is entitled *Allegory of the Church,* is again said to be based on Deguilleville's poem, the woman in the throne is the Madonna and the two women beside her are identified as Saint Catherine of Alexandria crowned, and Saint Catherine of Siena. The landscape is said to be "apparently symbolic of the world and its difficulties." The centaur is a "symbol of vicious inclination." The seated man is again a hermit in his cell, "indicating the best refuge for such temptations." In Berenson's list of Giovanni Bellini's paintings given in his *Venetian Painters,* the picture has a new title, *The Tree of Life,* but no interpretation of its symbolism is given. Another guide, Karl Karoly's old-fashioned *Guide to the Painting of Florence,* published in 1893, calls it a Holy Allegory representing the Madonna receiving the homage of saints. The two male figures outside the balustrade are called Saints Joseph and Paul, those on the terrace Saints Sebastian and Jerome. Hendy and Goldscheider in their *Giovanni Bellini* (Oxford and London, 1945) label it *The Earthly Paradise* and Van Marle in his *Development of the Italian Schools of Painting* (Vol. XVII, p. 274) the *Madonna del Lago* (The Madonna of the Lake). Finally Tancred Borenius in his edition of Crowe and Cavalcaselle's *History of Painting in Northern Italy* (London 1912, Vol. III, p. 7, note) accepts Deguilleville's poem as the source of the picture and interprets the terrace as the Earthly Paradise, the tree as the "mystic Tree" of the Song of Songs, the children as souls comforted by Christ, the woman on the throne as the Virgin and the crowned and kneeling woman beside her as Justice, both discussing the redemption of mankind, the men as Saints Paul, Peter, Sebastian, and Job, advocates and faithful friends of the souls, and the donkey and "hermit" in the middle ground as symbols of the kind of life which leads to least pain in Purgatory. This will suffice to show how a painting of this kind may stimulate a great variety of interpretations.[6]

In our own times, thanks to the work of Freud and his successors, we have again become aware of the significance of dreams, symbols of all sorts, unintended revelations of meanings. We now know that we see with our whole minds, not merely with our eyes. Seeing has become interpretation and we are aware of the fact that a given spectacle may mean a variety of things, depending on how deeply we want to explore their levels. Just as a geologist can look at a landscape and see it not simply as a visual pattern but also as an incident in a tremendous geological drama, here evidence of rocks which have been uplifted ages ago, there valleys which have been eaten out of the earth by rivers long since disappeared, so we have learned to see in pictures much that the artist did not know was there. To see with the whole mind is

6 Neither of us are iconologists, but I have taken the trouble to read through Deguilleville's *Pélerinage de l'Ame* and see no compelling reason to accept it as the source of the picture. This interpretation was first made by G. Ludwig in an article "Giovanni Bellini's Madonna am See in d. Uffizien, eine religiöse Allegorie," *Jahrb. d. K.Preuss.Kunstsamml.,* 1902, fasc. III-IV, pp.163, 186. It seems to have been accepted by most commentators on the painting. G.B.

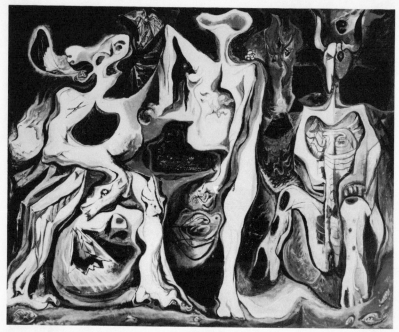

Fig. 141. André Masson: *There is No Finished World.* Saidie A. May Collection, Baltimore Museum of Art.

to see with our repressions, our emotions, our aspirations, to make associations unconsciously with past experiences, to project into what we see as much of our own lives as the artist projected of his. It has sometimes been said that most of our mental life is buried in the Unconscious and is released only from time to time when the Censor is not preventing or in symbolic form. The school of painters usually known as Surrealists frankly accepted this psychology and made it the basis of their program. They used painting as a release from the repressions put upon them by society.

In the Baltimore Museum of Art is a painting by André Masson (Fig. 141). This is a painting in which there are forms recognizable in part but not as a whole. The forms seem to flow into one another, changing before our eyes. On the right there is a figure which seems to be human but which has a bull's head with horns. His bowels are exposed and his feet merge into waves which are beneath him. The figure in the middle recalls a woman whose head has become an open funnel. The one on the left has human feet and legs but arms which terminate in a sort of dragon's head. As we look at this picture details begin to emerge from the background and sink again into it. We suspect that we have finally got hold of something firmly only to find it slipping away from us. Some bits are sharply outlined, others quiver in repeated silhouettes. This is clearly a picture in which the eye is forced to move about, as

in the Jacopo del Sellaio (Fig. 137), but here the motion is an essential part of the painting and the very instability of the work is integrated into it. Just as in a dream or reverie there is nothing fixed.

Interestingly enough, when one comes to ask the title of this work, one finds it called, *There is No Finished World,* a sentence, not a noun. It is the visual expression of a completed thought, a philosophy, an attitude towards life. The Baltimore Museum has in its possession a memorandum written by Masson which explains what this picture is about so that we do not have to guess at its meaning. With this key in hand, we can interpret the picture without guessing. In this respect it is no different from any other emblematic painting, but there is one outstanding difference. In traditional painting there was a more or less commonly accepted key. People were educated in its use and knew what the symbols meant without having to be told each time they saw a new picture. In Masson we have to have the title before we can do more than hazard conjectures about its significance. Some psychologists, Jung for instance, and Freud too in his early days, believed that such symbols were common to the human race and that, whether we were conscious of their meaning or not, they would make a deep impression upon us, causing us to accept them or to turn away from them in horror. It is true that frequently when people see such pictures as this one, they are indeed horrified. They are seldom pleased. But whether that is because they are in the presence of something which is unfamiliar or because they are confronted with visions which they would prefer not to see, cannot be asserted with any confidence. Are we horrified because we yearn for stability and find here only change; because we are trying to escape from our animal nature and find here men and women turning into monstrous beasts before us; because we hope to find solid earth beneath our feet and are given flowing water; because we think of our bodies as our outer covering and come here upon our viscera all exposed? Is this picture a flat denial of our aspirations and a flat assertion of the most primitive part of our nature?

There are a number of widely used symbols which Jung calls archetypes. These are supposed to represent the ways in which primitive man expresses his deepest thoughts and feelings. If modern man retains a residue of primitive mentality beneath the upper layers which are the accretions of civilization, the archetypes speak to that residue. It is difficult to understand how any individual man can retain the experiences of the race unless there is such a thing as a collective memory. Without assuming a role which does not fit our competence, we can at least point to a few facts which would seem to justify the theory of a racial unconscious. In warfare, for instance, it is the easiest thing in the world for modern urban man to shake off the upper layers and revert to savagery, in fact, to live in a manner very close to that of the wild beasts of prey. Moreover we read in the papers every so often of men who go berserk and refuse to accept the rules of normal social behavior. We sometimes see children whose education presents almost insuperable problems to their parents; it is as if they were struggling against civilization instead of

trying to conform to it. Sometimes we satisfy our animal instincts in play, rough and tumble games, dangerous sports, capering and rolling about like little beasts, dancing in a kind of savage frenzy. We know how easy it is to start a riot when mass hatred is aroused and in the Second World War we saw a whole nation turn into beasts worse than any in the jungle. When Hitler urged his people to think with their blood rather than with their brains, he was proclaiming a return to savagery as a program. So it is perhaps just as well not to reject Jung's theory too lightly. And it might be equally wise to re-examine the values of modern urban society and see how satisfactory they will turn out to be in the long run. We may perhaps be "too civilized" for our own good. Perhaps, as William James suggested, we ought to look for some substitute for savagery which will be less harmful than war and crime.

Though we have spoken of symbolic and emblematic pictures as if they constituted a special class, there is no painting whatsoever, from the most non-objective to the most representational, which does not contain some trace of symbolism. It could easily be argued that the horizontals and verticals of a Mondrian are a rejection of life, a reduction of vitality to geometry. The distortions of Matisse, which are made to fit the human figure into a design, may with equal ease be interpreted as the elimination of the picturesque, a commentary on models and studio furniture, the models serving only as elements in a visual organization of forms, the accessories being no longer jugs, pitchers, violins, chairs, and tables, but spots of color and shape. Is Matisse's *Blue Nude* (Fig. 13) simply an arabesque of lines and masses, or the outspoken rejection of all the Sleeping Venuses, Reclining Nudes, and Abandoned Ariadnes that punctuate the history of European painting? Are Degas's ballet dancers fairylike girls inhabiting an exquisite world of light and grace (Fig. 142), or was J. K. Huysmans right when he saw them as hard working young women, deliberately made angular and ugly? Courbet's *Stone Crushers* (Fig. 54) was rejected by the Salon and treated by the critics as socialist propaganda; to us it is simply an uncomplicated genre painting. But, as we have pointed out, back in the sixteenth century Caravaggio's *Death of the Virgin* (Fig. 120) was similarly criticized. It had been customary to represent the Madonna as the Queen of Heaven, with crown, royal robes, and jewels. Caravaggio painted her in the guise of an Italian peasant. But so did Tintoretto and, as far as we know, his *Annunciation* (Fig. 109) caused no outcry. Did Caravaggio think that Mary, the wife of a carpenter, was more like a woman of the people than a queen? Did he think that she stood for all women and that there are more peasant women than crowned heads? Who can tell now what he thought? It is we who must now interpret his paintings and we shall do it through what they "say" to us.

Pictures may be pictures of thoughts, ideas, sentiments, fears, religious dogmas, as well as of people and things. And the hieroglyphic painting, the emblem, may not necessarily be one which was made to be one. A picture is what we see it as being, for every time we look, we interpret. We have come to accept all sorts of exotic paintings as if they were an integral part of our

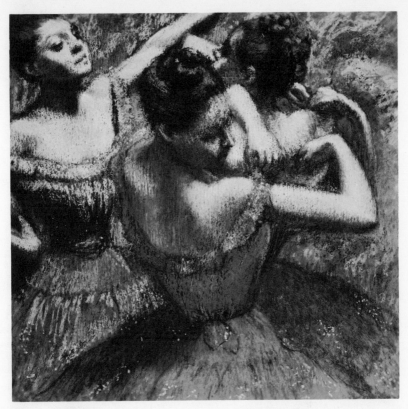

Fig. 142. Edgar Degas: *Dancers*, Toledo Museum of Art, Toledo, Ohio.

pictorial tradition: Chinese, Japanese, Indian, and even the rock paintings of our most primitive ancestors. But it is impossible for us to see in them exactly what their makers saw in them. African sculpture and even the paintings of children and neurotics, the paintings of the so-called modern primitives, the Sunday painters, are eagerly acquired and no one thinks any the worse of them because they were not made by graduates of our schools of art. Our aesthetic horizon has been enormously enlarged and we are becoming more universal in our appreciation, less bound to our own perspectives. This may well be a step towards a greater sympathy with humanity as humanity, from which our children and grandchildren will profit but of which we ourselves are just beginning to feel the effects. Just as systems of communication are causing frontiers to disappear and the globe to shrink, so art is binding us to our fellows who grew up in alien cultures. Even if we cannot see a Chinese painting as a Chinese sees it, we have become able to accept its aesthetic order as normal and not to reject it because it does not conform to the rules of Occidental art. Similarly we cannot act towards an African idol or mask as a

native African would. But we are now able to see it as manifesting a beauty of its own. By recognizing the complexity of pictures and refraining from laying down hard and fast rules governing what a picture "should be"— rules to which no practicing artists would pay the slightest attention anyway —we can accept pictures as they are. This seems at any rate to us a beginning of greater understanding, though it is of course only a beginning. But without understanding there will be no appreciation. And without appreciation there is a wanton impoverishment of life.

Conclusion

Two things at least should stand out now as the result of our brief survey of the purposes of paintings. First, any picture may be one of several kinds at one and the same time. That is, a picture may be both a design and a representation of some real or imaginary object; it may be both a literal representation and an allegory; it may be a caricature and an emblem. There seems to be no limit to the combinations of purpose which pictures may fulfill. If we have joined the possibilities in pairs, rather than in triads or more complex groups, that is simply for purposes of illustration. There is no picture which does not have some form, nor is there one into which an observer may not read a meaning. Just as pictorial allegories include representation, so they may slide over into emblems.

Second, what a picture is depends as much on the observer as on the painter. There would be no painting, it goes without saying, if there were no painter to paint it; but paintings have to be seen as well as painted and the observer is seldom identical with the artist. A given picture may "mean" one thing to one man and another to another and we know of no way of forcing a person to see in a painting only that which the artist intended to be seen in it. Looking at pictures is part of life and this book is not a plea for aesthetic starvation. If the observer is not to interpret pictures for himself, they might just as well be locked up in a cupboard after they are painted lest an alien eye contaminate them. Beside these two main points there are others.

Third, it is absurd for a painter to expect an observer to identify himself with him. No two people are alike psychologically, though all have some characteristics in common. Just as a person's speech may reveal to a listener a good bit about his education, his social status, and the region from which he comes, so a picture may reveal to a psychologist a great deal more about the artist's personality than the artist realizes. But at the same time it is equally absurd for an observer to read back into the artist's mind the feelings which his picture arouses in him and to argue that the artist intended to arouse these feelings. The two points of view, that of the artist and that of the observer, must be kept separate when one is discussing any work of art. A painting may seem trivial to an observer and have been of the greatest importance to the man who painted it. And similarly a painting which an artist may have tossed off without thinking much about it, a simple sketch or rough draft of a painting, may become more beautiful in the eyes of an observer than the finished painting for which it was a preliminary study.

Fourth, we have not been interested in appraising the different kinds of painting, in ranking one type above another. This might have been possible if we could have cut off the kinds with a knife and if a given picture could be isolated from all other kinds. But if the kinds of painting are determined at

the moment of seeing them by the observer, then we must grant the observer the right to classify them as he will and in accordance with his interests. Pictures are the locus of many values, not of one only. A given observer, moreover, at one time in his life may be sensitive to only one or two of these values and later grow into an appreciation of more. At certain periods of history critics may be more interested in one than in the others and their writings will fix in the minds of historians a typical interest for such periods. But all types are potentially present and may become actualized as the sensitive eye looks for them.

This is especially important at the present time when canvases are painted which resemble nothing more than large areas of one or at most two colors, areas on which the only difference appears to be difference in texture. Nevertheless some critics have read into these canvases emotional messages of tension, anxiety, elation, resignation, and the like. Before pronouncing judgment, one would do well to remember that a cloudless sky of blue, an unruffled surface of a lake, or a field of grass barely stirred by the breeze are frequently enjoyed as something purely visual. We are not here setting up a program for modern painters but merely pointing out that visual enjoyment is sometimes found in things which are undifferentiated as to color or even texture.

Fifth, when a critic begins to appraise paintings, he would do well to distinguish the values, let us say, of the design, of the accuracy of representation, of the artist's interpretation of what he is representing, of the allegorical and emblematic meaning of his painting. It will be rare to find a painting which is either thoroughly bad or thoroughly good, whatever standards of excellence are used. We do not say that such a thing would be impossible; we say it is rare. The failure to make such distinctions accounts to a large degree for criticism's seeming irrelevant to generations later than that of the critic himself. The fact that we are not likely to take Ruskin's point of view when looking at pictures does not mean that what Ruskin had to say was irrelevant. But to him a picture meant something that it does not mean to us. Similarly Tolstoy's criticism of works of art on the score of their morality seems beside the point to many of us today. But that does not prevent our recognizing that, given his premises, he might be right. If the art of painting could be entirely described as the art of producing only one of our five characteristics, then what we say would be trivial. But just as a man may be a good soldier and a bad businessman, an excellent scientist and a poor father, a charming companion and incompetent athlete, so a picture may be outstanding in some respects and inconsequential in others.

Finally, we are convinced and hope that we have convinced others that unless pictures make life more agreeable, give pleasure to those who see them because of one or more of their traits, they are dead, resembling stuffed birds and beasts in a showcase. One cannot transfer one's pleasure to others. But by arousing interest one also stimulates pleasure. Our purpose then may be summed up as having been to make pictures more interesting.